· 12°⁵

# Modern Negro Art

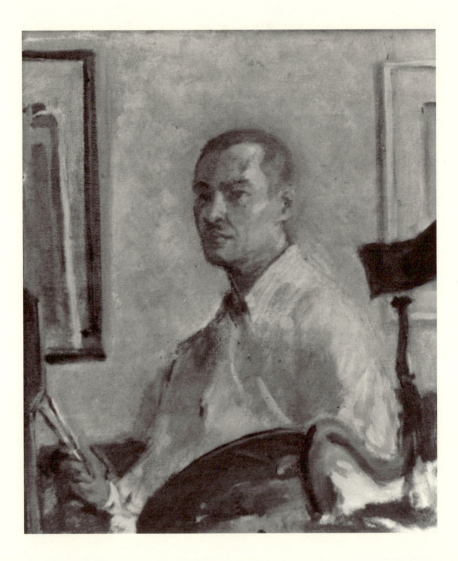

# Modern Negro Art

## James A. Porter

*With a New Introduction by David C. Driskell*

HOWARD UNIVERSITY PRESS

Washington, D.C. 1992

First published 1943 by The Dryden Press, New York, N.Y.
Published by Arno Press in 1969

Howard University Press, Washington, D.C. 20017

Introduction Copyright © 1992 by Howard University Press

Preface to the 1969 Edition Copyright © 1969 by Dorothy Porter

Manufactured in the United States of America

This book is printed on acid-free paper.

10 9 8 7 6 5 4 3 2 1

Library of Congress Cataloging-in-Publication Data

Porter, James A. (James Amos), 1905–
    Modern Negro art / James A. Porter ; with a new
  introduction by David C. Driskell.
        p.        cm. — (Moorland-Springarn series)
        Originally published: New York : Dryden Press, 1943.
        Includes bibliographical references and index.
        ISBN 0-88258-163-5 : $24.95
        1. Afro-American art.   2. Afro American artists.   I. Title.
II. Series.
N6538.N596    1992                                          92-37421
704′.0396073—dc20                                           CIP

Cover Illustration: James A. Porter, 1905–1971, *Woman with a Jug* (also known as
*Woman Holding a Jug*), ca. 1935, oil on canvas, 21 1/4″ × 23″. Courtesy Fisk University,
Nashville, Tennessee. Photo by Larry Whitson.
Frontispiece: James A. Porter, *Self-Portrait*, oil. Courtesy the James A. Porter family.
Photo by Milan Uzelac.

*To My Mother*

MOORLAND-SPINGARN SERIES

*Other Books in the Series*

*Black Bibliophiles and Collectors: Preservers of Black History*
Elinor DesVerney Sinnette, W. Paul Coates, and Thomas C. Battle

*Race Contacts and Interracial Relations: Alain LeRoy Locke*
Edited and with an Introduction by Jeffrey C. Stewart

Editor's Note: Howard University Press extends deep appreciation to all who have graciously assisted in the publication of the 1992 edition of *Modern Negro Art*, especially the following individuals: Scott Baker, Thomas C. Battle, Tritobia H. Benjamin, David C. Driskell, Kevin Grogan, Leslie King-Hammond, Eileen Johnston, Steven L. Jones, Richard Powell, and Lowery Sims.

# CONTENTS

# ILLUSTRATIONS

# PREFACE TO THE 1969 EDITION

THAT ART HISTORIAN WHO ATTEMPTS TO SURVEY ANY ART OR culture that has not run its course may be considered foolhardy, though he cherish the hope that all risks taken may be justified by solid achievements and the fortunate unfolding of events. In looking back on the early as well as the late chapters of this book, the realization comes home that what has been written has stimulated others and indeed the present writer to further research and appreciational studies of Afro-American art. It would seem, therefore, that history has chosen to enlarge rather than to diminish the scope and the rewards, or the actual and potential merits of the Afro-American artist.

In this connection, there has been a fortunate accumulation in recent years of further evidence in support of the unchampioned claims of the early black artisan in the United States. Equally significant is the fact that growing awareness of African survivals in the Western Hemisphere has brought wider recognition of the durable quality of the transplanted African's cultural gifts. In these respects, the historiographic as opposed to the ethnographic approach to early Afro-American art and culture has conduced to a better understanding or at least acknowledgment of both the slave laborer and the free black as craftsmen.

Further reason for encouragement lies in the fact that since this book was published, some early "lost works," by the remarkable cabinetmaker, Thomas Day, who worked in and near Milton and Raleigh, North Carolina, and by the brilliant and free antislavery artists Patrick Reason, Robert S. Duncanson, and Edmonia Lewis have been found. A separate mono-

graph on Duncanson's *oeuvre* now makes many of his less well-known paintings available for study and appreciation. In addition, the reappearance of works of sculpture by Edmonia Lewis and of landscape paintings by Edward M. Bannister— items which have been seen by few persons since Lewis' and Bannister's deaths—has greatly enlarged our conception of the development of those artists. The same is true for Henry O. Tanner, many of whose paintings and drawings were retained in his Paris studio after his death. In recent months, these works have been put up for sale in the United States and dispersed to collectors and museums.

It is likewise gratifying to note that a number of painters, sculptors, and printmakers who were young, both in years and experience, when this book was written have since emerged impressively mature. Some of them have been widely praised for their constant and inspiring contributions to the sum total of Afro-American art and culture. A few of their fellow artists, however, still lack that sympathetic and active support which their efforts deserve. Yet, the opportunity to observe and to interpret, through occasional criticism, the flowering of such talents as Hughie Lee-Smith, Charles White, Norma Morgan, Harper Phillips, John Biggers, Sam Middleton, Harlan Jackson, Paul Keene, Ed Wilson, Charles McGee, Richard Hunt, Ray Saunders, Richard Mayhew, David Driskell, Sam Gilliam and others of unique gifts, is also a privilege for which any art historian interested in the American scene ought to be thankful.

Perhaps it were best to mention at this time some significant aspects of change which have affected the progress of the Afro-American artist since the mid-1950's. In this period both new patrons and new audiences for Afro-American art have emerged; augmented though inadequate support has also come from elements of the black intelligentsia and certain of their institutions; and the productions of a few Afro-Americans have

been purchased for permanent showing in many foreign countries. But it is still depressingly true that by and large the public museums in America and their knowledgeable white representatives ignore the significant contributions which Afro-American artists are prepared to make to their collections. This is a condition that persists despite the recent protests of black militants against such exclusion.

In addition, some Afro-American intellectuals have sought nurture in black Africa's incipient cultural upsurge. Fascinated by the glittering values of "négritude" and by the unveiling of a new "African personality," they have begun to reassess their allegiance to the dynamic phases of the African heritage of soul and culture. Indeed the current disposition of several black artists to condemn the predominantly white leadership of American art as tantamount to imposing a form of cultural *apartheid* on Afro-American art may be taken as an extreme consequence of "Africanophilism."

The 1960's have also brought new goals as well as new opportunities for the Afro-American artist; yet, the behavior of some artists in respect to these new goals and opportunities is by no means uniform. There have been many new recruits to the ranks of the free-lance or independent artists who have not hesitated to question the "rights and assumptions" attaching to the positions of their senior colleagues. They have indulged in serious and even bruising arguments about the direction, the purposes and the meaning of "black experience" in the arts. But up to the present their denunciation of the still prevailing "cliques," "schools," and "academies" dominating American art has not precipitated an overturning of the same.

It is rather significant that the most effective of the new crop of artists of the 1960's have chosen to express themselves more or less in the idioms of surrealist fantasy or abstraction or in abstract expressionism, while others have reverted to *Dada*. A few, as might be expected, have lately caught up to

the featureless objectivity of the "New Aesthetic" which seems to suggest a strange alliance between existentialist art and metallurgic engineering. Theirs is not a free form of "minimal art" for all that it seems to say, "Nothing personal intended."

It is possible that the "Black Cultural Revolution" will enforce a return to the social realism of the thirties, or to a programmatic stylism that will equate art with race propaganda in accordance with a tacit insistence on the transvaluation of "black values." And no doubt a few artists will cling to traditional idioms just as a few of the mural painters are now beginning to do. But to judge by the hard-won and very substantial progress made by Afro-American artists over the years —a progress studded with original and enduring achievement— we may still expect "good art" to be the aim of their activity, no matter that it be sensibly cerebral, purely emotional, or a visceral and clamorous aspect of social realism.

*James A. Porter*
DEPARTMENT OF ART
HOWARD UNIVERSITY

January, 1969

# PREFACE TO THE 1943 EDITION

TEN YEARS AGO began the activity of locating and collecting the facts and documents that form the bulk of this volume. At that time very little was known and scarcely anything had been written about the Negro artisans and artists whose lives antedated the last quarter of the Nineteenth Century. But the constantly reiterated statement that "The American Negro has no pictorial or plastic art"—a statement for which both white and Negro persons were responsible—acted as a spur to my researches. Gradually the veil which had for so long a time obscured the past achievements of the Negro artist was rolled back. And I can remember how piqued was my curiosity on first seeing an early newspaper account of the career of Robert Duncanson and how my eyes were opened to the neglect and deliberate indifference with which Negro effort in the field of art was received.

By 1934 I had gathered a considerable mass of material bearing on the early Negro artist. In 1936, at the Fine Arts Graduate Center, New York University, I completed a study of Negro contributions to the handicrafts and to the graphic and plastic arts from 1724 to 1900. Shortly thereafter the discovery of additional data persuaded me of the need to prepare a thorough critical and historical account of this interesting though long-forgotten sidelight of American art.

I have attempted to place Negro art in proper relation to those general trends, events, and periods from the mid-Eighteenth Century to our day, through which it is possible to obtain an integrated view of American cultural history. This attempt to re-establish Negro production within the linear sweep of Amer-

xvii

ican history has provided challenging and illuminating experience. Naturally, it is my hope that this volume will prove illuminating to others, and especially to students and lovers of art of whatever age or nationality. And it is my further hope that it will swell the ranks of the friends of Negro art.

I gratefully acknowledge the suggestions and the very helpful recommendations of Dr. Charles H. Wesley, President of Wilberforce University, who took practical steps to see this work appear in print. I am also indebted to Dr. Walter W. S. Cook, to Dr. A. Philip McMahon, and to Dr. Robert J. Goldwater of the Art Institute, New York University, who read the manuscript and offered many helpful criticisms and suggestions both as to the preparation of the text and the arrangement of the illustrations. Record should also be made of the financial assistance advanced by the Educational Committee of the Alpha Phi Alpha Fraternity toward the publication of this book.

I wish to record my appreciation of Mr. Walter Pach's introduction to this volume. I acknowledge with thanks the many comments and suggestions offered by Mr. Alfred H. Barr, Jr. and Miss Dorothy Miller, of the Museum of Modern Art, who read with care the galley proofs of this book.

I wish to mention with thanks the invaluable aid of Miss Edith Daley, Librarian of the Municipal Library, San Jose, California; Dr. J. Hall Pleasants of the Maryland State Archives; Russell and Rowena Jelliffe, Co-Directors of Karamu House, Cleveland, Ohio; Mr. Holger Cahill, Mr. Thomas C. Parker and Mr. Robert Francis White of the Works Progress Administration in gathering illustrations and biographical data on the artists. Thanks are due Mr. Peter Pollack, Director of the South Side Community Art Center of Chicago; Mr. Benjamin Knotts, Curator of the Index of American Design, Metropolitan Museum of Art, New York; Mr. Hugh P. King of Hewlett, L. I., New York; Miss Ethelwyn Manning of the Frick Art Reference

Library, New York; and Mr. Alonzo J. Aden of the Department of Art, Howard University, for their kind permission to use some of the photographs that illustrate this book.

Finally, I wish to thank Mrs. Dorothy B. Porter, my wife, Supervisor of the Negro collection, Howard University, for sharing the onerous burden of research and bibliographic compilation that the writing of this book entailed.

<div align="right">J. A. P.</div>

# INTRODUCTION TO THE 1992 EDITION

The outpouring of interest that has come about in recent years on the subject of African American art would come as no surprise to James A. Porter, if he were alive today. The preeminent scholar on this subject, he paved the way for other scholars, collectors, and patrons of art to see the importance of the subject and to assess its relevant role as part and parcel of the larger field of American art, long before it was popular to do so.

Porter's committed pursuit of scholarly research in the field is commensurate with the vigilance of the prophet, whose vision of what lies ahead is seldom heeded in his or her lifetime. But life does not always honor with longevity those who deserve to hear their accolades spoken aloud in their own lifetime. Yet, long after such visionaries are no longer physically with us, we who witnessed their gifts of the spirit continue to profit beyond measure as we share their artistry and scholarship with future generations.

Porter bequeathed to those who have come after him an unusual legacy, the fruit of a creative mind whose eminence in art education was of such magnitude that he has been accorded a singular place in the history of African American art. Much of what we know about the cultural legacy that blacks in the visual arts inherited from their African forebears has come to us by way of his writings. Porter's *Modern Negro Art*, the classic work on the subject, was the first such book to denote and define the African impulse in the visual arts in the United States. Without his knowledge and constant vision of the role that artists of African descent played in American visual culture, many of us who attempt to carry on this noble tradition and to correct the omissions so inherent in African art history would be without the guidance we extoll to others.

I am one, among many such persons, who, blessed beyond account, benefitted thoroughly from Porter's wisdom and wise counsel. He served as my mentor at Howard University, where I studied the history of art and the practice of painting as an undergraudate. He inspired me to see art, particularly the practice of painting, as a necessary accompaniment to the study of art history, and I learned from him the dual pursuit of these noble endeavors.

Time will not permit, however, a personal account here of the influence that Porter had on my life as I have pursued both painting and writing nor indepth commentary on the role of his own art in the making of what we now call the black aesthetic. His writings were critical to those who sought to add clarity to the subject of black identity and its relationship to cultural emancipation from a Eurocentric ideal in the decade of the sixties. Nearly fifty years after its original publication, *Modern Negro Art* remains the most often quoted source in the field. Thus, it is both fitting and proper that on the eve of its golden anniversary this classic work should be reissued, particularly as its reprinting coincides with the opening of a major exhibition of Porter's art in retrospect. In this introduction, I shall attempt to highlight the salient contributions Porter made to the field of African American art scholarship, draw the contours of his successful career as a creative artist, and show how these pursuits fertilized each other.

The fact that Porter was able to carve his own niche into the tableau of history at an early age and to produce the kind of scholarship in art that remains relevant today should come as no surprise to any one who has followed his career. From the outset, he contributed essays of revealing scholarly importance on the subject of the Negro in art that were published in *The American Magazine of Art, Art in America, Opportunity Magazine*, and other journals in the years prior to and immediately after World War II. Of particular significance was the extensive essay, "Robert S.

Duncanson, Midwestern Romantic-Realist," published in *Art in America* (October 1951). Robert Duncanson (1821–72) was a second generation Hudson River School painter, and his landscapes were highly sought after in his lifetime. Like the work of his predecessor, Joshua Johnston (ca. 1770–1830), they were often mistakenly said to be from the hand of a Euro-American artist. Porter's research proved that both men were of African ancestry. His writings were both historical and prophetic in that they revealed important elements of our cultural past while looking beyond the contours of time to announce the relevance of black studies long before the disciplines of this curriculum became fashionable. Porter's meticulous research and scholarly review of early newspapers, wills, and authentic documents from the nineteenth century redefined the role of slave artisans by showing how they provided countless creative services to the households of the Old South as well as the emerging communities of the industrial North.

Perhaps even more important is the fact that Porter's research, much of which centered on the years of bondage and the search into our creative past, has inspired scholars across racial lines to investigate the margins of history more thoroughly. Many of these same scholars have spoken with strong voices for justice and equity in the arts, revealing the need for a revisionist approach to the study of American art history.

Porter was born in Baltimore, Maryland, forty years after slavery was officially abolished in the United States. The year of his birth, 1905, represents a critical time in the cultural history of African Americans. An acknowledged revolution in modern art was under-way. It had been inspired almost entirely by the exposure of Western artists to the powerful forms of sculpture from Africa that were beginning to be seen in European capitals, particularly in Paris. The dynamic expression that was observed in African art helped change the surface and styles of modern art forever.

Cubism would be born of such geometric observation, and Expressionism, as a style, particularly in Germany, would be greatly influenced by the abstract qualities of African art.

In America, the Niagara Movement, founded by W. E. B. Du Bois in 1905, paved the way for the establishment of the National Association for the Advancement of Colored People, which highlighted an agenda set on obtaining justice for people of color throughout the nation. A more militant mindset emerged in the decade of Porter's birth that allowed blacks and whites the chance to see themselves as allies against racism, anti-semitism, and sexism. Politics and cultural definition were the subjects of conversation among black intellectuals in the decade in which Porter was born, the eve of World War I.

Porter became keenly aware of the cultural plight of African Americans at an early age. He was born into a family in which everyone was expected to pursue a respectable profession. His mother, Lydia Peck Porter, was a teacher. His father, John Porter, was a Methodist minister and a recognized Latin scholar. Porter attended public schools in the District of Columbia, graduating, with honors, from Armstrong High School in 1923. For the next four years, he pursued courses of study in painting, drawing, and the history of art at Howard University. He received the bachelor of science degree in the Instruction of Art from Howard in 1927. He accepted an appointment at Howard in the fall of the same year as instructor of painting and drawing. While the teaching of studio art occupied an inordinate amount of Porter's time, he was not content to devote his time exclusively to teaching and he managed to paint and to continue his study of art history.

Recognizing the need to keep his own practice of the craft of painting at the forefront of his career, Porter enrolled in painting and drawing courses at Teachers College, Columbia University, during the summers of 1927 and 1928. He returned to New York City the following summer to study figure drawing and painting

with Dimitri Romanovsky and George Bridgeman, both of whom taught at the Art Students' League. In the spring of 1929, Porter's art was singled out by judges to receive the coveted Prize for Portrait Painting for the Harmon Foundation's *Annual Exhibition of Work by Negro Artists*.

Porter's paintings were later exhibited at some of the nation's leading museums, principally the Corcoran Gallery of Art in Washington in 1934 and 1936, the Detroit Institute of Art in 1932 and 1935, the Museum of Modern Art in New York in 1936, the Baltimore Museum of Art in 1935, and the Institute of Contemporary Art in Boston in 1936. During the next four decades, Porter's paintings were seen in a number of group exhibitions around the nation, including prestigious exhibitions such as *The Negro Artist Comes of Age* at the Albany (New York) Institute of Arts and Sciences in 1945, *The Negro in American Art* at the Wright Gallery in UCLA in 1966, and *Two Centuries of Black American Art: 1750–1950* at the Los Angeles County Museum of Art in 1976, to mention only a few. Numerous solo exhibitions were arranged of the paintings and drawings created in the United States, Haiti, Mexico, Cuba, and West Africa prior to the artist's death in 1970.

In the early years of balancing teaching, painting, and researching, Porter determined to make a systematic study of the history of art in an effort to see more clearly the role that people of African ancestry played in American art and in the art of other countries, such as Cuba and Brazil. In 1935 he received an Institute of International Education scholarship that allowed him to study abroad at the Institute d'Art et Archeologie at the Sorbonne in Paris. This experience offered him the chance to broaden his scholarship in art history to include European and West African art. In 1937 he received the master of arts degree in the history of art from New York University. For his thesis, Porter chose African American art, a subject that had received little attention

beyond the historical writings of his mentor, James V. Herring, head of the Howard University Department of Art, and the critical essays on the work of black artists written by colleague Alain LeRoy Locke, who headed the Philosophy Department at Howard.

Porter's thesis, *The Negro Artist* presented a historical overview of African American art, beginning with an examination of the early extant forms of arts and crafts from the period of slavery through the first quarter of the twentieth century. Always at his side during the pursuit of his research was his wife, Dorothy, whose invaluable service and bibliographical assistance could always be counted on. Together, they checked every available source known to them for information that aided their search for authentic examples of the art that would comprise the text of Porter's groundbreaking study of African American art. Porter's research, which centered on the slave artisan as builder and craftsman, revealed that some of the finest examples of workmanship in the plantation homes of the South such as furniture, cabinets, cooking utensils, tableware, and wrought iron implements were the products of slaves, many whose identity remains unknown to us today. His research further revealed that this superb endowment of artistic skill among slaves knew no gender barrier, as women, like men, often supplied many necessary craft items for southern homes while performing the usual duties of domestic servant and caretaker of the children of slaveowners.

Porter discovered that a number of craft items were made in a tradition that connected them iconographically to the art of West Africa, the region from which most African American slaves had come. Slave made vessels in the medium of clay such as the "grotesque jugs," as Porter termed them, walking canes, household textiles and a number of examples of architectural buildings such as the slave houses at Keswick Plantation on the James River, Midlothan, Virginia, and the African House at Melrose Plantation in Natchitoches, Louisiana, are among the many extant forms of

early African American workmanship that carry the imprint of their African origins. Porter's research highlighted the need for a text that addressed the areas of scholarship that he had unearthed in his thesis, "The Negro Artist." It was in this spirit of interest and scholarly devotion that Porter's masters' thesis was redirected to become the time-honored text called *Modern Negro Art*.

Immediately after its publication, *Modern Negro Art* met with high critical acclaim from art historians, art critics and academics around the nation. Laudatory messages and congratulations came from individuals such as historian Charles H. Wesley, former Works Progress Administration art administrator Holger Cahill and museum director Lloyd Goodrich. The book received wide recognition and reception at black colleges and universities throughout the South. It was immediately adopted as a standard text at Fisk, Howard, and Lincoln (Pennsylvania) universities, where courses of study that highlighted black achievements in world culture were already in place in their curricula.

Despite the wide reception given *Modern Negro Art* in 1943, few white authors writing thereafter on the subject of American art considered the body of work by artists of African ancestry cited by Porter worthy of inclusion in the current compendia. Helen Gardner's standard art history text, *Art Through the Ages* (1970, 1975), referenced neither African nor African American artists in its bibliographic index during Porter's lifetime. The same is true of David Robb and Jesse Garrison, whose much acclaimed art text, *Art in the Western World* (1953, 1963), made no mention of Porter's research on African American artists. Such were the omissions of a large number of scholars whose insensitive bearings on the subject of black culture helped to fuel the prejudices of those set on promoting the racial myths about the inferiority of members of the black race. Among those respected white scholars who welcomed Porter's scholarship by endorsing *Modern Negro Art* as one of America's essential cultural records was the respected author

and art connoisseur Walter Pach, whose book, *Masters of Modern Art* (1924), had set a high standard for scholarship in the interpretation of modern American art.

In his enlightening introduction to *Modern Negro Art*, Pach praised Porter for his insightful view of history, which gave parity to an imbalanced equation pertaining to the Negro in American art. Art historian Oliver W. Larkin later followed Pach's lead when he assigned the Negro artist a respectable place in his book, *Art and Life in America* (1949). Larkin discussed in brief the art of Romare Bearden, Aaron Douglas, Jacob Lawrence, Edmonia Lewis, Joshua Johnston, and Henry O. Tanner—an unprecedented number of black artists to be found at that time in a mainstream publication. Most often, however, these voices of reason, as in the case of Pach and Larkin, did not prevail in matters of race, since ignorance of the black race had so long been championed in the form of racial propaganda designed to promote racial disunity. Porter chose not to address the political aspect of the race question in *Modern Negro Art*. Instead, he spoke to a more accessible aesthetic that proved to be "culturally correct" in citing the omissions of black achievements from the history of American art. This he was able to do without resorting to the rhetoric of those who sought a more confrontational posture with white writers and critics of the period.

When *Modern Negro Art* was published in 1943, only two books devoted exclusively to the accomplishments of African American artists had preceded it. Both books, *Negro Art, Past and Present* (1936) and *The Negro in Art* (1940) were written by Alain LeRoy Locke, Porter's Howard University colleague. While both books were landmark publications in that they were the first to survey the field, neither addressed the critical issue of racial identity and self-affirmation in art as did *Modern Negro Art*, which painstakingly integrated the history of Negro art into the larger format of

American art without distilling from it that synthesis of form designed to give clarity to black creativity.

While *Modern Negro Art* sought to establish clearly, once and for all, a sense of territory or cultural space for the distinction that artists of color brought to American art, it did so with an unusual sagaciousness that endeared the book as much to white scholars as it did to blacks. When the book was reprinted in 1969 by the Arno Press, the black cultural revolution was well underway. Prior to the 1960s, few institutions of higher learning, other than predominantly black colleges and universities, offered courses of study in black studies. But this soon changed. So-called mainstream institutions throughout the nation began recruiting black faculty and students in an effort to become "relevant," both politically and culturally. Few reliable textbooks or reference guides highlighted the achievements of African American artists with the depth of *Modern Negro Art*. The Arno Press reprint made the book a classic.

In the final years of Porter's life, he further pursued research relating to the additions he planned to make to the literature in print of what he was then referring to as "Afro-American art." An important element of the author's continued research centered on his clarifying and correcting the record of some matters in African American art that had been invalidated by then current research. Most notable among the corrections and additions were details about the lives and work of Patrick Reason, Edmonia Lewis, and G. W. Hobbs, all of whom had been discussed in *Modern Negro Art*.

Prior to Porter's death in 1970, scholars writing on Reason seldom listed the date or place of his birth. Porter did not note with certainty Reason's exact birth date, but he assumed from other research that it was 1817. But a number of supporting documents have been found by the author's wife, Dorothy Porter, and Steven L. Jones, a visual arts consultant, that list several

relevant facts about Reason's life. It has been ascertained that Reason responded in writing to an inquiry about his life that affirms the fact that he was born in New York City on March 17, 1816. His death certificate notes the place and date of his death as Cleveland, Ohio, August 12, 1898.

In May 1969, less than one year prior to Porter's death, Porter ascertained that the celebrated neoclassical sculptor Edmonia Lewis is buried in the city of San Francisco in an unmarked grave. Further research revealed that Lewis was alive in the year 1911. More than thirty of her works in marble and plaster have been found since the original publication of *Modern Negro Art*.

More recently, significant research by Thomas C. Battle, director of the Moorland-Spingarn Research Center at Howard University, reveals enlightening information on the life of Reverend G. W. Hobbs, an artist who was assumed to be black and also thought to have painted the well-known pastel portrait of Reverend Richard Allen, the founder of the African Methodist Episcopal Church. Although Porter does not assign with certainty Allen's portrait to the hand of Hobbs, he does cautiously infer that he may have executed the work. A number of writers, ignoring Porter's caution, thereafter stated categorically that Hobbs was the artist of the portrait of Allen and some added their own interpretation of how Hobbs came to do the work. In a paper dated April 1983 entitled "Mistaken Identity: The Mystery of Reverend G. W. Hobbs and the Portrait of Reverend Richard Allen," Battle concludes that the Reverend (G)ustauvas (W)arfield Hobbs (1842–1925), a white Methodist minister who lived in Baltimore, was a painter, as recorded in Methodist history, but he could not have painted Allen's portrait in the year 1785, as was previously noted.

The relentless pace at which Porter worked during the final years of his life, searching the record to ensure corrections were made to some of the information in print, tells us in part how serious he was in attempting to leave an important legacy for those

of us who have come after him and chosen to study the history of
African American art. Equally important, however, to Porter's
review of history was his own art. He successfully achieved the
balance he had sought between his own creative life as a painter
and his life as a scholar, and the influences of these pursuits upon
each other are clearly discernible in his writings and his art.
Indeed, Porter was highly cognizant of the urge of the African
American creative artist to invest his own work with a very
personal and individualistic style that connected him both physically
and spiritually to the time and space of the African world. This
he attempted to do early in his career when he created visual
compositions that referred to an historical and cultural view of the
world he visited through scholarship, as in the case of Cuba and
West Africa, Haiti and Brazil. From 1928 through 1930, Porter
exhibited a wide range of his works at the Harmon Foundation
exhibitions that highlighted the visual achievements of African
American artists. He had already established himself as an artist
who had a keen understanding of the genre portrait of the African
American. The most widely exhibited among these portrait types
was *Woman with a Jug*, 1930, which is presently housed at Fisk
University in Nashville, Tennessee. Stylistically rendered in broad
painterly planes, *Woman with a Jug* represents Porter at his best
during the period when he diligently pursued a rather realistic
view of the world.

Special mention of Porter's adeptness at depicting particular
racial types was noted by Adelyn D. Breskin, the young director
of the Baltimore Museum of Art, in 1947, when a select number
of Porter's paintings were assembled for a showing at the Howard
University Gallery of Art on his return from his 1945–46 sabbatical
year of painting in Cuba and Haiti. In her introduction to the
modest catalog that accompanied the exhibition, Breskin cited
Porter's eminence as a writer and lecturer before commenting on
the strength of his recent work, much of which combined a salient

view of Caribbean culture with his extensive knowledge of the history of African people in the diaspora.

The most impressive work in the 1947 exhibition was a very well-crafted oil composition executed in 1946 entitled *In a Cuban Bus*. Some have called it the most successful genre painting done by Porter during his entire creative career. Music is the central subject of *In a Cuban Bus*, yet two people dominate the vertical design that Porter has chosen to emphasize. Not readily felt, when viewing the work, is the fact that an interior view from inside a crowded urban bus scene can be the ideal place for a very keen observer like Porter to scrutinize the true version of social manners that people practice. The passenger in the foreground holds a gamecock in his left hand while a musician playing the guitar stands behind stroking away at a tune in the same manner that one sees black musicians in the genre scenes of nineteenth-century American genre painter William Sidney Mount. But Porter's composition is action-filled and is somewhat of a commentary on the harmony with which people of different races live together in our island neighbor ninety miles south of Florida. While Porter may not have set out consciously to center the work on an historical episode in the manners and customs of the Cuban people, he, nonetheless, imbued the work with a sense of history and made an important statement about life in a nonsegregated society, which was unlike that in which he was accustomed to living in the United States.

After 1946, Porter continued to reflect the historical and social customs of people in his work wherever he chose to paint over the period of the next twenty or so years of his life. He traveled to East and West Africa, to Brazil and to Mexico, in search of information that later manifested itself in his writings on African survivals in the New World. Along the way, a series of paintings evolved, as did in the case of the twenty-four or more oils that Porter created during the 1963–64 school year. He had set out to validate his belief that an uncommon number of artifacts, buildings,

and visual objects, along with the proper accommodating social and cultural customs, were still undiscovered in Brazil, Haiti, and Cuba, all of which would add measurably to what he, in his own scholarly way, referred to as the "cultural strivings and visual mutations" left behind by the trail that black people made during their forced migration to the Americas. Many of Porter's notes that would have validated his fervent belief that persons of African ancestry had contributed significantly to the fine arts traditions beyond the acknowledged area of music remain to this day unpublished. These notes constitute an important body of research of the kind that has not been undertaken by more than a handful of competent scholars in the two decades since Porter's death. At the time of his death, Porter was working on a second book called "The Black Artist," aimed at exploring the historic influence of African art on the art of the Western world.

The final years of Porter's life did not pass without due recognition of some of the notable achievements he made to art education. In March 1965, Porter was one of twenty-six educators in the United States named "America's Most Outstanding Men of the Arts." This citation was presented at a White House ceremony presided over by Mrs. Lyndon Baines Johnson, during which Porter also received an award of $500 and a commemorative medal from the National Gallery of Art. Porter received these awards just five years prior to his death, and they were the most visible evidence of his acknowledged contribution to the scholarship of American visual culture but more important, to a neglected aspect of scholarly endeavor. Porter's death in Washington, D.C., on February 28, 1970, brought to an end a long career of dedicated artistry and accomplished scholarship in the history of African American art to which the book *Modern Negro Art* belongs as a permanent world-class record.

David C. Driskell
*Professor of Art*
*University of Maryland*

# INTRODUCTION TO THE 1943 EDITION

After considering James A. Porter's volume on the art of the Negro in modern times, and recalling other work of the author's, I come to a definite conviction that we have a book of permanent value and of extreme importance.

In saying "we," it is Americans as a whole that I have in mind, and the reason for my conclusion about the work is its testimony to the fact that the Negro does not stand apart in the civilization of the United States, but has an inherent share in it. The evolution of the Negro artist in America carries on the pattern of his white contemporaries—in the Colonial period as a craftsman, then in the earlier Nineteenth Century as a painter and sculptor, and later, with new influences from Paris and other European centers, learning—as did other Americans—until, at the present day, he partakes in the impulse toward a national expression, which is working to integrate our various efforts of the past.

The great contribution of the Negro to American music during that time is known by every one. But we have needed Mr. Porter's history to let us realize that in the visual arts the race has also done things that must be weighed in the balance with the rest of American production.

It would be interesting to appraise this book's importance—relatively—for the colored and the white sections of our population. As with music, again both groups influence each other reciprocally. While there is something of a specifically Negro genius in the Spirituals and other songs (both in their composition and in their rendering by Negro artists) their root lies in the soil and tradition of America, so that their acceptance as part of the heritage of white Americans, and as models for white musicians, is thoroughly logical. What may be less often realized

is that our white population needs this music far more as a document as to its relation with the Negro than as a matter of art.

Balancing, to a greater or less extent, various unhappy chapters in the common history of the two races in our country, the white man may point to the fact that it was in the United States that the Negro's expression of joy, sorrow and religious fervor took place. If, owing to the force of blind circumstances, and to a still imperfect understanding of American problems, there are painful memories in our past, we (Americans as a whole, once more) can look to our music for compensation—in the sense that Emerson gave to the word. There is no stealing from the Negro (of that which can never be taken from him) if the white man claims a share in the beauty of the music that his dark-skinned compatriots have given to the world.

Similarly, in the presence of the fine work of Negro painters and sculptors, the white section of our public can take pride in the fact that, with all the error that we lament of earlier times and that we have still to eradicate at the present day, it was American conditions that gave to the Negro inspiration and opportunity to do his work. The opportunity has been meager enough, to be sure, but its increase as time goes on is a much needed source of justification and of hope.

For the Negro, this book has a complementing message. In his hard-fought rise to a better economic and social position, the value of the evidence assembled by Mr. Porter seems to me absolutely inestimable. The ugliest and crudest effect of the propaganda of Hitler and his intellectual allies in the United States would be to bring about in the Negro a sense that he really deserves the stigma of inferiority that his enemies (the enemies of our whole way of life) attempt to place upon him.

Fortunately, the Negro is conscious that the falseness of such propaganda is even more complete than its meanness. Yet there

is a distinction to be made between knowledge based on an instinctive sense of worth, and knowledge based on concrete facts. Those offered in such scholarly fashion by Mr. Porter are, of course, only a part of the documentation of our claims as to the dignity of the Negro's position in the world of intellectual and spiritual achievement, but they are an important part. Brought together by one who is at once a creative artist himself, a teacher, and a permanently receptive student, they constitute a body of testimony that must endure with the other essential records of America.

<div style="text-align: right">Walter Pach.</div>

# Modern Negro Art

# CHAPTER I

---

# Negro Craftsmen and Artists
## of Pre-Civil War Days

THE LOWLY NEGRO joiner or blacksmith working in his master's plantation toolhouse never knew that the products of his efforts some day would interest a curious posterity. Later Americans, however, have come to realize that he has made a contribution to the civilization of this nation through his mastery of certain skilled handicrafts. The Negro artisan rose from slavery, yet found a creative joy in that work which contributed to the comfort of others. But he received scant credit from those who exploited his labor. The ingenuity of black yeomanry did not receive its just due until Twentieth Century scholarship made possible a dispassionate appraisal of labor in the Old South.

Even today we are tardy in our recognition of the Negro's creative labors as a slave artisan. Negro spirituals and fables and many early dance patterns have been sorted out from American folk-culture. But not so Negro crafts arts; these have not come down to us in any such comparable state of wholeness. In fact,

3

anonymity, a condition of slavery, has largely erased first-hand evidence of the Negro's part in the finer crafts production of pre-Civil War America. Nevertheless we are assured through a variety of Colonial and post-Colonial sources that the Negro artisan early became the backbone of American industrial development in the South and in parts of the Middle East.

Negro slaves were first brought to this continent in 1619 for farm work and the more commonplace domestic tasks.[1] These victims of the "inhuman trade" were not always as ignorant as some writers would have us believe.[2] Often their knowledge included a mastery of basic skills useful in the making of tools, weapons, utensils, and clothing, as well as decorative forms of a high order. But the slaves lost many of their tribal habits and customs, along with their technics, through a process which anthropology terms *acculturation*.[3] This acculturation, or process of assimilation and adjustment to the requirements of the dominant racial group, was part of a forced accommodation to new and generally unfavorable social conditions.

Negro slaves in America before 1800 were of two classes: first, the "raw" or "guinea" Negroes, imported directly from Africa; second, the "country-born." The latter might be imported from the West Indies or from some other colony, or they might be Negroes reared in the American colony where they were held.[4] Hence not only had the slave to adapt himself to the climatic, social, and economic conditions of America, but often he served a preliminary servitude elsewhere. But even before the Revolution some Negroes enjoyed a wide personal freedom and at times a relation of something like a business partnership with their masters. And there were free Negro artisans as well as apprenticed Negroes who became free after a period of service. In some of the Colonies Negro slaves were readily apprenticed to white journeymen that they might thereby be made more useful and profitable to their masters. Commonly in the northern and middle Colonies there were Negroes who as independent masters

or as hired-out slaves learned and practiced printing, goldsmithing, silversmithing, portrait painting, and cabinet-making.

Often the Negro and his master maintained a relationship of mutual trust. Marcus W. Jernegan, author of *Laboring and Dependent Classes in Colonial America*, lists four distinct relationships between a skilled slave and the person exploiting his labor: "First, there were those artisan slaves who applied their skill or produced goods when owned and kept by any free white or colored man or woman who wished to profit by such skill; secondly, there was the apprenticed slave who might produce goods even though bound to his instructors; thirdly, the Negro slave artisan might be hired out to some person by his owner for divers lengths of time for stipulated amounts payable to his owner; fourthly, he might be allowed industrial freedom by his owner, or the privilege of working when and where he could find employment. The condition on which the slave was allowed such freedom was that of turning over to the owner, at stated intervals, all or an agreed portion of the wages earned."[5]

An interesting example of the first kind of relationship appeared in Boston about 1724. Isaiah Thomas in his *History of Printing in America* tells of three Negroes who were "bred to press" in the home and printing establishment of Thomas Fleet, a Boston printer who had fled to America in 1721 to escape the ire of the High Church Party in England. These Negroes were an unnamed man and his two sons, Caesar and Pompey. All had been instructed in Fleet's own shop in setting type and engraving wood blocks. Thomas credits the father as an ingenious man "who cut, on wooden blocks, all the pictures which decorated the ballads and small books of his master. . . ."

Writers on the economic aspects of slavery have failed to concede the talent of many Negro slaves or to admit their emotional sensibility and even resourceful intelligence. It would seem as if they feared to grant that the Negro slave had creative ability. But in early American newspapers we occasionally find specific

reference to a slave's talent for graphic expression and even definite affirmation of his skill as a finished artisan. Three excerpts illustrate these statements:

In the *South Carolina and American General Gazette*, June 3, 1771, John Fisher, "cabinet and chair-maker," advises his friends that "He has purchased of Mr. Stephen Townsend his stock in trade and Negroes brought up to the business which he now carries on at the House in Meeting Street, Charleston, S. C. . . ." Those "who chuse to employ him will be supplied at the most reasonable rate and may depend on his diligence in executing their orders."

In the *Maryland Gazette*, November 2, 1774, one Andrew Leitch announces that there is to be disposed of "a person near seven years to serve, who understands engraving in all its different branches, such as raising and making impressions on gold, silver, copper, brass, et cetera, and likewise making small cuts of all kinds, woodcuts, arms, and figures on plate in the neatest manner."

In the *Pennsylvania Packet*, May 1, 1784, the following notice appeared:

> John Letelier.—Eight dollars reward. Ran away from the subscriber, a negro named John Frances, by trade a goldsmith. Said negro was carried to New York and left in charge of Ephraim Brasher, goldsmith, from whom he absconded, and returned to me—whoever takes up said negro and delivers him to John Letelier, goldsmith in Market Street, or to the subscriber in New York, shall have the above reward, and all reasonable charges paid.[6]

A remark in Peterson's *History of Rhode Island* indicates that in some parts of the New England Colonies the Negro artist may be counted among the pioneers of American portraiture. Peterson says Gilbert Stuart "derived his first impression of drawing from witnessing Neptune Thurston, a slave who was employed in his master's cooper-shop, sketch likenesses on the

heads of casks." The possibility of this contact between a slave and the first American master of portraiture seems even greater in the light of the following advertisement in an early Boston paper:

> Negro artist. At McLean's Watch-Maker, near Town-Hall, is a Negro man whose extraordinary Genius has been assisted by one of the best Masters in London; he takes faces at the lowest Rates. Specimens of his performance may be seen at said Place.[7]

In the one example we have a self-taught Negro slave artist, and in the other a free Negro of European training who may symbolize the native-born and the "imported" branches of Colonial art. In the former the folk art of America was produced largely by self-taught individuals, and in the latter by those who had training. in the academic or sophisticated modes of painting in vogue in France and England in the late Eighteenth Century and thereafter. Like Smibert, Copley, Matthew Pratt, and other American artists of the period, McLean's protégé had received technical training in Europe. This precludes us from regarding him as an American "primitive," but rather establishes him as a "lost" American painter whose apprenticeship to an English artist may have turned him sophisticate.

Throughout the Colonial period, however, the Negro artisan was never really integrated into American society. Even the talented Negro was subject to all the legal restrictions, social opprobrium, and caprice of slavery. Yet often his privileged position as a liberally treated house-servant, the awakening of an anti-slavery sentiment in some northern localities, and the fact of the small number of Negroes in the New England Colonies enabled the urbanized Negro to approach closer to the status of true citizenship and to find patrons of his creative ability. But this was not true of the Negro in the South before 1871. From the generalization, of course, are excepted those Negroes who were themselves members of the master class.

Before emancipation in Massachusetts, Negroes there had commonly enjoyed the ordinary rights of free laborers. The classic example of a Negro slave who received paternalistic treatment from a genteel bourgeois culture is the poet Phillis Wheatley. In a poem, "To S. M., a Young African Painter, on Seeing His Works," she mentions a Negro contemporary painter-slave, one of the first Negro artists of the servant class in America. A manuscript note penciled at the end of the contents of a 1773 London edition of her volume *Poems on Various Subjects, Religious and Moral,* in which the above title appears, identifies S. M. The note reads:

> Scipio Moorhead, Negro servant to the Rev. John Moorhead of Boston whose genius inclined him that way.

An elegy written by Phillis Wheatley and dedicated to Miss Mary Moorhead on the death of the latter's father shows that the poet was acquainted with Scipio's owners.[8] The recognition and cultivation of the slave's talent by Sarah Moorhead, wife of the minister, led to wider notice of his abilities. Sarah Moorhead herself was a teacher of art and expert in the technics of drawing, japanning, and painting on glass.[9]

We may conjecture that this slave may have tried his hand at portraiture and even surmise that he is the author of the unsigned portrait of Phillis Wheatley that adorns several of her published works. This portrait is a copper-plate engraving and probably is the only contemporary likeness of the poet. The work is of provincial character and exhibits several naïve traits of design. These very traits are the strongest reasons for attributing the work to an amateur, which Scipio undoubtedly was. The conjecture is strengthened by the fact that this portrait and the poem to Scipio first appeared in the 1773 London edition of the poems.

A northern Colony, too, saw the first contribution of the Negro slave to American architecture. Interestingly enough, nowhere

in his researches has the writer found a single instance of a Negro slave whittler, a vocation to which many detractors of the Negro might suppose he was naturally and indolently inclined. But this interesting craft apparently was ignored by the slave and the finer and more complex trade of carpentry and cabinet-making was followed instead. Far up the Hudson River, in the little known Shawangunk Mountains, a house was built in 1712 for a Dutch patroon. This structure was erected by the skilled hands of Negroes who were worked in numbers by their Dutch masters on the large plots of land granted by the West India Company.[10]

In the great Jansen House built on this site, there still exist, intermingled with Dutch and English influences, certain features of construction and ornamentation that are clearly African. While the hallways and living rooms are English, the great Dutch hall-door, hung in 1712, still bears the tremendous hand-forged hinges that helped it withstand the attacks of hostile Indians. The construction is unusual in that the ceiling beams are laid crosswise rather than lengthwise with the house. But most striking is the delicate detail of the huge fireplace, pains-takingly wrought by slaves during the long winter evenings.[11] The present dining room, according to a recent authority, was the original kitchen. Its large fireplace could accommodate all the utensils needed in cooking for the Jansen family. The slaves had two fireplaces in the basement which served as their sleeping quarters and also for storage space.

This interesting piece of American domestic architecture re-calls an early Negro cabinetmaker and wood-interior finisher named Thomas Day, who lived and worked in the vicinity of Charleston, South Carolina, from about 1820 to 1870. Day's talents as a cabinet artist were sought after by the richest clientele in Charleston and in Virginia. His furniture, many pieces of which were created on the orders of his numerous patrons, was

of a pure style, though founded on earlier adapted types of American and European period styles.

However, years before Day's time, Negroes had been introduced to the skilled and "nobler" trades in South Carolina and other localities of the South. Of course, the plantation system which dominated social and industrial life in the southern Colonies, and later in the southern States, could not promote a widespread secular culture.[12] The main energies of the planters were centered on material gains, or the settling of marginal areas. This was necessitated by the difficulties in a pioneer agriculture. The inconvenience of furnishing plantations with needed implements and provisions caused the landholders to strive for economic self-sufficiency. This required the clearing of vast tracts of land for farming and a division of labor on the great manorial estates.

The diversification of farming and industry was the chief cause for the employment of the slave in non-agricultural and manufacturing pursuits.[13] In time it appeared necessary to enact legislation to increase the supply of artisans. Later acts were passed to encourage local manufacture and to prevent the export of raw material. Meanwhile the volume of employment of the Negro in southern and middle Colonies at skilled tasks became so great that laws were passed to curb and in some places to halt it. Victor S. Clark in his *History of Manufactures in the United States* says that colored shoemakers, tailors, and blacksmiths followed their trades from Pennsylvania southward. Isaac Weld, a British traveler, observed that in 1796 all the iron furnaces and forges in Maryland were worked by blacks. At about the same time a Kentucky furnace operator advertised for Negro hands; and "sprightly Negro boys" were sought as apprentices in western nail factories.[14] Negroes also were often used as carders, spinners of yarn, and cloth weavers on many southern plantations. Records show, furthermore, that Negroes first trained in the northern communities were sent south to assist in the instruc-

tion of both black and white workmen in their crafts.[15] Documentary proof of their accomplishments has been uncovered through the researches of *The Index of American Design*, as the illustrations in this volume show.

Although the diversity of slave industrial labor in early American life is proved, there is some speculation about the talent or artistic yield in the slave artisan's output. On this there is a paucity of evidence. R. B. Pinchbeck, however, in his *The Virginia Negro Artisan and Tradesman*, infers from considerable data of his own that southern Negro artisans were employed in all the skilled trades. He also mentions the originality of Negro craftsmanship in the neat construction of small cabins, and the simple beauty of wood-interior ensembles executed for many rural mansions of the South.[16] Even if no other evidence of slave craftsmanship existed, there would still be that which survives in much of the now decaying architecture of the Old South.

In North Carolina there are two outstanding examples of the architectural skill of slaves—the neo-Gothic Chapel of the Cross at Chapel Hill, built entirely by them, and the Torrance House at Cedar Grove, Mecklenburg County.[17] In Alabama, says the W.P.A. Guide to that state, "While the affluent toyed with painting and filled the rôle of patrons of art, Negro slaves and members of the small farmer families developed rare skill with miter-box, hand-saw, hammer, and needle. Many of the finely carved cabinets and mantels that graced plantation homes were made by skilled Negroes who were also adept in ornamental iron work, tinsmithing, and shaping utensils of various design from pewter. . . ."[18]

By the last quarter of the Eighteenth Century Negro slaves and freemen partly or completely manned the iron manufacturing plants of the southern Colonies. Not only did the slaves then fashion the rude implements needed for the plantation, but they also made the finer utensils, kettles, pots, bowls, andirons, pitchers, forks, tongs, and the essential furnishings of the

kitchen and dining room. Their resourcefulness interested many proprietors of smelting furnaces and ironsmithing shops in their labor. By 1795 in York County, South Carolina, more than eighty Negroes were employed in the Aera and Aetna Iron Foundry in several types of work. Some were forgemen, others blacksmiths, founders, and miners; still others prepared patterns and molds. Thus they engaged in every important task in the production of both plain and ornamental iron.[19]

It is impossible to determine how much slaves earned when employed by their owners or when hired out to proprietors. Many of them certainly deserved the best wage of their day, judged by the pre-Civil War decorative iron of Charleston and New Orleans. The relationship of Negro labor to the production of ornamental iron for those two cities is still obscure, but it is known that much of the New Orleans iron was wrought after the rebuilding of the city following a series of disastrous fires, the first of which occurred in 1780. It is also known that gangs of Negro slaves worked under the direction of the Governor, Carondelet, and later under the architect and builder Don Almonaster y Roxas, in the excavation of the canal and "Old Basin" connecting New Orleans with Bayou St. John.[20] And they helped construct the new buildings of the city between 1785 and 1805 and also its walled defenses which resisted the British in 1812.

According to tradition, local iron foundries, even though owned and operated by French and Spanish tradesmen, depended largely on Negro blacksmiths. These foundries supplied those exquisitely forged balconies, grilles, escutcheons, lamp-brackets, hinges, and locks that can still be found in the Old Quarter of New Orleans.[21] The pirates Jean and Pierre LaFitte are said to have been among the chief exploiters of Negro slave labor in the iron trade. Their commercial and political racketeering did not end until 1814 when they were tricked into surrendering after informing the Governor of British naval secrets. From their

shops many of the best examples of iron work are said to have come.[22]

After the War of 1812 there was an influx of German trades-men from Philadelphia and New York City. These migrant journeymen introduced the more mechanically efficient if less artistic process of cast iron.[23] Not long ago some wooden temp-lets found hanging in the old Shakespeare and Leeds foundries in New Orleans prompted the belief that they were·cut by German artisans and cast by Negro forgemen.[24]

There were trained Negro blacksmiths in the Louisiana Ter-ritory of the Lower Mississippi at an early date, as is shown in the following advertisement, which is typical of the printed records:

> To Planters, A white workman, blacksmith by trade, who own a negro slave also a blacksmith (and has no other dependents) wants employment upon a plantation where a smithy is already established or whose owner wishes to establish one. Address in the city [New Orleans] Mr. A. Bonamy. October 6 [1809][25]

Contemporary opinion, too, supports the belief that the laborers in the early smithies of New Orleans and other Louisiana localities were Negroes. At least two writers are convinced that black labor alone was responsible for this production.[26] Even Albert Sonn, whose books have increased the public appreciation of American iron production in the Eighteenth and Nineteenth Centuries, agrees that a large part of both the forged and the cast iron was turned out by Negro slaves.

With tongue in cheek the noted Louisiana historian Henry Castellanos says:

> During the two or three decades that followed the transfer of Louisiana to the United States [1803] the tide of immi-gration [into Louisiana] was slow and uncertain. . . . A scarcity of white manual labor having ensued, it became necessary to substitute slaves and free colored people in all

mechanical pursuits. Thus it was that in our factories and blacksmith shops bosses or foremen would be whites, while the operatives were either blacks or mulattoes. And so with other trades, such as bricklayers or masons, carpenters, painters, tinsmiths, butchers, bakers, tailors, etc. In fact, had not the progress of the country, from the condition of unrest under which it had been laboring, developed itself into the proportions which it has since assumed, there cannot be the least doubt but that all the lower mechanical arts would have been monopolized in the course of time by the African race. But the reverse fortunately took place, by reason of the influx of white immigrants, so that even the branches of industry which had by common consent surrendered to the colored population as too menial for the white race, were wrested from them by the encroachment of foreign labor.[27]

Another writer suggests that "it would have been a satisfactory experiment had the wrought iron of the Negro black-smith continued uninterruptedly for a century."[28] He meant that so promising had their efforts been that, given a longer period, they probably would have effected a flowering of the craft of hand-wrought iron in North America.

The chief distinguishing characteristics of this iron are slenderness and grace. In these two qualities a host of others is implied. The linear complexity of some of the specimens asserts a definite character. This complexity combines almost magically with, first, a breath-taking fluency and then a ripened languor of line such as in the side and central balconies of the Cabildo, or Town-House, in New Orleans; or in the details of the gate of Casa Flinard where there also appears an intriguing motif of repeated perpendicular spearheads mounting the pickets of the gate. Local and possibly adventitious traits are also found in the wrought-iron balcony and lattice grilles of the Arsenal, in the "garde de Frise" of the Galley House on Chartres Street, and in the rather gauche hinges that support the interior doors of Beauregard House. French and Spanish models and patterns dominate the remainder of the older type iron in the Vieux

Carré, but hardly anywhere do the specimens show absolute dependence on European designs.

Majorca and Versailles find only delicious parody and brilliant paraphrase in the iron of this New World city. The humor of the Negro and the supple play of his muscles, accustomed to hard labor and creative abandon, have stamped the old iron of New Orleans with originality and life.

This opinion is supported by the W.P.A. Guide to the State of Louisiana:

> Cast and wrought ironwork in Louisiana forms one of the most popular means of ornamentation. Many of the balconies of the French Quarter of New Orleans date from the late Eighteenth and early Nineteenth Centuries. . . . In general, the wrought iron can be distinguished by its simpler design; the more ornate oak and grapevine motifs are cast iron. . . .
>
> The metal work used in the construction of the first Ursuline Convent, now known as the old Archbishopric, was forged by slave labor; and through later years both slave and free forge workers made grills, guards, rails, gates, and other wrought iron pieces that survive in Louisiana's time-worn buildings. . . .[29]

Neglecting those ornaments that bear the mark of Directoire and Empire and are of much later date,[30] the inter-crossed lozenges of the balcony railings and the naïve combinations of ellipses and ovals of different sizes demonstrate a meeting of tradition with local simplicity. From our knowledge of the use of slave labor before the Civil War and from the strength of local tradition in the vicinity of New Orleans, we can assume that local artisans, among them French and Spanish designers as well as Negro craftsmen, were responsible for the greater portion of this art which so enriches American treasures.

Similarly in Alabama Negro slaves and French émigrés worked together to adorn public and residential structures with

the gracious beauty of wrought iron. From the W.P.A. Guide for Alabama we learn that

> Ornamental ironwork was introduced in the 1870s and by the turn of the century it had gained wide use. In the early days the iron was imported from France, but occasionally some of the best examples were wrought by local craftsmen, usually Negro slaves. The delicate patterns beaten out over a forge were among the most artistic creations of the Negro during early slavery days. . . . One of the best examples of this wrought iron is in the French Double House, at 58 Conception Street, Mobile, built in 1824, which has delicate iron balconies on each wing.[31]

The diversity of the trades of Negro slaves and the growth of their numbers in the nobler crafts indicate the integration of the Negro into the basic skills of early American industry. Until about 1830 the Negro held a monopoly on most of the mechanical arts throughout the South. In Louisiana the dominance of the black tradesman was broken only by the violent clashes between white and black workers in the third decade of the Nineteenth Century. But elsewhere it was eased by legal action against the hiring of Negro mechanics in considerable numbers.

A review of the original performances of American goldsmiths, silversmiths, and pewtersmiths of the Eighteenth and Nineteenth Centuries must note that there were also Negroes recognized in these crafts. In our admiration of the excellent foundations, the brick work, the clapboard sides, and shingled roofs of many architectural monuments of the Old South, we may recall that when they were built Negro labor often served in the capacity of contractor or carpenter or both. There was a Negro contractor and builder named Sampson in Wilmington, North Carolina, who in the 1820s was one of the outstanding men in his field. By "building a house for a house" he amassed a large fortune in time and gave employment to other Negro workers, thus helping many to obtain their freedom. Further,

Negro wood-carvers and wood-turners sometimes contributed to American folk art, as is shown by two remarkably carved chickens attributed to a slave of the pirate Jean LaFitte and reproduced in full color for *The Index of American Design.* Also from this collection are two interesting brown-glazed mugs of the type commonly called "slave pottery," and a carved wooden cane of which the provenience is Missouri.

From the days of slavery, however, there remain only a few monuments proving the creative genius of the Negro artisan. Among those surviving, the most striking are works of the Negro artisan-painter and engraver. We have mentioned Scipio Moorhead. In Baltimore two Negroes talented in painting were at work in the last quarter of the Eighteenth Century. Dr. J. Hall Pleasants of the Maryland Historical Society has rediscovered and identified the first of these, Joshua Johnston.[32] Johnston is said to have been variously the slave of Colonel William Stricker, General William Smith, and John Moale—all of Baltimore—and to his brush are credited twenty-one portraits of white subjects, who were his master's friends and his own patrons.

Certain consistent traits in Johnston's work, betraying peculiar preferences of the artist, have been pointed out by Dr. Pleasants. In addition to the rather stiffish, though neatly and diligently rendered poses of his subjects, Johnston shows a predilection for jewelry as an adornment of his female subjects, and a liking for the kind of Sheraton furniture that is decorated with Spanish nails or studs. But Johnston's portraits are worthy of the best tradition in American primitive art. The source of his instruction or training is not yet established, but, to use Dr. Pleasants' own words, there appears in his painting a "striking generic resemblance to the work of three members of the Peale family." These three artists were Charles Wilson Peale, Charles Peale Polk, and Rembrandt Peale. It is possible that Johnston saw the paintings of Charles Wilson Peale as that painter was working in Baltimore and its vicinity in the 1790s.

Richard Allen, first bishop of the African Methodist Episcopal church, says in his *Autobiography* that he spent the greater part of 1784 in and around Baltimore and Philadelphia. It is possible that in this year his portrait was made by a Negro Methodist minister, G. W. Hobbs, then residing in Baltimore. Hobbs had virtually established himself as the portrait painter of the Methodist Episcopal church in that area, according to one writer. There is an allusion to his work in James A. Handy's *Scraps of African Methodist Episcopal History*. Since Allen in his youth had been a member of the Methodist Episcopal church, it is possible to regard the small pastel sketch now in the Moorland Collection at Howard University as the work of a colleague whom he had known in Baltimore—perhaps G. W. Hobbs.

The portrait of Allen was received personally by the writer from the late Henry O. Tanner, noted Negro painter, on the occasion of a visit to the artist's studio in Paris. Tanner had obtained this work from his father, Bishop Henry Tucker Tanner of the A. M. E. church, who had written on the back of the frame: "This portrait was executed in the twenty-fifth year of the subject's life." Hence the date of the work is 1785.

Here our account of the creative work of the Negro as slave and as a free artisan in the days of slavery ends. But it should dispose us to look for further evidence of the Negro's artistic beginnings in the United States. The Negro artist in America emerged from a background of folk art, and his formal speech was grounded in the industrial idiom of the New World. The Negro's survival in this sphere has been difficult, but historical evidence shows that his crafts productions must have been considerable, and so suggests a future complete review based on a searching investigation into the whole body of American folk art. In this way the Negro's contribution to American handicrafts can be brought into better focus.

# CHAPTER II

## Freemen as Artists: The Pioneers

AFTER THE ABOLITION of slavery in certain northern states, but before Federal emancipation, the Negro freeman enters the field of art, becoming increasingly conscious of his rights to the trades. Aided by whites opposed to slavery, he struggles into their studios and workshops, painfully learning steel engraving, lithography, sign and coach painting, portrait painting, and clay modeling. Slavery had limited the expression of the Negro, but the free artists were more articulate. Furthermore, being free-born or liberated, they had attained an ideological independence that enabled them to transmute their feeling of liberty into their efforts.

The entrance of the Negro into the field came as American art was struggling for survival—just before the birth of the Hudson River School,of landscape painting. The same European tradition that served this early group of white American painters supported some of the first Negro painters, and both

belong to the childhood of American art. The few works left from this period show that the free Negro artists were courageous and talented. But as outcasts of their profession they had small opportunity to practice it. Their work, however, provincial as it may have been in certain cases, was praised in their own time as the very flower of Negro culture. It invigorated the Abolitionist movement, and because these early Negro artists strove for physical as well as cultural emancipation, nearly all allied themselves with the anti-slavery leaders—William Lloyd Garrison, Benjamin Lundy, and Frederick Douglass.

Records point to Robert M. Douglass, Jr., of Philadelphia, as the first of these Negro pioneers in art.[1] There is scant knowledge of his life, but here and there his story is sharply etched by published items and by bits of information preserved by his descendants. He was born in Philadelphia, February 8, 1809. His father was Robert Douglass, an emigrant from St. Christopher Island, British West Indies; and his mother was Grace Bustill Douglass, of Philadelphia. Robert Douglass, Jr. and his sister Sarah, who became a prominent Philadelphia teacher, were educated by the Quakers.[2] Under their tutelage Douglass mastered French, Spanish, shorthand, and learned dramatic reading and guitar playing. In his versatility and many humanitarian interests he resembled Washington Allston, a contemporary; but Allston, though brilliant, seldom felt impelled to complete his projects. Douglass, like other better-known American artists, had to struggle for achievement against the usual obstacles, but to these was added an almost insurmountable race prejudice.

Douglass' works have been lost, perhaps forever. But the work of one of his pupils, a cousin, David Bustill Bowser, may serve as a criterion by proxy. Bowser's work will be discussed later. More definite sources from which to evaluate Douglass' efforts are contemporary and later-published comments on his ability. That Douglass had attained notable recognition when he was

only twenty-four, is shown by the following excerpt from *The Emancipator*, July 20, 1833:

> Robert Douglass, Jr.
>
> This gentleman is a very respectable colored gentleman, in Philadelphia, and has for several years carried on the business of sign and ornamental painting. His establishment is located at the corner of Arch and Front streets. Few persons, if any, have made greater proficiency in this line than he has done for the time he has been engaged in the business. . . . He has lately turned his attention to portrait painting in addition to his other employment. In this too he has been eminently successful. We have seen several of his paintings that would scarcely suffer in comparison with those of many who are considered among the finest artists of our country. . . .[3]

High praise indeed! But its very frankness and an impression of restraint lend it value. More important, it is supported by other testimony. It is interesting, too, in disclosing that Douglass started his career like many white artists of his day—as a sign painter.

Another reference tells us something of his ability as a portrait painter and mentions that he had been a disciple of Thomas Sully, an excellent portrait painter of Philadelphia.[4] Sully, apparently was impressed enough to give Douglass "the highest commendations" in letters of introduction to friends in Europe.

Later, in 1833, Douglass made a lithographed likeness of William Lloyd Garrison, the Abolitionist. Prints were placed on sale in New York City and Philadelphia for 50 cents each. Douglass also announced that he had other portraits of distinguished philanthropists, and that these works had been praised by their friends as "striking likenesses." None of these much publicized portraits has been recovered.

About this time Douglass was becoming active in civic affairs, particularly in literary organizations, one of which he helped to organize. Later he served as a delegate to Abolitionist con-

ventions and as a convention officer. This activity was interrupted by a number of trips abroad, first, it appears, to the West Indies, and later to England and France.

Several letters referring to Douglass indicate that he intended to visit Haiti in 1837. One writer says he went there at the invitation of the President of the Republic, Fabre Geffrard, whose portrait he made.[5] This is not implausible, for the same writer reveals that Geffrard "had done all in his power to assist the men of the black race in the United States who, on account of color prejudice, were exposed to cruel humiliations," and that "he sent an agent to New York intrusted with the mission to induce them to emigrate to Haiti. . . ."

Proof of Douglass' visit to Haiti is found in two letters dated respectively January 1, 1838, and May 9, 1838, and addressed from Port-au-Prince. These letters were published in an anti-slavery newspaper, *The Colored American*. One, addressed to the artist's father, contains a vivid description of typical features of Haitian agriculture of the time and of the mountain scenery of the island. The other, which is in fact a report of the official celebration of Haitian independence on January 1, 1838, describes the elaborate martial character of that celebration with such verve and color of language as to indicate that Douglass may well have been a good colorist, although we have no painting of his.

In the letter to his father, Douglass reveals the friendship that had developed between him and the venerable Secretary-General of the Republic, Balthazar Inginac. After describing a journey by horseback to the latter's coffee plantation, Douglass tells of an attempt made by a native to assassinate Inginac on the occasion of the *fête d'agriculture*, May 2, 1838.

Douglass is silent as to his reasons for being in Haiti, nor does he mention any paintings he may have been engaged to make while there.

Another letter published in the *National Anti-Slavery Stand-*

*ard,* later copied in full in *The North Star,* indicates that Douglass made a second trip to the West Indies in 1848. The letter appears in the appendix to this book. It concerns Douglass' artistic projects in the West Indies, and he informs "Friend Gay," presumably a Pennsylvanian, that he had been commissioned to draw several Jamaica missionary stations. In reprinting this letter, Frederick Douglass, editor and publisher of *The North Star,* made the following comment on it:

### Letter from Robert Douglass.

> Our friends in Eastern Pennsylvania will be glad to see the letter from Mr. Douglass, late of Philadelphia. It will interest our readers to know that Robert Douglass is an artist of skill and promise, who, in this country, was unable to gain a livelihood by his profession, though he added to it that of a Daguerreotypist; and has therefore emigrated to a country where he hopes the colors he uses, and the way he uses them, will be the test of his merit, rather than that upon his own body, which he neither put on nor can rub off.

In letters between the artist's sister and a New England Abolitionist Quaker, there is a reiteration of the fact that racial prejudice drove Douglass to seek more congenial environment abroad. In 1839, provided with Sully's letters of recommendation, Douglass intended to go to England for further study, but his application for a passport was rejected on the ground that "the people of color were not citizens and therefore had no right to passports to foreign countries."[6] This experience somewhat undermines the claim that Douglass was accepted as a student in the Pennsylvania Academy of Fine Arts. It seems plausible that Sarah Lewis, speaking before the Third Anti-Slavery Convention of American Women, was alluding to Douglass, though not mentioning him, when she cryptically remarked that "the young artist found a friend in one of the members of this convention; under her patronage he pursued his profession until he had realized a sufficient sum to carry him to a distant land. . . ."

His determination to study in Europe had been formed, she implied, after a violent experience in racial discrimination when he tried to visit an Academy exhibition. The courtesy shown a contemporary Puerto Rican was denied a native Philadelphian because of his color.

Neither of these rebuffs, however, deterred Douglass from studying abroad. An advertising card in the *Pennsylvania Freeman* adequately confirms his success:

Robert Douglass, Jr.

Portrait & Miniature painter. No. 54 Arch St. R. D. Jr. has studied drawing in the British Museum & at Saville House, Leicester Square and painting in the National Gallery in London. Marking on linen, silk, etc. by S.M.D. [Sarah M. Douglass] Specimens may be seen in the gallery.

The Central Sign Painting Est. also in the same Bldg. at short notice—signs of every description may be obtained. Pictorial, Lettered, Plain, Gilt & Fancy. Also Banners, Transparencies, Masonic Emblems, etc.

R. D. Jr. having acquired the above-mentioned arts by great labor & expense & having had to struggle against peculiar difficulties, flatters himself that a liberal public will not refuse him encouragement.[7]

To this sketchy outline of the artist's career there is one more citation proving his claim to recognition as a painter of banners on linen, silk, and other material. It comes from *The Elevator*, an extremely rare anti-slavery periodical, and is a detailed description of a banner presented to Unity Lodge, Philadelphia, the Grand United Order of Odd Fellows, in the First Presbyterian Church, June 5, 1845:

The banner is rich and beautifully painted on white satin by the celebrated artist, Mr. Robert Douglass, Jr., of this city, and reflects much credit upon him as an artist. The design is exceedingly beautiful; on the right is a group of four, representing a widow and orphans, or love and charity —the two strongest features of the institution; on the left

there is a well-drawn figure representing an Odd Fellow in full regalia, holding out the hand of friendship and charity; in the background the ark of safety is represented, and at top of the staff is a well-carved golden eagle bearing a splendid wreath of artificial flowers.

Robert Douglass, Jr., died October 26, 1887. Unfortunately the disposition of his possessions has never been learned. Apart from a few vague recollections given the writer by two persons who knew Douglass, there is nothing definite from which to reconstruct his art. His claims as an artist, meanwhile, must remain a half-veiled mystery until his work is rediscovered.

When we turn to Patrick Reason, however, we find far more primary evidence. Reason was an engraver and lithographer. His work found its way into books and magazines, and so was preserved. And as Reason, like Douglass, was closely connected with anti-slavery groups, the association of his art with anti-slavery propaganda gave it a sizable public.

The parents of Patrick Henry Reason came from Haiti and settled in New York, but it is unknown what year they arrived or whether Patrick was born in Haiti or America. His name first appears on the frontispiece of Charles C. Andrew's *History of the African Free Schools*, where his age is given as thirteen. Since this book was published in 1830, we infer that he was born in 1817, if there is no interval between the frontispiece publication and the time of the drawing, for the legend reads: "Engraved from a drawing by P. Reason, a pupil, aged thirteen years."

Further details of his life can be told briefly. Through the efforts of anti-slavery workers in New York, Reason was apprenticed as a youth to a white engraver. One biographer, David M. Stauffer, does not give the master's name, and in fact mis-states Reason's given name as "Phillip."[8] About 1835 Reason found employment as a free-lance engraver and the few specimens of

his work remaining indicate he was then well prepared to do portraits in both stipple and line technics. He obtained several important commissions and fulfilled them with charm and competence. The portraits of Granville Sharp, James Williams, and DeWitt Clinton are among his first performances as an independent draftsman and engraver.[9] About this time, too, he began his brief collaboration with Abolitionism and Garrisonian propaganda.

On July 4, 1837, Reason made an address on the "Philosophy of the Fine Arts" before the Phoenixonian Literary Society, in New York City. The speech was reported in the *Colored American* as ably written, well delivered and indicative of talent and research. Two months later he joined a group to honor Dr. James McCune Smith, Negro physician, who was returning from an important educational mission in Europe.

Reason's own card in the *Colored American* in April, 1838, announced himself as a "portrait and landscape Engraver, Draughtsman and lithographer." His address then was 148 Church Street, New York City.

An autobiographical novel of 1838 by James Williams, a slave, carried a frontispiece proof of Reason's power as a portrait engraver. The engraving was made after a drawing of Williams by a white artist, but we can give credit only to Reason for the qualities preserved in the reproduction. It is an interesting likeness, fairly well drawn and indicative of a fine sense of tonal balance. As usual with Reason, the textures of flesh and clothing are very rich and his lucid structural method is revealed in the mass with fine effect. Although this is a stipple engraving, like the preceding likeness of Sharp, it is softer in handling and more dramatic in effect. It compares favorably with the stipple engravings of Pelham and Tanner.

Almost none of this first generation of free Negro artists attempted figure or group composition. Reason is one of the two or three exceptions. His first essay with the human figure prob-

ably remains to us in the famous little representation of a kneeling suppliant slave, chains hanging from the wrists. The figure was reproduced again and again in Abolitionist publications, and many prints of this stipple engraving still exist.[10] The motif was probably not original with Reason.[11] A reproduction in shaded outline of the two sides of the Jubilee medal, struck in Britain in 1834 to commemorate the emancipation of the slaves in the British West Indies, is found in Samuel May's *Liberty Catalogue of Anti-Slavery Literature*, published in 1839. One side of this medal shows a kneeling slave, his wrists in chains, his arms extended in supplication. The subject is in profile, as in the Reason engraving, and is against a simple horizontal ground or platform. Under the image reads the phrase: "A voice from Great Britain to America, 1834." Above the image, clockwise, are the words: "Am I not a man and a brother?" This wording also was used by Reason on some engravings of the same subject, and when he introduced the interesting variation of a suppliant female slave, the words "Am I not a woman and a sister?" appear as superscription.

Reason's public activities continued for several years after 1840. It is possible that around 1850 he taught drawing and painting in one of the New York City public schools. Those subjects were in the curriculum of Public School No. 1, as is shown in a report of the American and Foreign Anti-Slavery Society—an organization with which Reason was actively connected. The last contemporary reference to him is by James McCune Smith in the introduction to the *Memorial Discourses . . .* of Henry Highland Garnet. This credits Reason with having engraved the copper nameplate of the coffin of Daniel Webster.*

---

* For further evidence of Reason's skill with figure groupings and figure drawing, consult the frontispiece to *The Liberty Bell* for 1839, the copperplate engraving of the Certificate of Membership of the Masonic Fraternity, and the sheaf of engravings preserved in the Prints Division of the New York Public Library.

Reason was truly an "archaic" American artist, a bit dislocated in time, but generally naïve, simple, and delightfully prone to wander from rigid technic. One of his unsigned lithographs shows the head out of proportion to the length of the body and breadth of the shoulders, but well constructed nevertheless. And this portrait of Henry Bibb is also marked by that intensity of expression which characterizes a Reason face. The coat and hands, set bluntly, even crampedly, are not accurately rendered, but still carry conviction of form. The extraordinary spirituality of the face would be almost painful if it were not so sincerely and faithfully depicted. Such work deserves consideration since its every aspect comports so completely with the type and pattern of provincial American portraiture and portrait engraving.

Reason's importance as an early artist enlarges when we recall that he was an active anti-slavery worker who came in contact with some of America's greatest champions of freedom. Like Trumbull and Gilbert Stuart he preserves, without guile, the features of such men as Benjamin Tappan, DeWitt Clinton, and James Williams. In this respect his portraiture is on the level of that of Neagle, Rembrandt Peale, Hoffy, and John Paradise who did not hesitate to make dignified and truthful portraits of prominent Negro clergymen of Philadelphia and elsewhere. The weaknesses of Reason's productions may be ascribed to the lack of a strong, realistic culture and to the technical simplicity of his engraver's equipment.

By the end of the first quarter of the Nineteenth Century itinerant painters, landscape draftsmen, and other pictorial craftsmen had increased considerably because of the growing demand for reproductions of historical pictures and for accurate views of American towns and harbors.[12] While the coach and sign painters of this era do not diminish noticeably, they tend to become submerged in the rising commercial activity. Itinerant artists such as John Wesley Jarvis still found their painting tours profitable, but

others were identifying themselves with particular cities. Rembrandt Peale had harbored for years a desire to introduce a system of drawing in the Philadelphia schools, and he finally did so in 1840.[13]

Nearly all the serious artists of the period realized that popularity and security were to be attained through affiliation with some organization. Indeed, the need for such agencies had been felt since the beginning of the century, for an appreciative, dependable patronage was not available for the American artist until much later. To this fact we have the testimony of Mrs. Anthony Trollope whose famous journal of the American scene of 1838 is so often cited with regard to the culture of that epoch. She says in one of her most caustic remarks:

> The Medici of the Republic must exert themselves a little more before these can become even respectable. . . . I should hardly be believed were I to relate the instances which fell in my way of the utter ignorance respecting pictures to be found among persons of the first standing in society. . . .[14]

The Negro artists of the times were victims of such conditions. As craftsmen they were excluded from the drawing academies, artists' associations, and mechanics' institutes. Information and instruction did reach them, however, either through their own efforts or the assistance of interested and unprejudiced white friends. In Philadelphia there were entire families of Negro craftsmen. From these emerged two or three painters. Probably the dynastic character of their art was a measure of protection for Negro business, for the benefit of which they took all the necessary steps, even publishing their own trade directory.[15] David Bustill Bowser, previously mentioned as cousin and pupil of Robert Douglass, Jr., belonged to one of these enterprising Negro families.

Little is known of the early life of Bowser. He was born January 16, 1820, and given the name of his father, who had lived for some time in Philadelphia. His grandfather had been a baker

for the Continental Army and later had become one of the first Negro school teachers in Pennsylvania. By an early marriage Bowser had children, some of whom are still living. During his life he made and sold numerous portraits, many of them of eminent persons of his day. His earliest sustained occupation, however, was as a painter of emblems and banners for firemen's companies and fraternal organizations of Philadelphia. One of his children possesses an interesting insignia which he designed for the "Old Hose House" in South Philadelphia.

Bowser was the perfect example of the amateur painter. His technic was labored, and it varied but little with change of subject. His portraits and landscapes were not painted as a source of livelihood but from a compelling desire to record graphically his own ideas and impressions. Hence he is strictly an "occasional" painter. In his practical interests he resembled his cousin Douglass, though probably he was not as active a daguerreotypist and sign painter. His apparatus for making daguerreotypes is still in the possession of a member of his family.

A comment in the *New York Herald* for April 16, 1852, throws light on Bowser's art:

> There is now open in Philadelphia [April, 1852] an exhibition of colored mechanics on the plan of the Franklin Institute, and for the first effort it exceeds the most sanguine expectations of all. On visiting the place I was surprised to see the beautiful specimens of work exhibited there, which would be of credit to any mechanic.* The portrait painting of Vidal of your city, and Wilson of this, are very creditable. The marine paintings of Bowser are excellent. Dutere, an undertaker, has some fine work in his line. Dr. Rock has some of the most splendid specimens of artificial teeth that we have ever beheld, and his recommendation as to character

* The American middle-class point of view at this time was to regard painting as a "manual art." Since the writer of this article made no distinction, we may assume that he was not better informed.

and science we have never seen equalled. There is an inven-
tion by Roberts for replacing cars on the track when thrown
off which is quite ingenious. There are many creditable things
such as sofas, spring bedsteads, fancy tables, bonnets, embroid-
ery, stoves, stereotyped plates, stone-walls, saddles, etc. For
the whole, we think the exhibition reflects credit on the
colored people.

While this appraisal of the work of Bowser and his co-exhibi-
tors is naïve, it shows that he was in the forefront of Philadelphia
Negro craftsmen of his day. Although it may not be possible to
evaluate Douglass' painting from the work of his pupil, it is pos-
sible to see—in the two or three Bowser portraits which remain—
the influence, however weakly infused, of the English tradition in
portraiture. As with Thomas Sully and Samuel Waugh, there is
the predilection for vermilion as a transitional color between the
deepest shadows of the face and the quartertones of the high-
lights. And like Sully, Bowser used large amounts of white mixed
with yellow as a color base to give greater brilliance to the flesh
tones.

Bowser left a number of portraits of Abraham Lincoln, and
some believe these are copies of an original made from life.[16] In
support of this claim relatives mention a check made out in
Lincoln's handwriting to David B. Bowser. For reasons of senti-
ment, it is stated, this check was never cashed and is reported still
in the possession of its Philadelphia owner. The fate of the
original Lincoln painting is unknown, but the Lincoln portrait
in the Home for Aged and Infirm Colored Persons in Phila-
delphia is the work of Bowser. It is impossible to say that Lincoln
sat for this portrait; its condition now is too poor to justify an
opinion. It was very thinly painted, especially the flesh tones, the
remains of which show they were merely a peach-colored film
laid over a chalky white base.

The most important remaining works of Bowser are a few

marines and landscapes and an engaging portrait of a baby. A
list of these is in the notes to this chapter.[17] Although the works
are unskillful, they have a compensating genuineness that mark
them as inspired. And here we see the first real attainment of
these early Negro artists, folk-bound as they still were. Bowser's
work, perhaps no more articulate than Reason's, is certainly more
original and is the expression of an individual culture.

Although Bowser was busily occupied from 1850 to 1865, his
output was rather slight. And while most of his work remains
unknown, yet he is sufficiently important for inclusion among
the provincial American artists. Bowser died June 30, 1900.

Other Philadelphia Negro artists were William H. Dorsey,
John P. Burr, and J. G. Chaplin, all of whom matured about the
same time as Douglass and Bowser. Burr is mentioned as a por-
trait painter, but none of his portraits has been found. Dorsey was
the dilettante son of a well-to-do Philadelphia caterer. He had
the advantage of European travel and he made a small collection
of paintings by both Negro and white artists. Occasionally he
executed a watercolor, a medium in which he revealed expert
skill. And it is to Dorsey's interest that we owe the preservation
of a few tiny paintings by Chaplin. Chaplin was trained in
Düsseldorf, Germany;[18] was fond of Shakespearean character
portrayals, and painted a number of imaginary subjects that
betray the source of their inspiration. He was also the painter
of a now deteriorated portrait of President Fabre Geffrard of
Haiti, a work made after a daguerreotype.

II

Now we consider a few representatives of the second and
third generations of Nineteenth Century Negro artists. While
they were generally contemporary with those already considered,
their work is a development of later years. They escaped the

stolid American provincialism and rose above the prosaic con-
ception of their vocation as mere craftsmen. They began their
careers in a time of national and social change, and of course no
artist of the era could completely overcome his Colonial heritage
without European contact. In Europe art was more generously
fostered by state and personal patron, and in some countries the
artist enjoyed high prestige. For these reasons many now famous
white American artists chose expatriation. And several mid-
century Negro artists, too, went abroad, not all to forego their
American patrimony, but some merely for wider and more liberal
association.

Not until after the Civil War did the Anti-Slavery Society
relax its effort to nurture Negro talent. Then the Society's cause
was taken over by new groups which sought to justify the
freedom that had been bestowed on the Negro. The Freedmen's
Aid Society, founded after the war, was one of these patron
groups of culture among the liberated Negroes.

Robert S. Duncanson was one of the youthful artists who, prior
to the Civil War, received help from the Anti-Slavery League.
An article in the *New York Age* for March 17, 1928, recounts
that he was sent abroad by that organization for study. As his
early years in Cincinnati were marked by struggle and disappoint-
ment, it is likely that such conditions led him to seek permanent
residence in Europe.

Duncanson was born in 1821 and was at least twenty-six years
old before he had the opportunity to study abroad. His work was
first noted in Cincinnati, however, about 1843, the year in
which he is believed to have painted "The Trial of Shakespeare,"
a canvas still in Cincinnati. The city then was prosperous and
culturally efflorescent; its leaders sympathized with the needs and
rights of the masses, including opportunity in the fine arts, while
its industrial life was enhanced by the Mechanics' Institute.[19]
Artists were respected if not heavily commissioned, and the
bustling frontier environment of Ohio engendered the spiritual

fraternity that opened the society of a group of white artists to Duncanson.*

Two interesting references to Duncanson contain the most detailed descriptions we have of his painting "The Lotos-Eaters." The first is a letter in the *Cincinnati Gazette* of about 1865. It was written by the famous Moncure D. Conway, a militant Presbyterian minister and one of the enlightened Americans of his day. The letter was sent to the *Gazette* from London:

> *A Cincinnati Colored Artist in England*
>
> In walking through the gallery of miniatures at the South Kensington Museum the other day, I met Mr. Duncanson, whom some of your readers will remember as one who, a few years ago, was trying to make himself an artist in Cincinnati, and who had already produced a worthy piece of imaginative art in a picture of Tennyson's *Lotos Eaters*. Duncanson subsequently left Ohio and repaired to Canada, where his color did not prevent his association with other artists and his entrance into good society. He gained much of culture and encouragement in Canada, retouched his *Lotos Eaters*, produced one or two still better paintings, and set out for England. In Glasgow and other Scotch cities he exhibited these paintings with success. He has also received a letter from the poet laureate, Tennyson, inviting him to visit at his home in the Isle of Wight, where he will go and take with him the *Lotos Eaters*.

As attempts to locate this painting have failed, a more lengthy description of it is warranted. The following excerpt exemplifies British journalistic art criticism of the time as well as English reaction to the first school of American landscape painting:

> America has long maintained supremacy in landscape art; perhaps, indeed, its landscape artists surpass those of England;

* Whether or not the artist was the subject of the letter in *The Liberator* for Aug. 21, 1846, it is impossible to say. The proud spirit of the man and his liking for a free, adventurous life do not allow us to accept readily that bedraggling description of Duncanson and his habits of living.[20]

certainly we have nó painter who can equal the works of Church; and we are not exaggerating if we affirm that the production under notice may compete with any of the modern British School. Mr. Duncanson has established high fame in the United States, and received his art education there; but it has been "finished" by a course of study in Italy, by earnest thought at the feet of the masters, and by a continual contemplation of nature under southern skies.

The picture to which we more immediately refer (although hereafter we may describe such as make us familiar with Canadian scenery) is a "composition," but one in which the natural beauties of Greece are brought together with consummate skill. A bit may have been taken here and a bit there; yet there is perfect harmony in the whole; insomuch that the same scene may have been presented in its entirety, for we need the statement of the artist that it is not altogether the truth.

The "Painted Poem," continues the writer, has been suggested by Tennyson's *The Lotos-Eaters*:

> Here are cool mosses deep,
> And through the moss the ivies creep,
> And in the stream the long-leaved flowers weep,
> And from the craggy ledge the poppy hangs in sleep.[21]

This shows a feeling of sincerity and faith in the work of the artist, even though not the highest appreciation of art.

From extant landscapes by Duncanson we have a more accurate idea of the nature of his painting. There is the small work "Evening" wherein the artist suggests the melancholy effect of early twilight, observed especially in northern atmospheres, veiling a wooded scene through which the perspective of a wide stream is drawn. The reproduction recalls certain panoramic effects of the Hudson River School, but is a more integrated composition and more poetic than the average product of that school.

Is this work an exception to the general rule of Duncanson's productions? Not so far as his landscapes are concerned, for it bears the impress of that strongly classic bias which dominated

Duncanson's landscapes before his expatriation, though in this respect it is not quite so well developed as that series of mural landscapes which he was commissioned to paint for Nicholas Longworth of Cincinnati. The same caressing warmth of tone and voluminously decorative masses of trees are found in another landscape first reported by the present writer in 1936. This, "The Pass of Leny," is a still more effective example of Duncanson's landscape painting, though somewhat hallmarked by its dependence on the topical and decorative landscape first clearly formulated by Poussin.

Duncanson's "Trial of Shakespeare" and "Indians Buffalo Hunting" are also interesting though less finished works. He did not draw figures well, and in this respect the student often regards his compositions as amateurish. The color scheme of these two paintings is matter-of-fact, so much so as to suggest those mid-century chromo-lithographs of the same subject. This deficiency is explained by the fact that these two canvases belong to the artist's earliest period. The mural landscapes painted for the Longworth Mansion (now the Charles P. Taft Museum), dated between 1843 and 1851, are vastly superior to the buffalo hunt, and are among the finest paintings of their kind in America.

Duncanson did not remain expatriated long. He returned to this country possibly late in the '60s, but was not in good health and is believed to have died in 1871 while a patient in a Detroit hospital for the insane.

The men to whom Rodolph Desdunes refers in his *Nos Hommes et Notre Histoire* were artists bred in a quite different environment. They too, like the Negro artists of the North, were victims of prejudice. Desdunes, an obscure creole teacher and writer of New Orleans, mentions three or four of his Negro contemporaries who were passionately devoted to art. He includes Eugene Warbourg and his brother, Daniel, and the painter Alexander Pickhil, all three natives of New Orleans. Their lives

and work are little known. As Desdunes is our sole source of information, his claims for their creative powers are unsupported. Yet we should expect some Negro talent in New Orleans after 1820 when the social life there favored artistic expression.

Eugene, according to Desdunes, was born in New Orleans about 1825 and died in Rome in 1861. He is credited with a "natural penchant" for sculpture, which received its first formal development under a French artist, Gabriel. Eugene made rapid progress with his master and his productions soon attracted attention. When he began work on his own account, he had no difficulty in obtaining patrons, and many prominent personages of the day—magistrates, generals, and other notables—are reported to have sat for him. In addition, he is said to have done monuments for cemetery tombs and to have created other statuary for the town's clergy. These commissions aroused the jealousy of other local artists, and Eugene decided to give up the studio that he occupied with Daniel, an engraver and stone mason, on St. Pierre Street between Bourbon and Royale.[22] Eugene went abroad, visiting France, Belgium, England, and Italy. In England he obtained the patronage of the Duchess of Sutherland who commissioned him to make some bas-reliefs illustrating episodes from *Uncle Tom's Cabin*. Desdunes does not report what works Eugene created while living in Rome, his adopted city. The two "masterpieces" to which Desdunes refers, "Le Premier Baiser," and "Le Pêcheur," were done before Warbourg left America. We are told that he represented Louisiana at the Paris Exposition of 1867.

The only painter mentioned by Desdunes is Pickhil, who is said to have destroyed nearly all his work in disgust over adverse criticism. Desdunes reports that Pickhil preferred to die unremembered rather than to prostitute his art. Even his portraits of high clergymen were destroyed in anger against his unjust critics. Pickhil died in New Orleans between 1840 and 1850.

A remarkable painter of New Orleans, Julien Hudson, not

mentioned by Desdunes, recently has been identified as the creator of a portrait of Michel Jean Fortier, Jr., who commanded a corps of free Negroes at the Battle of New Orleans in 1815. This unusual painting hangs in the Louisiana State Museum near an interesting self-portrait by the artist. Hudson, who flourished in the 1830s, was a skillful portrayer of faces, though a certain rigid conventionality clings to his treatment of the clothed bust, as both the "Fortier, Jr." and his self-portrait reveal. The self-portrait supports the tradition that Hudson was an octoroon.

Toward the middle of the Nineteenth Century there were scattered efforts to impart art instruction to Negroes. Our scant information is still sufficient to indicate that two or three colored persons saw the need to include art among the educational opportunities for the free Negro at this time. A realistic attitude was developing, too, among the new Negro masses confronted with the staggering problems of education, self-help, and social adjustment. As literacy spread, there followed increased strivings and successes in the field of art.

By 1840 a man of great social vision was coming into prominence in the service of the young African Methodist Episcopal Church. He was Daniel A. Payne, later Bishop Payne, who initiated the program for a literate clergy. His efforts in this cause were practical and far-reaching and transcended the narrow bounds of creed.[23]

In his *History of the African Methodist Episcopal Church* Payne recounts the first efforts in Baltimore in 1849 to cultivate aesthetic talents in the church. They began with a "literary and artistic demonstration for the encouragement of literature and the fine arts among the colored population." Prizes were awarded; and "for the best piece of oil painting on any historical subject taken from the scripture and painted on canvas, not less than two feet by three, the figure or figures to be painted in full length, a silver medal, with not less than twenty-five dollars was offered."

Other classes were set up in this competition and work was offered in all of them except that of oil painting. Later, in Philadelphia, a similar effort in behalf of art was made, and while much talent in drawing was discovered, again no one offered oil paintings.

Throughout his career as a church leader, and especially after taking the presidency of Wilberforce University, Bishop Payne encouraged young Negro artists. There still hangs at Wilberforce a group portrait probably by A. B. Wilson of Bishop Payne's family. It was through Payne's efforts that the work of the young artist, A. B. Wilson, was brought to light. An excerpt from the history of Payne contains all that we know of Wilson:

> There was about this time, a youth by the name of Wilson, son of a member of Bethel [A.M.E. Church] in Philadelphia who had a gift in this direction, but it was uncultivated. He was tolerable good in proportion but defective in coloring and grouping. To young Wilson the same patron and encourager of the fine arts gave the commission for the oil painting to represent the parents of his first wife, Julia, and two sisters, Caroline and Sarah Becraft; also two relatives, a lad of nineteen and a girl of fourteen. In this painting to which was added a portrait of an infant daughter, the figures were seen grouped in a garden attached to the old homestead—the old home of William Becraft, the natural son of Charles Carroll of Carrollton. It is still in existence and is certainly the work of a genius. No one can tell to what eminence he might have attained had he been trained in some school of design and lived long enough to have had his talents fully developed.

This implies that Wilson died early before his powers had matured. Only one of his works has been traced, a portrait of the Rev. John Cornish, pastor of the Bethel A.M.E. Church of Philadelphia, of which Wilson and his family were members. This portrait is a lithograph by M. A. Traubel made after a painting by Wilson. The pose of the minister is unusual for at that time portraits seldom showed the clergy in the act of preach-

ing. This picture is not flattering; indeed, the oversized head and sketchy pulpit with large bible bespeak provincial amateurishness. But the work is sincere and even its immobility has an eloquence. Beneath the portrait is the line: "But as for Pharaoh and his host he overthrew them."

Edward M. Thomas of Washington, D. C., was another Negro leader of keen intellect and executive ability who was attempting at this time to arouse interest in Negro talent. Publishing frequent articles and editorials in Negro and white periodicals, he exhibits an astounding familiarity with the history of Western art and with the economic struggles of contemporary artists. A quotation from one of his essays shows his conception of the duty of society to recognize and support the artist:

> I propose in this article to touch upon the various points, and give expression to the various reflections and motives that should induce us, as a race, to attend to proper cultivation of the Fine Arts in all their different departments. In starting out, it would be well to notice that Art has been invariably connected with civilization, and that where civilization only partly existed, Art existed but in a crude state; that where civilization attained perfection, Art flourished in all its splendor, and that where nations are plunged in the chaos of barbarism, ignorant of those great principles of law and justice that cement a nation with their benign influence, Art is totally unknown; and so it plainly appears that the Fine Arts follow in the footsteps of civilization and enlightenment; and are not only companions of it but the crown that exercises it.

> Hence it appears that where the Fine Arts are not reflected, there exists some great fault in the construction of a nation, and the same reasoning is applicable to the individual, for those who make man's varied disposition their study, or who are in any manner observant of the workings of the mind, must necessarily notice that the man who cares little for Art and its inducements, is insensible to those higher thoughts

and noble-minded ideas that should pervade the human breast. . . .[24]

Thomas through his writings and solicitation among friends and organizations brought about the first considerable exhibition of Negro fine and industrial arts in this country. The showing was made in New York in October, 1862, a pioneer date in the cultural history of the American Negro.

Two portraits by William Simpson, first reproduced by the present writer, give hope for further discovery of the work of this unusually talented artist. As to Simpson's merits as a painter, we have only the enthusiastic testimony of William Wells Brown, an early Negro writer and Simpson's contemporary. Our only other information is the listing of Simpson's name in the Boston directories for 1860 and 1866.[25] Brown does not record the date of Simpson's birth, but says that the artist died in 1872.

Simpson produced many portraits, according to Brown, and the statement that "his patrons came from several of the Northern states and Canada," is a tribute to his industry and ability.

His extant portraits are the work of a man of strong artistic powers.[26] Though they are now faded, it is possible to see that they once shone with unusual richness of color. The colors in the face of Jermain Loguen, the male subject of the portraits, have softened and deepened into a rich golden tonality. And we can trace the hand of a skilled and imaginative draftsman in this transformation of optical values into the subtle tints of an ideally molded face. A comparison of a photograph of Loguen with the painting reveals the artist's intelligent handling of facial expression. The shrewdness, vast self-confidence, and resilient force of the subject are admirably and discerningly suggested by Simpson.

The classical drawing of the head of Caroline Loguen will catch the appreciative eye. Here the painter has achieved a warm transference of his sensitiveness to the force of his subject's personality. The work recalls some of the heads of women drawn

by the great romanticist painter, Théodore Chassériau, who was himself of Negro extraction. In fact, Simpson may have known the works of Chassériau, so similar are his use of oval forms and his lush color.

Another noteworthy quality of these portraits is the quiet reserve pervading them and expressed in the self-contained poses and the reticent handling of tonal values. The transition from the tone of the neck of the female subject to her lace collar and thence to the deep black of her dress is superbly rendered.

Brown suggests that Simpson painted only portraits. The one known exception is a "sketch that hung in his studio, an allegory of summer, which exhibited marked ability." Brown also tells us how Simpson's career developed from his youth, when he was punished in school for indulging his gift for drawing instead of following the class work. We suppose he completed grammar school and then became the apprentice of "Mathew Wilson, Esq., the distinguished artist" in 1854. He moved with his master to Boston, where he labored for a thorough knowledge of his profession. About three years later he painted the two portraits described in this book. His powers are suggested by his feat of portraying whole families on one canvas, grouping the figures in natural conversational poses.

According to Brown, an unlocated portrait of John Hilton, a well-known Negro of his day, was painted by Simpson for the Masonic Lodge of Boston.

A few other Negroes were establishing themselves as artists about the middle of the Nineteenth Century. Their works are lost, hence their merits must remain unknown. One of the less obscure was Nelson Primus, born in Hartford in 1843. About 1858, after a few years of experience as a carriage painter, he resolved to become an artist. H. W. French in his *Art and Artists in Connecticut* relates that Primus, with the help of one Mr. Francis, overcame the handicaps of birth and color and so

rapidly developed his talent for drawing that in 1859 he won a medal for drawing at the State Agricultural Society Fair.[27] After this, Primus moved to Boston, in 1864, to test himself as a portrait painter, but there met with only partial success. G. F. Richings in his *Evidences of Progress among Colored People* says he met Primus in Boston in 1895, and speaks of Primus having painted a "wonderful picture . . . 'Christ Before Pilate'," and reports that the artist's portraits were received in Boston with high praise.

Gerritt Loguen, one of the three children of Jermain Loguen (subject of the Simpson portrait) was an artist. A long list of his drawings and paintings appears in a catalog of the Industrial Exposition of the Negro in Washington, D. C., in 1897. However, only two known pieces of his work have been found; the first is a crayon-drawing bust portrait of Frederick Douglass in fur cap and overcoat, the second is a lithographed drawing of John Brown of Harpers Ferry fame. The latter obviously is a free copy from a daguerreotype and represents Brown's features with some distortion but still with some strength of design and beauty of tone. Both these works are in Washington.

# CHAPTER III

---

# Transition to Freedom

OF THE EARLY NEGRO ARTISTS the work of Edward M. Bannister is the most objective and free from racial influence. In a biographical sketch of Bannister in William J. Simmons' *Men of Mark*, it is recounted that he began his studies with the determination to disprove a statement in the *New York Herald* in 1867 that while the Negro may harbor an appreciation of art, he is unable to produce it. And it is probable that Bannister regarded such criticism of Negro art as a challenge to his own best efforts.

Bannister was born in Nova Scotia in 1828. As a young man he went to Boston and there attracted patrons by his painting. Later he married and moved to Providence, R. I.

Bannister's first occupation in Boston was the making of solar prints. These sold well at moderate prices and soon he was afforded the leisure to sketch and paint scenes around the city. In a short time he took a studio and installed himself as a professional artist. By 1854 he was meeting with success and already

had produced "The Ship Outward Bound," his first commissioned work.[1] It would seem that Simmons' date for the beginning of Bannister's career is corrected by this fact.

John Nelson Arnold, a fellow-artist and personal friend, says that in 1885 Bannister was attending an evening drawing class at the Lowell Institute in Boston. Here a dozen or so artists drew from the living model. In that group also were Martin Filmore, a sculptor; William I. Norton, a marine painter; and Edwin Lord Weeks, a painter of East Indian figure subjects, and Bannister's studio companion. Arnold says of Bannister that "from the first he followed no master nor any school, nothing but his own instincts."[2] Such praise is contradictory to Arnold's own testimony elsewhere that Bannister studied with Dr. William Rimmer, the anatomist and sculptor, and enjoyed friendly and helpful association with other artists. But Bannister derived much simply from the observation of nature, as his preponderant interest in landscape painting proves. He rejected opportunities offered him for study abroad.

Bannister was a regular participant in the exhibitions of the Boston Art Club and also was a leader of a group that became the nucleus of the Rhode Island School of Design—the Providence Art Club.[3] This organization was virtually founded in his studio in 1873. It is impossible to estimate which played the more important rôle in the development of his art, the Boston Art Club or the Providence group; but in the Providence of the 1870s and 1880s there would be little reason for a Negro artist to concentrate on racial subjects; the art climate was rather academic and there was no emphasis on racial differences.

Bannister's most noted painting, "Under the Oaks," was exhibited in the group representing the Massachusetts artists at the Centennial Exhibition of 1876, in Philadelphia. Proof of its appearance among the items sent from Massachusetts is afforded in the following contemporary notice:

> E. M. Bannister of this city whose picture "Under the Oaks" was spoken of in these columns some weeks ago has had an offer for it by a Boston party with the understanding that it is to go to the Centennial Art Gallery.[4]

The painting drew a medal of the first class and was bought for $1,500. When the artist presented himself for the award he was insulted by the gallery guards who did not know that a Negro was a guest of the exposition.

Still we cannot bestow unreserved praise on Bannister's art. While his paintings are interesting specimens of their kind, they do not reveal a more than average talent. The one we reproduce here is characterized by a certain tender, bucolic poetry, reminiscent of some paintings of the Seventeenth Century Dutch landscape school, but it fails to stir in us that response to the forms of nature as do a number of examples of the Dutch school. Yet it is obvious that the painter had no stilted appreciation of nature. In fact, this work justifies Arnold's statement of Bannister's powers as an interpreter of natural beauty:

> He looked at nature with a poet's feeling. Skies, rocks, fields were all absorbed and distilled through his soul and projected upon the canvas with a virile force and a poetic beauty. . . .

His technic though original was never inadequate to the feeling of the artist except, perhaps, in his old age, when his infirmities made his work increasingly fumbling in character and hurried in effect.

Among the sixteen paintings by Bannister in the Museum of the Rhode Island School of Design there are a number of very fine landscapes, and several show such a genuine flair for landscape painting that they invite study by students of this genre. In two paintings, "After the Storm," and a large landscape that may well be entitled "Dusk," the originality of the artist is not salient, but is well balanced by his clear perception of the normal structure of natural objects perspectively regarded. One feels,

too, that in each case he has sympathetically and honestly caught a mood of nature. His transcription of the scenes is eloquent and honest, although some persons purport to see an obeisance to the Barbizon *Intimistes*. Comparison with the work of Alexander Wyant of the Hudson River school would be more apt, for Bannister's paintings recall the frank, meticulous work of that artist.[5]

Edmonia Lewis, sculptor and picturesque character, was a contemporary of Bannister and a co-exhibitor at the Centennial. Her dialect, untouched by formal schooling, her direct and naïve manner, and the masculine touch to her attire which sometimes "departed radically from the conventional" all suggest an unusual if not an especially gifted woman. She was of mixed Indian and Negro parentage, as the chroniclers are careful to mention.

Before embarking on her career as a sculptor, Edmonia did have some training at Oberlin College, ending about 1860, at which time she went to Boston.[6] This fact is attested by records not hitherto consulted by those who have written about her. The confused report of how she obtained her first opportunity to model blur the otherwise clear outlines of her early life. These accounts repeat the well-authenticated facts of her birth, July 14, 1845, near Albany, N. Y., of a Negro father and Indian mother, her early orphaning, and her first experiences as a Boston art student. The same sources that overlook her study at Oberlin make much of the legend that she was so illiterate as not to know by what name to call a statue.[7]

The true story of Edmonia's introduction to clay modeling seems to have been different. Encouraged by her Boston friends to study art, she sought out the studio of Edmund Brackett, a fairly successful sculptor then living in Boston. From him she obtained clay, modeling tools, and a "baby's foot." Three weeks later she returned with a fair reproduction of the foot and received the artist's commendation. He then gave her the cast of a woman's hand, and to carry out the instructions she made herself a set of modeling tools the exact counterpart of those she had

borrowed. Having succeeded in this assignment, she received from Brackett a letter to a "lady who gave her eight dollars," and with that capital she opened a studio. Above the door she displayed the sign: "Edmonia Lewis, artist."

As her own master, Edmonia began to model creatively. Her first work, a medallion of the head of John Brown, was praised by her friends. Then she modeled from photographs a bust of the Civil War hero, Colonel Robert Gould Shaw. Both the medallion and bust were completed in 1864, and the bust was immediately purchased by the family of the deceased colonel. Subsequently it was placed on exhibition at the Boston Fair for the Soldiers' Fund. One hundred copies of it were sold and with the proceeds Edmonia set out for Europe.

In Rome she attracted the interest of Harriet Hosmer and Charlotte Cushman, both of whom became her friends. A correspondent of the London *Art Journal* sent home from Rome an interesting letter which was printed in the January, 1865, issue of the publication. The letter makes clear that immediately upon her arrival in Rome in 1865, Edmonia had begun to study and to attempt original sculpture. A bust of Dionysus Lewis of New York, a portrait commission, is also mentioned, together with some Indian groups inspired, we are told, by Longfellow's *Hiawatha*.

In 1865 "Hagar," "The Marriage of Hiawatha," "The Departure of Hiawatha and Minnehaha," the bust of Dionysus Lewis, and the emancipation group called "Forever Free" were completed—at least in clay. We know that the "Forever Free" group was done in marble the following year, as the artist appealed to American friends for funds for the project. It was completed and sent to America for exhibition in 1868. It is now in the possession of a Negro family of Boston. The composition comprises two figures, a Negro man and woman, both slaves, who are overcome with emotion on receiving the news of emancipation. The work betrays an amateurish technic, yet its very crudity imparts

a strength that saves it from the commonplace. It is a noteworthy attempt to express those poignant feelings that swept the Negro on his "morning of liberty."

Edmonia's earliest attitude toward her art and its emotional content was that of a realist. All the descriptions of her creations support this view. But despite her rugged character, her youthful interest in sculpture was marked by emotionalism. Whence did this stem? Several explanations are possible. The unusual circumstances of her birth and early life may have enriched her emotions which subsequent creative work disciplined. John Mercer Langston reports that through no responsibility of her own, two of her dearest white school companions were poisoned.[8] Edmonia promptly was accused of trying to kill them. The victims themselves did not involve Edmonia, but had she not been spirited out of town she might have been lynched. Such an experience may have left a deep impression on her. Or we might explain her emotionalism by the effect of the turbulent events of the time on her alert mind. The Abolitionist fights, the slave hunts, the Civil War, and the cruel humiliations inflicted on the Negro undoubtedly left their mark upon her.

But none of this explains her adoption of the neo-classic idiom. That can be accounted for only by her study in Rome and the influence of her associates, such as Harriet Hosmer, Hiram Powers, and others who were under the spell of Graeco-Roman art and the reputation of Canova. So agreeable did she find this interest in the neo-classic style, with its sentimental worship of a great historical art, that she soon was able to make her own crude realism conform to the discipline of that style. In time her work took on a more markedly neo-classic character. A contemporary description of "The Wooing of Hiawatha" and "The Marriage of Hiawatha," from a letter by Laura Curtis Bullard, illustrates the quality of early realism:

> Among Miss Lewis' other works are two small groups illustrating Longfellow's poems of Hiawatha: her first,

"Hiawatha's Wooing," represents Minnehaha seated making a pair of moccasins, and Hiawatha by her side with a world of love and longing in his eyes. In the marriage they stand side by side with clasped hands. In both, the Indian type of features is carefully preserved, and every detail of dress is true to nature; the sentiment is equal to the execution. They are charming bits, poetic, simple and natural. . . .[9]

A fine group, "Madonna and Child" with adoring angels at their feet, was completed in 1867. It is said that this work was purchased by the Marquis of Bute for an altar piece. Between 1869 and 1871 Edmonia executed a portrait medallion of Wendell Phillips, a memorial monument to Harriet K. Hunt, and two small groups of babies carved in poses of sleeping and waking. The Laura Bullard letter contains further information about these works:

> Miss Lewis has a fine medallion portrait of Wendell Phillips, a darling group of babies and some other minor works in her studio. She is just about finishing a commission which Harriet K. Hunt of Boston has given her, a monument for her last resting place at Mount Auburn, Massachusetts. . . . We have not seen this but we are told that it was Dr. Hunt's own design, a life-size statue of Hygeia with various bas-reliefs on the pedestal.

This letter also mentions a fine bust of Longfellow ordered from the sculptor by Harvard College.[10] It was then ready for marble.

There is some uncertainty about Edmonia's visit to this country in 1870 when she held an exhibition of her works in Farwell Hall, Chicago. But by the following year she was back in Rome.

There is a brief mention of the visit of Elisabeth Buffum Chace to Edmonia's studio in Rome about the middle of 1873. From this contact, which proved agreeable to both, came an order for a marble copy of the head of Octavius—a famous work more generally known as "The Young Augustus." Mrs. Chace purchased this piece by Edmonia, declaring that it "seemed the

. . . best reproduction of the original then offered by any artist in Rome."

About seven months later the artist was back in America, ostensibly to exhibit new sculpture from her studio. Receptions were given in her honor in Boston and Philadelphia.[11] By this time Edmonia had achieved a reputation both at home and abroad. She had obtained many commissions for sculptures and her work was known to a discerning public in three countries. She had patrons among the aristocracy of Italy and England. Some of her own countrymen also helped to advance her fame. Henry T. Tuckerman, who later wrote of her with enthusiasm, had visited her studio in Rome and in several of his published statements mentioned his hope for her continued development.[12] It was natural that at the Centennial in 1876 Edmonia as a successful sculptor found her place in the Memorial Hall of the exposition. To the Centennial she sent "The Marriage of Hiawatha," "The Old Arrow Maker and His Daughter," "The Death of Cleopatra," two small groups of babies, "Asleep" and "Awake," and some terracotta busts of Longfellow and John Brown. "The Death of Cleopatra," which earned the widest mention, will be considered later, but only through the descriptions of writers, for the work itself disappeared long ago. The statue revealed forceful qualities derived from an astute and scientifically achieved realism. By resorting to the application of anatomical knowledge, its creator had contrived to suggest the emotional struggle of the dying Egyptian queen. It was this that probably prompted Lorado Taft to term the effect of the statue "strange and repellent." In *Artists of the Nineteenth Century* Taft writes the following criticism:

> This was not a beautiful work, but it was a very original and striking one, and it deserved particular comment, as its ideals were so radically different from those adopted by Story and Gould in their statues of the Egyptian Queen. . . . The effects of death are represented with such skill as to be

absolutely repellent. Apart from all questions of taste, how-
ever, the striking qualities of the work are undeniable, and
it could only have been reproduced by a sculptor of very
genuine endowments.

May not these brief remarks be evidence of the changed out-
look of this artist—a change that came with a disciplined style
or a practical interest in form? Such emotionality and objectivity
of aim are not mutually exclusive, nor was Edmonia the first to
reconcile them. It is Donatello's very genius that the plastic intel-
ligence behind his statuary blends with a rugged and even
macabre imagination. And it is interesting, too, that a later Negro
sculptor, Meta Warrick Fuller, began her first important work
at this point which, for Edmonia Lewis, was the apex of her
art.

Photographs of three other works by Edmonia have been
obtained through the kind co-operation of Miss Edith Daley of
San Jose, Calif. These are the two charming groups in marble
representing babies asleep and awake, and the bust of Abraham
Lincoln, also in marble. All are in the Municipal Library at San
Jose, their donors unidentified. They testify to the neo-classic
influence on the sculptor, but from the photographs we judge
that they bespeak no great depth of neo-classicism. In the direc-
tion taken so undeviatingly by Canova and Thorwaldsen, even
Harriet Hosmer appears to have progressed further than did her
friend, Edmonia Lewis. The Lincoln bust lacks the breadth of
design and vital quality needed to make a good neo-classic por-
trait significant. Its lack of these qualities is especially noticeable
when compared with an earlier sculpture like "Forever Free."
The latter has a strong primitive flavor, the rude hewing of the
forms by a less skillful hand gave power and conviction to the
whole conception.

Edmonia scored a success at the Centennial. Many visitors
were amazed at her work, and the artist was showered with orders
from wealthy citizens. Tuckerman's wish was not fulfilled—that

this frail girl of mixed racial origin should "indicate to her countrymen working in the same field, a distinctive if not entirely original style in sculpture which may ultimately take high rank as the American school."[13] But for a while her efforts gained wide support and recognition. Had the circumstances of her life and talent been more fortunately balanced, she might—with her originality of approach—have led the American school of the later Nineteenth Century in the attempt to co-ordinate the disparate trends in American sculpture. Posterity often judges as much by the spirit as by the outward form. But Edmonia Lewis is forgotten. Her vogue passed during her lifetime. We do not even know the year of her death.

# The Fourth Generation: New Values

FOUR GENERATIONS were required to produce the first genius among Negro artists. But the interval prepared the way for Henry O. Tanner. His predecessors, white and black, had shown the possibilities of realistic and impressionistic landscape, of portraiture, history painting and genre, according to the fluctuating canon of taste in the Nineteenth Century. Now it was for Tanner to find an original field and explore new paths of feeling. He was well prepared for his mission and his success greatly affected other Negro artists.

Henry O. Tanner was born in Pittsburgh, Pennsylvania, June 21, 1859. Hence he was still a youth when Edmonia Lewis and Edward M. Bannister were showing their works at the Centennial Exposition. However, he had awakened to an interest in painting at the age of thirteen, as he himself reveals. One day he and his father were walking along a path in Fairmount Park, Philadelphia, not long after the family had moved to that city.

They paused to watch a painter at work on a landscape comprising a large tree and a high knoll. Suddenly the boy asked his father: "If that man wants to paint that tree, why doesn't he go closer to it?" The father replied that the painter wished merely to suggest the tree, not copy it. The next day the boy himself began to paint with great eagerness, using a house painter's brushes on the cardboard backs of an old geography book. He wanted to depict the view on which he had seen the artist at work the day before.

We are fortunate in knowing the facts of his early life, though they have received little critical attention. Many of his first paintings, though not his most interesting, were produced in this country. In these works racial, national, and local interests were subordinate. The subjects of some of his first portraitures in clay and oils were selected from both whites and black, and his treatment of these had no aesthetico-racial bias. From the beginning he was attracted by themes containing an element of abstraction, and from the outset his work was characterized by a reflective, probing personality which in maturity enabled him to impart the almost incommunicable spirit of reverence to his religious themes.

In his boyhood Tanner modeled the animals in the Philadelphia zoo. His interest in nature was aroused by the marine painter, Alexander Harrison, whose work was on exhibition in a Philadelphia gallery. Tanner resolved to try his own hand at marines and went to the oceanside near Atlantic City. During a brief stay there he composed a number of canvases for an exhibition made possible for him by a friend and admirer. For some time previous he had been a student at the Pennsylvania Academy of Fine Arts, and had already acquired an effective if laborious technic. One of these works done at the seashore, "A Windy Day on the Meadows," now hangs in the Pennsylvania Academy.

The painter's father, Bishop Benjamin Tucker Tanner, gave him all the support possible. Still the young artist was confronted with vast obstacles to his career. For a time he took a teaching

position at Clark University in Atlanta, but even there he was forced to open a studio of photography to supplement his meagre salary. During these late 1880s Tanner resumed his painting of animal pictures. These, with other previously completed works, he sold at extremely low prices, some for as little as $15.

The patronage and encouragement of friends, however, were not denied him. He developed a close friendship with his first painting instructor at the Pennsylvania Academy, Thomas Eakins, whose commendation won him other friends.* Bishop Daniel A. Payne, who had aided earlier Negro art students, was one of Tanner's first patrons. Payne appraised Tanner's gift and ventured a prediction which largely has been fulfilled: "From specimens of his paintings in my possession and from other pieces which he has produced, I think that he will go down in history as one of the most successful of American artists which the present century has brought forth."[1] Tanner made a portrait of the prelate that has been described by an early writer as a highly creditable effort. Three of the artist's oil paintings are on the walls of Wilberforce University, placed there by Bishop Payne. These works have been termed "seascapes—one, somewhat Turneresque in its dashing impressionistic style of representing a storm at sea; the other two small panels, rich in coloring . . . giving a hint of future excellence."[2]

Several works of this period possess outstanding merit and lead to the heart of Tanner's artistic problem. Among them are the portraits of his father and mother, now owned by Mrs. Sadie Alexander of Philadelphia; and a large landscape done at Atlantic City. The portraits remind one of Eakins' painting at its most humanly penetrating and richly psychological moments. Not the "pale" but the warm cast of thought hangs over them. The pigments have darkened noticeably but the strength of the

* A portrait of Tanner by Thomas Eakins, presented with other works by the "American Master" to the Pennsylvania Museum of Art, has been left out of the permanent installation of the collections since it is privately owned.

artist's impression remains. In them we see the evidence of deep humanity and spiritual sensitivity. In each case the image is brought out in sturdy relief against a rich lake-saturated background, the surface reduced to a schematized simplicity analogous to a small Cranach or Clouet portrait.

Another churchman who aided Tanner in his early days of need was Bishop Joseph Crane Hartzell of the Methodist Episcopal Church. The prelate and his wife supplied the funds that afforded Tanner his first opportunity to study abroad. The artist had been continuing landscape painting in the North Carolina mountains and had attempted also two or three genre subjects. Of the latter the most outstanding is "The Banjo Lesson," now at Hampton Institute, Virginia. Its composition is an example of the developed style of Tanner's "first period." Fundamental traits of this style, which reappear with greater significance later, are the placing of the two appealing figures in a deep space warmly illuminated by the glow of an unseen hearth fire, the radical perspective of the floor and the objects on it, and the poetic play of the dark masses of the figures against the luminous background. Works of this kind comprised Tanner's exhibition in Cincinnati in 1891. From the standpoint of sales, the exhibition was a failure. It was at this discouraging time in Tanner's career that Bishop Hartzell stepped in and offered "all that he would take" for each unsold item. The amount realized did not exceed $300.[3]

With this sum and some additional funds, Tanner went to Paris where he began his studies at the Académie Julien under Benjamin Constant in 1891. Like other American artists, he had found it necessary to seek instruction and inspiration abroad. But his reasons were different. Tanner felt that to escape American race prejudice, he had to find a cosmopolitan public. To achieve that, he suffered, physically and mentally. He lived for three or four years as an impoverished art student on five francs a day, and he was forced to give up several projects already begun

though perhaps not broadly developed, such as the series of land-
scapes and portraits he had proposed to do as a commentary on
American life. "The Banjo Lesson" and some of his portraits had
raised the hope that "a portrayer of Negro life had arisen indeed."
But his versatility of interests saved him from this narrower pre-
occupation with illustration and racial documentation.

After five years abroad Tanner sent to the Paris salon "The
Sabot Makers," a work that won favorable comment. Like "The
Bagpipe Lesson" of the same period, it is a genre of Breton life,
dealing humorously and facilely with the leisure pursuits of the
peasants. It is a kind of social study, but the artist has no inten-
tion of stating a social or aesthetic problem. Instead, he appears
devoted to nature and the search for expressive syntheses of rich
psychological situations. He does not sermonize; the incident is
pleasant and he plays upon it lightly and skillfully. Here there is
no pathetic realism to clash with the fancy of the artist's brush,
only a happy, if excessively pedantic, statement of rustic buffoon-
ery.

During his summers in Brittany, Tanner's work differed little
from what he had produced in America, but he enjoyed a greater
personal freedom, a sense of expanded manhood, and a con-
sciousness of self-responsibility that fed his ambition and energy.
At Pont-Aven he had artist friends who had come to see what
Gauguin had found there, and whose common interest must
have reinforced his own.

Tanner returned to this country for a brief visit in 1892, bring-
ing with him a number of the paintings he had done on his
summer excursions in Brittany. Some of the titles were "Bois
d'Amour," "Evening Near Pont-Aven," "Rocks at Concarneau,"
"Return of the Fishing Boats," and "The Foster Mother." These
with other works previously done in America were exhibited at
Earle's Galleries in Philadelphia in 1892. "The Bagpipe Lesson"
was among those exhibited. It now hangs in the library of Hamp-
ton Institute in the company of "A Lion's Head," which, accord-

ing to W. S. Scarborough, was a preliminary study of one of the beasts later depicted in "Daniel in the Lion's Den."

Except for an enlarged social experience, a wider knowledge of the art, and his own solid progress as a painter, Tanner had advanced little beyond "The Banjo Lesson" and his early portraits of his father and mother. After returning to Paris in 1893, he continued with genre until 1895 when he suddenly determined to paint religious subjects, to reinterpret many of the pictorially suggestive episodes of the Bible. He began work in the methodical fashion of the academic masters under whom he had studied. To divest himself of his teachings, an artist first must go through a period of struggle and disillusionment. For Tanner the precepts had been reinforced by the personal friendship for his teacher Benjamin Constant; but more important, the artist had set his mind on achieving success in the academic salons.

The first product of this new, unintegrated phase was "Daniel in the Lion's Den," for which Tanner received an honorable mention after it had been rehung in a place of honor through an appreciative gesture by the painter Gérôme. This picture is not a great or original work, and yet it is not a slavish exercise in approved academic manner. The archaeological strain of Gérôme runs through this piece of "atmospheric setting" which suggests the tiled wall of an Assyrian palace. The compositional effect, however, is massive, and the juxtaposition of massive forms and the frail prophet is an effective device. The freshness of the artist's point of view has enlivened a trite subject and prevails over the coldness of a schooled technic. By an artistic alchemy the character of the prophet is evoked; even the dim dungeon light helps suggest the bleak and powerful isolation that symbolizes his strength or the strength of his God within him. The very "souls of the beasts" have been sketched with great effect. The animals are hulking shadows enhancing the terrible gloom of the place. Tanner has supplied the writer with a United Press dispatch about the Paris salon that year. It follows:

Henry O. Tanner . . . is again to the front with a large canvas representing "Daniel in the Lion's Den." The prophet is in a large chamber of Assyrian brick, on whose walls is shown a frieze of colored lions. Part of a gallery or balcony dominates the prison, from which supposedly the king occasionally witnessed the sport provided for his amusement below. Daniel is leaning against a projection which serves to give additional strength to the great walls of the construction. The moonlight enters through a window or trap-door over his head and catches on his folded hands and richly embroidered robe. The upper part of the body is in shadow with the head turned toward the window above. In the deep shadow are the dark bodies of the lions walking restlessly up and down, their fiery eyes giving additional terror to the darkness. One lion is resting on his haunches near Daniel, part of his head and paw being in the line of the moonlight, while in the background a streak of moonlight catches the back of another lion.

From a criticism in the *Journal des Artistes* we take the following excerpt:

A citer encore, après ces trois toiles remarquables nombre d'envois importants qui présentent le plus réel interêt, et par exemple, de M. Henri Tanner, un *Daniel dans la Fosse aux Lion*, où l'artiste a très bien marqué le calme divin du prophète comme le subit apaisement des fauves, dramatisant la scène dans des conditions très vraies, si ce n'est peut-être qu'il a exageré l'obscurité mystérieuse dont-elle est enveloppée. . . .

In his "Resurrection of Lazarus," next submitted to the salon, Tanner's originality became identified with a weighty and plastic style of painting that he never afterwards lost. This now famous work has for some time been exhibited with other American paintings owned by the French government in the *Jeu de Paume* at Paris. It was a salon sensation in 1897, attracting both popular and critical attention, and it "won for the artist his first salon triumph."[4] Lucrative commissions immediately followed, and this popular success must have confirmed his decision to con-

tinue with scriptural themes. A medal of the third class was awarded the "Lazarus," and Tanner sold it to the Ministry of Fine Arts. An American critic writing from Paris not long afterwards said of the painting:

> Mr. Tanner's work illustrates very interestingly a sympathetic alliance of art traditions with the glowing modern temperament of the young American race.
>
> Those who pass by quickly and gaze superficially would be likely to say of this dramatic and tonally sustained "Resurrection of Lazarus": "a fine old picture, quite in the Rembrandt manner." But such a careless and summary judgment would work injustice to Mr. Tanner's powerful and well-poised painting.
>
> His figures are strongly grouped, energetically designed, tense in expression without gesticulation. The color scheme, with its tonality derived from the tone of oil paintings, is rich and forceful throughout.[5]

The most striking quality of this work is Tanner's interpretation of light. The source of the light is usually a visible and occasionally unique part of the pictorial drama, as in the great "Annunciation" now in the Memorial Hall of the Pennsylvania Museum. It is visible but caught by the various surfaces that reflect it. By this means an intense aura is thrown about the focal point or mood of the design, and its effect is the same whether an interior or exterior scene is depicted. The contrasting gloom filling the corners of the picture is irradiated by the gleam of a single source of light, and this is the key to the complex emotion that the artist seeks to communicate to his work. This is Tanner's way of groping toward the unearthly, the sacred, and the miraculous. Religious feeling was never alien to Tanner. He read the Bible daily and evinced keen interest in the Holy Land and the biblical characters that he represented, even though the protagonists of "art for art's sake" have criticized his attention to such interests as sentimental and pedantic.

The originality of Tanner's work is undeniable. While the

"Resurrection of Lazarus" shows a mixture of traditional influence from Constant and Rembrandt, as well as Titian, yet only the originality of the artist can account for the deep psychological interpretation of the text or the eloquence and emotional fervor of the work. A Paris letter to the *American Magazine of Art*, March, 1927, says:

> Henry Tanner's "Resurrection of Lazarus" is another example of originality of idea, here coupled with deep feeling . . . the somber, indeterminate color of the whole suits the supernatural character of the scene. . . .

With this resurgence of originality after a period of academic interest came significant changes in the studio practice and life of the artist. His interest increased in the creation of appropriate "atmosphere." The setting up of studio scenes was a vogue among historical and genre painters of this time. Tanner bought all the properties he could from the studio of the deceased Hungarian painter, Munkácsy: oriental costumes and ceramics, and furniture. The writer has seen in Tanner's studio two of the chairs that were used by Munkácsy in the painting of his large work "Milton Dictating Paradise Lost." Tanner did not use these materials in a literal manner, but as a part of the "atmosphere," and they play a compositional rôle in the interplay of the subtle meanings of line and color. For instance, in the "Annunciation," now in the Wilstach collection in Philadelphia, the great rug at the Virgin's feet plays a definite part in the mysterious drama there unfolded. It is a material substance, like that of the stone arches in the wall. Yet it is a "silent witness" of the occasion. Who can deny that the artist has endowed it with the sorcery of his color, so that it acquires an almost personal character, participating sensibly, like the animals at the Nativity, in the miracle?

Tanner's travels in the Holy Land after his first salon triumph were also a phase of his new inspiration, his search for atmos-

phere. Compared with the interest that later took him to Algiers and other parts of North Africa, this one seems pedantic. And in his later visits he revised his impressions of oriental life. His first attitude was that of a research worker, or anthropologist, collecting in Palestine data on racial types and customs. Tanner's mission became more absorbing after he received the backing of the late Rodman Wanamaker, who was then abroad buying up the works of French and American artists. The "Judas" of the Carnegie Institute in Pittsburgh, and the "Nicodemus" of the Pennsylvania Academy, both of this period, represent a distilled, more ethereal type of orientalism. The artist is getting away from large orchestrations of figures and the compulsion of illustration. Instead, he selects simpler events, a more general color scheme, and more rugged forms. His last effort in the old style inherited from Gérôme and his colleagues is the "Wise and Foolish Virgins," a large canvas first exhibited in 1908. Wanamaker bought this canvas but it has never figured among the most important works of the artist. It is a grand summation of all the defects, as well as many of the merits, of Tanner's academic period.

A painter of religious subjects today is more or less of an anachronism, but the spiritual and artistic conviction of Tanner's work, especially that after 1900, cannot be ignored. And even before that date he might have been regarded as the first modern exponent of religious painting; for many paintings, i.e. paintings based on religious themes, had been produced in Europe and America, but none commands the respect of Tanner's. Guy Pène DuBois, in a comparative criticism of some religious compositions by George Bellows and Tanner, compares Bellows' "Crucifixion" with Tanner's handling of religious themes:

> . . . George Bellows might here, in perfectly good grace, have accepted the challenge of the old masters. Having recently seen the religious pictures by Henry O. Tanner at the Grand Central Gallery, I am easily convinced that if Mr.

Bellows did accept the challenge, he did it on technical and not on religious grounds. Mr. Tanner paints religious subjects because they impress him. It is possible that Mr. Bellows paints them because they will impress someone else. . . .

It may be, however, that Mr. Bellows has suddenly become modern. In that case the subject matter which he employs is without point except as it may be an excuse, excuse by way of compromise with the public idiosyncrasy for an arrangement of forms. Mr. Tanner, who paints religious subjects because they impress him, might (another guess) see in this something on the verge of sacrilege. But this, again, is not for me to say. . . . With Mr. Bellows in his "Crucifixion," painting is the result of an attitude, unrelated to subject matter or art.[6]

Continual practice for Tanner brought increasing clarity to pictorial exposition. The work of his middle period betrays the struggle to reconcile simple color with terse, uncomplicated drawing. A sign of this struggle is his preference for the low-pitched, subtle colors of moonlight. "The Disciples on the Road to Bethany" is one of the best examples of this period. Other strong studies in nocturnal color harmony followed, such as the remarkable "Christ Walking on the Water" (now in Des Moines, Iowa), and "The Miraculous Draft of Fishes," in which the famous "Tanner blues" and blue-greens confect a surface comparable to iridescent enamel. But the masterpiece of this period is the "Disciples at the Tomb," now in the Art Institute of Chicago. In this work Tanner comes as close to the real essentials of painting as he ever came. It is a bold, unusual conception of the theme, depending, like a cinematographic "close-up," on the power of the human face to convey pathos. The warm, glowing color is put on in brusque impasto technic, without fussiness or excessive modeling. This is the apogee of Tanner's religious paintings. William R. Lester might well have been looking at it when he wrote that "he [Tanner] is a practical believer in the fact of spirit. His somber, dramatic portrayals of moving scriptural scenes unite modern art with

religion, as in those earlier days when immortal masters pictured on walls of canvas the earnest faith and profound soul-experiences of humanity."

During the 1914-1918 war, Tanner was supervisor of a canteen outside Paris, and instructed French veterans in elementary agriculture. He had little leisure for painted notes of the life around him. The writer knows of only two canvases of this period dealing with camp scenes; both are now in the War Museum of the American Red Cross at Washington. The painter's unfailing sense of composition and his clever mastery of the human silhouette permit him in these works to invest shadow with substance. Yet these pictures seem frozen, inanimate, compared with his more exalted themes. One accepts the massive and gloomy forms of houses and trees in the background— primitive apperceptions like the "Disciples at the Tomb" or "The Three Maries." The half-toned silhouettes of the gawky soldiers, however, have not the same formal integration. They contradict by their stark and angular silhouettes the atmosphere that materializes the houses and the trees. Oddly, they have a rôle subordinate to the light diffused from some invisible point to the right-center of the composition.

In his declining years Tanner's painting lost much of its force. The old sincerity persisted, as did his ability to suggest infinite meaning with a reduced palette—a certain indication of the mastery of his art. An outstanding picture of his post-war days is "Christ at Emmaus," a large work in acid yellows, shining greens, and resonant blues; one of his most alluring compositions. Here his use of rugged, massive forms, and dramatic, plastically manipulated color reaches its most expansive stage. So rough-hewn is this painting that the light on the face of Christ and around the fingers of His upraised hands has the weight and function of a second plastic outline of those parts. From this it is but a step to the relief effects of his half-tempera and half-oil paintings, the last of which is the one bought through subscrip-

tion for the Howard University art gallery, and for which Tanner was paid two months before his death on May 25, 1937.

The writer believes that the high-water mark of Tanner's production was his 1906-1914 period when the artist was intent on solving the problems of tonal form and nocturnal atmosphere. However, if we look back on the whole series of his paintings, we realize that the credo once enunciated by Tanner in the presence of the writer was the foundation stone of all his efforts as a creative artist. He spoke as follows:

> It has very often seemed to me that many painters of religious subjects forget that their pictures should be as much works of art as are other paintings with less holy subjects. Whenever such painters assume that because they are treating a more elevated subject than their brother artists they may be excused from giving artistic value to their work or from being careful about a color harmony, for instance, they simply prove that they are less sincere than he who gives the subject his best attention.

In these sentences Tanner summed up his aesthetic creed. It is one that should be memorized by those who mistake meticulous realism for personal and poetic interpretation. Finally, it helps us understand why Tanner was regarded with such deep respect by fellow American artists in Paris who referred to him affectionately as the "dean of American painters."

No younger member of the fourth generation attained the artistic stature of Tanner. This holds true for the entire field, and there were several among the men whose work we shall now review. Perhaps social and economic reasons partly explain the fact. After the Centennial, the country was in a state of nervous, almost furious activity. The American frontier was still expanding and industry and commerce were revolutionizing and complicating our social order. The Negro was marginal to this social change, or buried under it, but he was still free in a

creative sense if he did not encroach too far on racial snobbery and cultural boorishness.

Of course, some of the new, mediocre Negro talent would not have thrived under any adverse conditions. Some remained illustrators or commercial workers, and among these there are no outstanding names. Other dabblers and amateurs, due to poverty or public indifference, did not go beyond a few timid exercises. Among these were Charles F. Holland, the painter of a curious version of the first service conducted by Richard Allen after his secession from the Methodist Episcopal church; Clark Hampton; Ella D. Spencer, a watercolorist; and Lottie Wilson Moss, reputedly a sculptor. Their efforts indicate an upsurge toward finer and more lasting values by the Negro masses in the last quarter of the Nineteenth Century.*

In 1894 a young woman of original ability entered the Pennsylvania Museum School of Industrial Arts. She had early given promise as a sculptor. She was Meta Vaux Warrick (Mrs. Solomon Fuller) whom we have cited as a continuer of the emotional realism or romanticism of Edmonia Lewis. Mrs. Fuller's father was a barber, her mother a hairdresser in Philadelphia, the city of her birth. They were able to provide well for their daughter's training, and she studied for five years at the School of Industrial Arts, where she impressed her teachers deeply. "The Head of Medusa" was her first original piece in clay and marked her debut as a "sculptor of horrors." Criticism did not deter her. When required to submit something for metal work, she made a crucifix with a Christ in anguish. It was frowned upon, but she protested: "If the Savior did not suffer, then wherein lay the sacrifice?"

Meta Vaux Warrick went to Paris in 1899 to study at the

* See John Daniels: *In Freedom's Birthplace, a Study of Boston Negroes*; Houghton Mifflin Co., 1914, pp. 201-202.[7] Statements herein on the work of the Boston Negro in painting, sculpture, and other media in 1914 would be as true of Negro groups in Washington, Philadelphia, New York, at least in 1890.

Colarossi Academy. There her work won the attention of some
of the great names in the Paris art world. Rodin visited her
studio and encouraged her, and she found his conception of
sculptural form and his philosophy of art helpful in resolving
her own problems of expression. Some of her saturnalian
conceptions created a sensation when shown at Bing's *l'Art
Nouveau* galleries in Paris. These tortured forms show her
regard for science and design in the realization of aesthetic feel-
ing. A successful example of her early manner is the "Thief on
the Cross," a work in which she compromises between her
romanticism and its emotional objectification in form.

On her return to America this exuberant melancholy left
her. In 1910 fire destroyed nearly all the pieces of her early
period, and thereafter a more sober individuality characterizes
her work. Gone are the former stylefulness and impressionism
of surface. Her exhibition of 1914 included pieces of sculpture
that were direct, easily understood, and forthright. There were
many portraits exemplifying her new-found reserve and power
of organization. Even such slender examples of relief as the
panel of the "Four Seasons" and that of the "Magi" bespeak
greater self-consciousness and a check-reined technic.

There is an ingratiating charm in her most recent sculpture.
In her mature work, such as "The Exodus" and "Richard B.
Harrison," there is an intimate sense of human nature. It
emanates from the beautiful character of the artist herself; her
calm and gentle manner is well balanced with frankness and
an eager desire for self-expression.

In Oakland, California, there was a gifted woman artist at
work in 1890. She was Pauline Powell, born in Oakland, June
27, 1876, and reared in a community that afforded her many
advantages of education and environment. M. A. Majors in his
*Noted Negro Women* reports that she produced very fine paint-
ings, some of which were exhibited in Oakland in 1890, and
were the first works to be shown by a Negro artist in California.[8]

Majors also mentions Fannie Hicks, an artist and drawing teacher. She held classes in drawing in Louisville, Kentucky, and later "applied for space at the World's Fair, at Chicago, in which to exhibit work of the pupils of the University."

Some sensitive portrait drawings of Negroes and pen-drawn illustrations were published by Professor John Henry Adams, Jr., a teacher at Morris Brown College, Atlanta. These appeared chiefly in the *Voice of the Negro*, a periodical published in Atlanta from 1904 to 1906. Adams' portraits, made from photographs, may have limited aesthetic appeal, but this Boswell of the crayon had a real understanding of the interpretation of physiognomic character through line and delicate shading. With the disappearance of the journal his work passed from all except local attention. This is regrettable for some of his illustrations deserved wider public interest. Of especial merit is a double-page drawing by Adams published in *The Crisis* for December, 1910. The drawing shows a Negro farmer and his wife facing each other across their coverless table. The care-worn lines of the faces and the coarseness of the clothes molded to the homely bodies are quickly and poignantly brought out with heavy, plastic lines. Other of Adams' portraits are more delicate, or more ruthless, or more pedantic, but this drawing is above them all as an early documentary illustration, in the colloquial manner of Dunbar, of Negro peasant character.

There were also a number of "crayon artists," makers of solar prints, who labored heavily and prosaically. Their dark, uninspired "chromos" generally were made in imitation of daguerreotypes, and usually were merely enlargements. Edward Stidum, of Philadelphia, occasionally did this kind of work. But primarily he was a portrait painter and the limited financial means of his patrons were the only deterrent to his specialization in oil portraiture. He has left two interesting though partially decayed portraits of Stephen Smith and his wife, Anna, the two old Philadelphians who generously endowed the still extant

Home for Aged and Infirm Colored Persons in their city. The very literalness of these portraits is fascinating, and the rapid decay of the pigment has not destroyed all their vital originality. Stidum executed "speaking likenesses" of several of the leading citizens of Pittsburgh, including Andrew Carnegie. He died in Pittsburgh about 1917.

# CHAPTER V

---

# At the Turn of the Century

THE AMERICAN NEGRO about 1900 began to evince greater interest in his cultural opportunities. With the new century his hopes rose for increased advantages in the land of his birth. Maneuvering through educational and religious channels, his leaders sought encouragement and support for him among both Northern and Southern whites who were fair-minded enough to admit the Negro's right to equal cultural opportunity. Since the 1830s the Negro had struggled to establish industrial schools for his wider participation in the productive life of the nation. In the last quarter of the Nineteenth Century these schools contributed several thousand trained workers to American industrial manpower.[1] The "money and work" slogan of Booker T. Washington in the 1890s marked the broadening educational and industrial opportunities for the Negro. In both the North and South the rapid growth of Negro-owned business was a heartening sign of race improvement.

Through the South, however, there was stubborn resistance, sometimes brutal violence, on the part of the white with respect to Negro expansion in business and the mechanic arts. The white Southerner, resenting the aid given the Negro by northern philanthropy, religion, and politics, took social and economic vengeance on the colored populace. Everywhere in the South the cultural segregation of the Negro was complete; his labor was exploited but he was denied the creative leisure which his own industry made possible.

These facts are well recorded, including the diminution of national interest in Negro cultural advancement as a result of Booker T. Washington's industrial education program.[2] White writers of the time appeared determined to perpetuate the traditional southern conception of the Negro, and their influence was one of the viciously repressive factors on the improvement of race relations in early Twentieth Century southern society. The indifference or hostility of most white Americans to the cultural betterment of the Negro is mirrored in the literature of the late Reconstruction era and the first decade of the Twentieth Century. The portrayal of Negro character by southern fiction writers and illustrators, for example, dealt only with the fabulous, comical, quaint, or criminal side of Negro personality. This was especially true of the school of Thomas Dixon and Thomas Nelson Page, which set the pattern for the fictionized Negro in that "plantation ideology" still evident in the writings of Octavus Roy Cohen.[3] Such writers were ably seconded by illustrators of the stamp of E. B. Frost and E. W. Kemble, who immortalized the "Uncle Toms," "Aunt Chloes," "Rastuses," and other overdrawn "darky" or villainous types. This trend suffered its first check in the declarations of such a critic as William Dean Howells, the literary "discoverer" of Paul Laurence Dunbar. In fact, the maturity of conscious Negro art and literature almost dates from Howells' article in the *Atlantic Monthly* in 1900 in which he states:

. . . In many of the arts it [the Negro race] has already
shown, during a single generation of freedom, gifts which
slavery apparently only obscured. With Mr. Booker T. Wash-
ington the first American orator of our time, fresh upon the
time of Frederick Douglass; with Mr. Dunbar among the
truest of our poets; with Mr. Tanner, a black American,
among the only three Americans from whom the French gov-
ernment ever bought a picture, Mr. Chesnutt may well be
willing to own his color.

Although Howells' statement refers only to the best-known
names in the fields of Negro art and literature, there were other
Negro painters and writers engaged in serious production at the
time. Even ·though less talented than Tanner or Dunbar, they
were still important. These artists, working independently of
any traditionally native style or European affectation, explored
other subject matter, and added to the repertory of Negro art.
But they were regarded by all except a minority of their friends
as impractical dreamers, or worse, as fools. They insisted on
offering the community exactly what was least desired or expected
of a Negro.

Within the Negro community then as now, there was no
effective organization to aid the artist in his struggle for recog-
nition and appreciation. There were occasional, loosely banded
groups of tradespeople and domestics such as those of which
Daniels speaks in his *In Freedom's Birthplace*.[4] These groups,
however, were evanescent; their purposes were realized better in
the Negro normal school and college which at that time were
offering sporadic instruction in industrial design and represen-
tational drawing—such as Wilberforce, Hampton, and Barber-
Scotia.

But white institutions such as Pratt Institute in New York and
the Pennsylvania Museum's School of Industrial Arts were
among the best agencies providing systematic instruction in the
subjects demanded by a small segment of the awakening Negro
populace. Negro attendance at these schools was rare, yet they,

and Negro schools as well, inculcated no race precepts, but made available an eclecticism in philosophy and art in the best European and American educational manner. Still, they could hardly prepare the less determined artists to fight the battle necessary for the Negro who would be creative.

It is possible that the southern Negro, with his long tradition of skilled craftsmanship, might have achieved a success in the rapidly expanding field of industrial design, had he been given proper encouragement and intelligent leadership. The scope of the industrial arts is enormous, involving the collaboration of artist, engineer, architect, cabinetmaker, and many other skilled workers. Yet the fact is that the Negro failed to become integrated into this cultural phase of American life.

Negro art, music, and literature maintained only artificial relations with such professional middle-class movements as the Niagara Conference of 1905 and other later ones. While these conferences projected a program for the reinterpretation and reorientation of the Negro in national life, actually they proceeded on the narrow basis of racial chauvinism, with an inadequate understanding of African background and achievements. In view of this non-realistic approach to the tremendous problems of racial adjustment and economic organization, their attempts to mobilize the Negroes for cultural effort were foredoomed to fail.[5]

The fault was not all theirs, however, for the Twentieth Century Negro has not been acutely aware of his own cultural problems. Herein lay the bitter experience of those artists who preferred to starve at home during the first two decades of this century rather than cut themselves off from their own heritage. There was not, even in the first decade of the Twentieth Century, a sufficiently defined middle class among the Negroes which the artists might culturally represent. At the same time the artists and intellectuals were at variance with the cultural trend of the masses. This explains the futile and sometimes

grotesque individualism of many American Negroes seeking careers in art after 1900.

Paradoxically, though, the leadership and creativity of the Negro artist made his race gradually conscious of its folk heritage in song and story. The Negro musicians' research and arrangement of the traditional idiom became the foundation of original Negro music. James Bland, Will Marion Cook, Nathaniel Dett, J. Rosamond Johnson, Clarence Cameron White, and others were both originators and beneficiaries of Negro music. Through the sound instincts and well-founded experiments of these composers, both the popular and "classical" schools of American music have been enriched. Nor must the influence of Negro choral organizations, such as the Fisk Jubilee Singers and the Amphion Society of Washington, be forgotten.

The new race consciousness began to work more slowly among the painters and sculptors. If Negro music had only a small audience in its beginnings, Negro pictorial art was still more lonely. The painter and sculptor then were not aware of the folk heritage of the Negro. Accordingly, they did one of two things: either they worked simply and naïvely, using the material at hand without borrowing or imitating and without reference to racial tradition; or, if trained in art and ambitious for employment and commissions, they moved from one city to another, putting their talents to work in the service of all who would employ them. An exception was the artist-teacher who usually found and remained in a teaching position, rarely sending his pictures or statuary to public exhibitions.

At this time some public appreciation of African art, or of any good primitive art, would have been a boon to the Negro artist. But primitive art had enjoyed no vogue as yet in this country. The strongest single influence on the Negro artist in the first decade of this century remained the academic tradition perpetuated by the schools; and the schools were not likely

to stimulate many artists to treat Negro subjects either for their own sake or for the sake of original art.

Exhibitions at State Fairs provided Negro artists of this day their first opportunity to exhibit and publicize their art. Even these exhibitions were controlled by promotional exigencies, but at least they provided the occasions for the showing of Negro-made wares and afforded some relief from the usual public indifference to Negro cultural progress. The chief fault of these exhibitions lay in their tendency to segregate Negro participants. The Negro hardly received adequate space at any but the Jamestown and Charleston Expositions, and even in these two he was relegated to his own buildings or to some separate unit. Protests were made in vain to the boards of management of the Charleston and St. Louis Expositions.[6] Furthermore, the art exhibits themselves were never properly selective; prizes were awarded indiscriminately, and attention was never directed to the fundamental qualities of the art works.

At the Jamestown and Charleston Expositions the Negro was represented predominantly by educational displays. Music and painting were poorly represented. Some slight recognition of the Negro artist resulted, but with Tanner excepted, only two names emerge as contributors from these early campaigns— for this is what they appear to have been. They are Meta Vaux Warrick (Mrs. Solomon Fuller) of Philadelphia and Thomas W. Hunster of Washington.

At the Jamestown Exposition, the Negro art exhibit was given considerable space. There were 484 drawings and paintings, 14 works of sculpture, 51 pieces of stone-carving, and 20 examples of china-painting.[7] Much that was of little value was included, a fact not surprising since good formal training and adequate experience had been enjoyed by very few Negro artists. Meta Vaux Warrick won a gold medal award. The "most meritorious" paintings were submitted by Hunster, then a teacher of art in the Washington public schools, by W. O.

Thompson of New York City, and by Allen Jones of Nashville, Tennessee. A sculptor, Bertina Lee, whose name, to the writer's knowledge, has not occurred elsewhere was credited with "ten excellent pieces of work."

Most of this art has disappeared into deserved obscurity. This is nearly always true of art productions made for or exhibited at state fairs. Meta Vaux Warrick's "Ethiopia Awakening," made for the New York State Centennial, is the only surviving piece of that exposition.

'The *impasse* of the Negro artist in the first fifteen years of this century was largely that of all the members of the race. Social and cultural segregation affected the Negro's entire experience. The bits of occasional criticism and the notices about Negro artists that appeared in the press exemplify this. The full weight of prejudice may not always be judged by its effect on the artist; he may be able to evade or ignore it. But it is interesting to note some contemporary opinions, such as the following from an article by W. O. Thompson, Negro artist and writer, who occasionally published in *The Voice of the Negro*:

> . . . Perhaps not alone in the art of landscape, but in none of the branches of painting where the best emanates, are conditions scarcely other than that of discouragement and harsh criticism. Both Mr. Collins and Mr. DeVillis [Negro painters] have to face those conditions that success in art in any phase incurs, plus those discouragements that take the form of ethnic powers. But poor drawing and bad coloring are more to be feared than the latter.
>
> . . . . . . . . . . . . . . . . . . . . . . . . . . . . . . . . . . . . . . . . . . . . . . . . . . .
>
> . . . If there is any distinct characteristic peculiarly Negro, it is a smiling indifference to vicissitudes. We have a good example of it in our institutions of learning. On one side the young Negro is told that it is futile for him to take the higher education, and on the other he is told that it is useless to be a skilled mechanic, because the labor unions will not admit him. And yet both the higher schools and the industrial

swell their attendance each year. . . . It is those indestructible efforts to infold and develop in plant and animal life which tell, and not those that fall by the wayside. . . . If Mr. Collins and Mr. DeVillis do not at some time make some distinct and noteworthy contribution in art, there will surely be disappointment, for they both have the poet's vision; they have that African stoicism to smile at hardship and discouragement, and they have talents, decidedly so, and their training has been purely American.[8]

And there is the following comment from a white writer, Florence Bentley, sometime art and literary critic of the Chicago *Record-Herald*:

This is Mr. Harper's [William A. Harper] second important exhibition, and it indicates that he has in no way fallen from the standard of excellence which he set in the canvases shown last year in the Chicago Artists' Exhibition, when he made his first bow before an American public. . . . The work shown last year was the fruit of Mr. Harper's year of study in France and England. "An Afternoon, Montigny" was especially distinguished for beauty of color and atmospheric qualities, and richly deserved the central position which it held in the large gallery. Of it, a well-known critic has said, "It has no superior in the exhibition, and will ever be a source of delight to its fortunate possessor." . . . The group of English and French landscapes are doubly significant, from the standpoint of the artist's development. They not only reveal that freshness and youthful charm which usually accompany the first utterances of a strongly poetic nature, but they, in a way, represent the end of one phase of the man's art life—the period when the young student, with that modesty which befits inexperience, and that early reverence for tradition which is at the root of all culture, confines his search for beauty to well-travelled roads and to places made sacred by the brush of masters.

Voluntarily to take one's place with a struggling minority, demands a degree of courage, and the artist who insists on offering to American buyers beauty purely American, such is the paradox of our boasted democracy, places his bread and

butter in a very perilous place, and it must be admitted that bread and butter are of an importance that must appeal at times to the most enthusiastic dreamer. But when it is considered that this devoted worker is a Negro, one of that class of Americans of whom American prejudice takes nothing good for granted, the situation is not without peculiar interest.[9]

It would be easy to dismiss these remarks as sentimental, but they have a certain interest; their author was assuming the rôle of an intermediary between artist and public. And in the cases of Collins and DeVillis that was a deserving service. These two artists were among the traditional pioneers, largely self-taught, and genuine native products. With greater opportunity they might have done work comparable to that of John Sloan, George Luks, and Everett Shinn, who founded the so-called "Ashcan school" of American art.[10] Collins illustrated rural landscape and achieved brilliant interpretations of that genre. He was a regular exhibitor with the Washington Watercolor Club. DeVillis was a sailor and manifested his love for boats and the sea in a number of rapidly brushed marines showing all the spontaneity of a watercolor.[11] His studies of horse-racing were also charged with a healthy vitality.

The decade ending in 1910 was one of serious efforts by Negro artists toward various goals. It was not a period of supreme achievement or material prosperity for the artist. Our discussion of this era is intended to disclose the main trends in Negro life; but it is easier to appreciate the social context in which the artists worked than it is to judge the value of their work, especially since much of it has disappeared and is recorded only in photographic reproductions, usually of poor quality.

Harper's work, although strong and worthy of note in any chronicle of American art, has been neglected. No exhibition since his death in 1910 has recalled it forcibly to public attention. However, he was well grounded technically, and he was versed

in the congenial and stimulating tradition of the school of Barbizon.

Harper caught the vision of Claude Gellée of Lorrain as embodied in the canvases of Theodore Rousseau with their minute tracery of closely observed details. It is precisely the fine-spun architecture of Rousseau that makes its way into the paintings of this Negro artist. Harper, less profound but more poetical than Rousseau, has successfully disengaged the forms from their multifarious natural embroidery and placed them in an accented relation to a more generalized pictorial structure. Not only did he draw his inspiration from the Frenchman, but he also made him more understandable to us.

In the landscapes mentioned by Florence Bentley as marking Harper's second period, his gifts achieved their freest expression. His poetic treatment of trees is akin to Bannister's.* More than any other Negro painter before Hale Woodruff, Harper realized the importance of scale in materializing the vast perspectives of distance in landscape. His death was loss for Negro art, for already he had won a prestige in the West that might have made him as well known as Tanner.

Not even William Edouard Scott, who early in this period had launched his career as an illustrator, was the equal in his own *métier* of Harper. Scott's early illustrations were done in pen and ink as well as wash, and they frequently dealt with Negro subjects, but they were not serious attempts and were supplanted by more ambitious compositions in oils. Scott had received sound art instruction at home and abroad. This training resulted in good, if unexciting, draftsmanship and in reliable color technic. In his later work his color shows a remarkably supple quality, and even the deeper psychological character of color that thrills us in the canvas of a Daumier or a Forain is not

* As witness "An Autumn Day in France," a landscape now hanging in the Wabash Avenue branch of the Young Men's Christian Association in Chicago.

unknown to him. In the painting "La Pauvre Voisine," purchased from the artist for the Argentine Government, we have a very Tanneresque subject. Scott here reveals his debt to Tanner, who was his teacher. The head of the woman who sits at table and helps feed the infant is similar to the heads of women pictured by his master. The handling of the light, and even the plaster-like density of the *impasto* recall Tanner's later religious paintings.

Scott's brush, usually rapid and voluptuous, became more animated and steeped in color under the haze of the Haitian sky. His painting at one time shows a strong sympathy with the pathos of Haitian peasant life, as in the "Blind Sister Mary," now the property of the Harmon Foundation; and at another time, revels in transient and picturesque attitudes, as in the "Turkey Market." Haitian life for Scott was a swiftly moving pageant, with no suggestion of sluggishness or indolence that some have purported to observe in the island inhabitants. Now and again, however, Scott jeopardized the effectiveness of his work by inexpressive outline. While his powers as a colorist may have been the cause of this, such errors frequently mark those practitioners who simply renovate a school technic without imparting originality to it.

Two of the most talented men of this epoch, Richard Lonsdale Brown and Lenwood Morris, died in mid-career before fulfilling early promises. Brown died in December, 1917, leaving a few outstanding landscapes and some unimportant portraits. But his reputation might rest on two small watercolors and one oil painting, although the word *reputation* with its connotation of self-consciousness is scarcely descriptive of Brown's simplicity. Despite all his technical skill he remained a naïve artist. He was a housepainter in his youth, and wandered to New York City doubtful of his own talents. George DeForest Brush, a distinguished white painter whose specialty was portraits of mothers with babes in arms, took him into his studio and gave

him some guidance in painting.[12] Then Brown interested officials of the National Association for the Advancement of Colored People in his work, and through them sold a number of paintings and obtained employment at Shaw House, Boston.

This modest success did not affect Brown's simplicity. His already intimate knowledge of nature ripened, and his ability to paint fanciful allusions matured. He remained true to his original and ingenuous view of landscape, as a chronological series of his work reveals. The evolution in his art is technical, not spiritual. While his perceptive faculties sharpened, the original clarity and lyricism of his talent remained constant. The three landscapes of his which we have mentioned are without titles. Each is spontaneous and delightfully simple. In design they rank with some of the vaporous landscapes of the Chinese masters.

One of the most interesting Negro personalities of the second decade of the century was May Howard Jackson, a sculptor of Philadelphia. She came of a middle-class Negro family and received her training as a sculptor in her native city. Unlike Meta Vaux Warrick, she chose to remain completely American in her study, and held a certificate from the Pennsylvania Academy of Fine Arts. Some of her bronzes and plasters show that she was an expert modeler, and the writer can add personal testimony to this fact, as he worked in one of her classes in clay-modeling. The "Suffer Little Children To Come Unto Me" is a fine example of her lyrical and positive style. She never departed far from the definite and calculated system of modeling that she had been taught at the academy. In fact, this remains the aesthetic basis of her art, prosaic though it may seem. But in the above-mentioned composition, as well as in her "Sherman Jackson" and "Francis Grimké," she conveys a sense of appealing humanity. Still, there was no great originality in any of the pieces she attempted, and she made no noteworthy departure from the American pictorial tradition in sculpture as exemplified in the

cognate styles of St. Gaudens and Charles Grafly. She worked largely in a manner chosen by others. She died in July, 1931.

It is hardly possible to exaggerate the economic poverty of the Negro painters and sculptors of the first twenty years of the century. They possessed scarcely any of the facilities available to whites for the exchange of ideas and the circulation and marketing of productions. Certainly, the white artist, too, had his trials in the philistine reactions of an uneducated public; yet he had powerful advocates and well-organized societies in all the fields of the pictorial and plastic arts. The social and artistic connections of the white artist were neither so narrow nor so dependent on a patron class as were those of the Negro. And the white artist was largely free to determine the course of American art, and, more important, could do much to alter prevailing trends in taste. While the handful of Negro artists then working should have been enjoying ample commissions and employment, the opposite was true. Development of the Negro as artist was ignored in the more general concern with the problem of mass education and culture.[13] Little attention was given to art training in the program of Negro education until after 1921.

In the last ten years groups of public school teachers and some intellectuals, including white friends of the Negro, have helped to establish concourse between Negro artists and to effect a common meeting ground for them and the rest of the American public. An exhibition by the "Colored students of greater New York" was held as early as 1912, and among the participants are such names as Clinton DeVillis, Ernest Braxton, and Robert Lewis. The *Evening Star* of Washington, June 2, 1915, made note of the fact that an art exhibit of the works of "colored folk" sponsored by the Phi Beta Sigma fraternity was about to close. Some entries in this show were not insignificant, as Richard Lonsdale Brown, May Howard Jackson, and Samuel O. Collins were represented.

After this exhibition there is a barren interval of six years until

the more comprehensive showing by Eastern artists in August
and September, 1921, in the public rooms of the 135th Street
branch of the New York Public Library. The exhibit was
arranged with the assistance of a large executive committee com-
prising some of the prominent Negro citizens of New York. Of
the 198 separate pieces shown not all were noteworthy, but the
exhibition, supplemented with historical bibliographical displays,
did give new hope for a renascence of Negro art. And certain
works by recognized Negro practitioners lent a stability to the
entire exhibition, which in a sense was the first worthy chrono-
logical display of modern Negro artists.[14]

Tanner, who by that date had been made an Associate
National Academician, was represented with his now famous
"Washing of the Disciples' Feet." Laura Wheeler (Mrs. War-
ing) entered several landscapes and portraits, and there were
three pictures by W. E. Scott, "Pro Patria," "At the Front," and
"Auntie," a portrait. Meta Vaux Warrick's sculpture gave added
weight to the event; and several young painters, among them
Palmer Hayden, Braxton, and James L. Wells, imparted youth-
ful flair to an occasion that threatened to become too somber.
This exhibition is a landmark in the progress of the American
artist.

In 1922 the Tanner Art League, a well organized group of
Washington artists and art teachers, held an extensive Negro art
exhibition in the studios of the Dunbar High School, Washing-
ton, D. C. On display were 112 paintings and nine pieces of
sculpture. This was a significant demonstration of the growing
creative power of the Negro artist, not only in the number of the
productions but also in the merit of the offerings. The writer saw
this exhibition and recalls well the strong impression made by
Meta Vaux Warrick's bronzes and Tanner's oil paintings.

The next important showing of Negro art did not take place
until the miniature festival in Chicago, in November, 1927.
Under the auspices of the Chicago Women's Club, a program

of *The Negro in Art* was offered during the week of November 16 to 23, and the presentation included Negro literature and drama as well as painting and sculpture. This event opens the second and last period of Twentieth Century Negro art, occurring as it did with the "awakening" of the younger writers and artists after 1924. Its results were important; professional and lay critics were roused by the contacts with Negro art and artists made during this week of celebration. A prominent Chicago Negro business man purchased two of E. A. Harleston's paintings, and Richmond Barthé, who then had lived only a short time in Chicago, received wide notice for his portrait drawings and small sculptures.

At last America was becoming conscious of the collective strength of Negro art, and at last there was arising a Negro middle class which increasingly was to require the services of the artist.

# CHAPTER VI

# The New Negro Movement

THE ARTISTIC REGENERATION of the Negro began in the second decade of the Twentieth Century. After a long period of intermittent success, Negro genius found a more promising outlook for creative activity in the years following the First World War. This new orientation was in part the result of the work of the Negro artists themselves, but in a broader sense it was the articulation of the yearnings, beliefs, and attitudes of the Negro masses by their new spokesmen. This dynamic relationship between "the people" and their leaders, set up through racial or intellectual pride, produced what is known as the New Negro Movement.

The industrial needs of the First World War lured thousands of Negro peasants and laborers from a life of poverty in the South to one of fairly steady employment in the cosmopolitan North. Many left the South willingly, while others were induced to migrate on promise of industrial or domestic employment.

Yet they were not always welcomed in the northern communities they chose for settlement. In some places their entry was bitterly opposed by whites for ignorant or selfish reasons, or because of prevailing anti-Negro labor policies. In some instances violent outbreaks against Negro workers followed their entry into a community; they were deserted by their employers, and were the victims of the law itself in organized attempts to restrict the Negro to inferior residential areas of the cities. Negro and liberal white leadership in the North sought relief for the victims of such discrimination. Social and philanthropic agencies, with the help of the clergy, the press, and numerous writers, developed a program for the interpretation of the Negro and his problems to the whites. In this way national attention once more was directed to the plight of the Negro.

In metropolitan areas, such as Detroit, and New York, the Negro population virtually doubled between 1916 and 1922. In each city the Negro was faced with a different problem. In Detroit he adjusted rapidly to the industrial life, but in New York where there were few basic industries but many commercial enterprises, art galleries, varied entertainment, and the best schools, the new Negro masses were impressed with the educational and cultural opportunities. A Negro cultural rejuvenation was under way by 1925, not only in Harlem, that "city within a city," but also in Washington and Chicago.

With the concentration of the Negro population in New York in the relatively small area bordering Central Park and the exclusive Park Avenue section, opportunities were plentiful for inter-race mingling at night clubs, theatres, and other places of entertainment. The so-called "night spots" mushroomed in Harlem for downtown whites. Cultural intermingling was fostered in the literary and artistic atmosphere of writers' and artists' groups, and visitors from abroad began to visit Harlem for one of the most novel scenes of cultural expression in American life.

Negro intellectuals strove to give direction and tone to this welter of cultural exchange and social assimilation, but there was little assistance for the painters and sculptors clamoring for recognition. Dr. W. E. B. DuBois as early as 1915 had included Negro art in the fields which demanded aid and nurture,[1] and he and other associates of *The Crisis* were striving to bring public recognition to Negro artists. *Opportunity* magazine since its founding in 1922 had devoted occasional articles to the Negro in the arts. But only after a time was it evident that a transformation was occurring in the plastic and pictorial arts as well as in Negro literature. Soon the publication of a symposium on these "new directions" in American Negro life seemed opportune, and this was done in a special issue of the *Survey Graphic*, March, 1925, appropriately titled "Harlem, Mecca of the New Negro." Here the phrase "New Negro movement" first was used consistently to characterize the more advanced social and cultural position of the Negro of the 1920s. Later the same year Dr. Alain Leroy Locke's de luxe volume, *The New Negro*, an expansion of the *Survey Graphic* symposium, appeared. Within the covers of this book was first presented a number of paintings and drawings representative of the new trends in Negro art.

It was difficult for Negro writers and artists of the 1920s to find well-established white publishers who would accept their work. Traditional preconceptions of Negro character held by certain whites prevented an objective point of view toward either the content of Negro writing or the forms of Negro art. And these preconceptions, offering no insight into Negro character, were not adequate symbols for the creative artist. They insured, rather, the perpetuation of such Negro stereotypes as the grinning, sentimental servant of Reconstruction literature and art, the tragi-comic mulatto, and the lustful black peasant of the race-problem literature of the late Nineteenth and early Twentieth Centuries. Another preconception of the Negro con-

cerned the "zestful primitive" wanting nothing from life but sexual pleasure and the enjoyment of folk-song and dancing. This notion had been fortified in the inter-racial experiences of the Negro "literary renascence."[2]

Even Negro writers and artists often found some truth in the picturization of the Negro worker or domestic as a magnificently healthy, but irresponsible, and sometimes dangerous individual. And Negro intellectuals, feeling bound to proffer apology for the point of view adopted perforce by the Negro artist, extolled African Negro art as the "art of the noble savage," justifying an alliance of art with primitive mentality, and a naïve perspective with true achievement. For the clearest formulation of this apology we cite Dr. Locke's essay "The Legacy of the Ancestral Arts" in *The New Negro*.[3] Arguing that the Negro artist, lacking a mature tradition, might consider the new-found African arts (here designated by him as "ancestral arts" of the American Negro) as his real and exploitable heritage, Dr. Locke says:

> There is a real and vital connection between this new artistic respect for African idiom and the natural ambition of Negro artists for a racial idiom in their art expression. To a certain extent contemporary art has pronounced in advance upon this objective of the younger Negro artists, musicians and writers. Only the most reactionary conventions of art, then, stand between the Negro artist and the frank experimental development of these fresh idioms. This movement would, we think, be well under way in more avenues of advance at present but for the conventionalism which racial disparagement has forced upon the Negro mind in America. . . . The Negro physiognomy must be freshly and objectively conceived on its own patterns if it is ever to be seriously and importantly interpreted. . . . We ought and must have a school of Negro art, a local and racially representative tradition. And that we have not explains why the generation of Negro artists succeeding Mr. Tanner had only the inspiration of his great success to fire their ambitions, but not the guid-

ance of a distinctive tradition to focus and direct their talents. Consequently they fumbled and fell short of his international stride and reach. . . .[4]

Some Negro writers and scientists, taking these remarks as addressed to themselves, questioned this insistence on a racial heritage. They saw that such self-conscious pursuit of the primitive inevitably would stress a separate and singular existence for the American Negro, and they objected to the implication that he could resist the countless integrating influences of his environment. They held that this view of Dr. Locke and others would set apart, even if unintentionally, the form and content of Negro art, and they did not feel that this necessarily would make Negro art more acceptable to the white public. Between plantation tradition and African tradition, the Negro realist saw little choice.

Other Negro writers who took their politics seriously challenged the political implications of the views of the Negro apologists. Soon opinion was sharply divided. One group contended that to avoid imitation of white tradition the Negro must deny everything that might be construed as derivative from white experience; the other insisted that the Negro should encompass all experience, not attempting to suppress non-Negro influence, for such suppression meant intellectual and aesthetic negativism. Hence the intelligentsia with their division into philosophical camps threatened the whole Negro cultural movement.

A symposium on the purport and limitations of creative writing by Negroes was printed in *The Crisis* for June, 1926. The following were some of the questions posed by various writers and answered by outstanding critics:

1. When the artist, black or white, portrays Negro characters, is he under any obligation or limitation as to the sort of character he will portray?

2. Can any author be criticized for painting the worst or the best characters of a group?

3. Can publishers be criticized for refusing to handle novels that portray Negroes of education and accomplishment, on the ground that these characters are no different from white folk and therefore not interesting?

4. What are Negroes to do when they are continually painted at their worst and judged by the public as they are painted?

5. Is there a real danger that young colored writers will be tempted to follow the popular trend in portraying Negro character in the underworld rather than seeking to paint the truth about themselves and their social class?

The answers showed a fine sympathy with the problems of the black artist and, occasionally, shrewd observations indicating the way to greater freedom of expression. Some, like Robert T. Kerlin and Jessie Fauset, sent in very complete statements, but the average was brief. Generally, to the first question the answer was an emphatic "no"; to the second, "no" again, but with thoughtful reservation against malicious axe-grinding; to the third, the most conclusive answer came from Kerlin: "Publishers can be censored only for commercial stupidity." All the respondents agreed that the best answer to the fourth question would be the continuous production of first-rate works of art by Negroes. The fifth was one that only Jessie Fauset could answer with authority because her writing dealt with refined and cultured types of Negroes, and she spoke out of her own experience. Her answer to that question was an unqualified "yes."

George S. Schuyler and Langston Hughes in *The Nation* took opposing views on the issue of racialism in art. Mr. Schuyler said in part:

> . . . The Aframerican is merely a lampblacked Anglo-Saxon. If the European immigrant after two or three generations of exposure to our schools, politics, advertising, moral crusades, and restaurants becomes indistinguishable from the mass of

Americans of the older stock (despite the influence of the foreign language press), how much truer must it be of the sons of Ham who have been subjected to what the uplifters call Americanism for the last three hundred years. . . . As for literature, painting and sculpture of Aframericans, such as there is—it is identical in kind with the literature, painting and sculpture of white Americans; that is, it shows more or less evidence of European influence. . . .[5]

Hughes, who shrewdly understood the "blues" psychology of the Negro, replied in opposition. His statements, published under the title "Negro Artist and Racial Mountain," evidently were based on his experiences as a racially biased poet. He wrote:

One of the most promising of the young Negro poets said to me once, "I want to be a poet—not a Negro poet." . . . And I was sorry the young man said that, for no great poet has been afraid of being himself. And I doubted then that, with his desire to run away spiritually from his race, this boy would ever be a great poet. But this is the mountain standing in the way of any true Negro art in America—this urge within the race toward whiteness, the desire to pour racial individuality into the mold of American standardization, and to be as little Negro and as much American as possible.[6]

Whatever Mr. Schuyler and Mr. Hughes may think of the question today, it is obvious that the greatest weakness of their arguments at that time was insufficient evidence. Mr. Schuyler offered no evidence that racial character always becomes submerged in the cauldron of American manners, while Mr. Hughes in his more recent writings—especially his poetry—unwittingly proves that not only race as such but its whole environmental setting, such as discrimination and unequal opportunities for employment, are constitutive of the forms as well as the materials of Negro art.

A less direct but more scientific criticism of the position of the apologists came from Dr. E. Franklin Frazier, then professor of sociology at Atlanta University. In the Negro Anthology

*Ebony and Topaz* he maintained with sober reasoning that "to turn within the group experience for materials for artistic creation and group tradition is entirely different from seeking in the biological inheritance of the race for new values, attitudes, and a different order of mentality." Dr. Frazier added:

> . . . In the philosophy of those who stand for a unique culture among the Negroes there is generally the latter assumption. Moreover, while the group experience of the Negroes in America may be a fruitful source for the materials of art and to some extent a source of group tradition, it offers a very restricted source for building up a thorough-going group life in America. By the entrance of the Negro into America, he was practically stripped of his culture. His whole group experience in America has been directed toward taking over cultural forms about him. . . . Mr. James Weldon Johnson has indicated, it appears to the writer, in *God's Trombones* the unique contribution of the Negro artists. In this work of art he has used the literary language of America to give artistic expression to the racial experience of the Negro in America. Whatever of racial temperament there is in these poems has been made articulate through cultural forms which were acquired by the artist in America. . . .

We quote these opinions so as to leave no doubt as to the tangible issues involved in this renascence of the Negro spirit. Indeed these problems poignantly affected some of the sensitive minds in the New Negro Movement. The troubled outlook of the Negro artist was expressed by Countee Cullen in a remarkable poem entitled "Heritage":

> What is Africa to me?
> . . . . . . . . . . . . . . . . . .
> Africa? A book one thumbs
> Listlessly, till slumber comes.

Elsewhere he has posed the question more pertinently, with a feeling of melancholy:

Yet do I marvel at this curious thing:
To make a poet black and bid him sing.

Similar problems were posed for the Negro painter and sculptor. An article in the *New York World* in 1930 carried the terse remarks of two Negro painters on the question of the "racial content of art," and each was a categorical denial of the importance of racial content. Malvin Gray Johnson, then one of the most promising of the younger Negro painters, registered his protest:

> A noted American etcher* has accused Negroes of imitating their white fellow-workers. No doubt this is true. Not so much from the standpoint that they imitate white artists of this or any other country in as much as they are trying to do what artists of all races do—follow the principles of fine arts technically.
>
> We are taught to use lines, forms and color, never being told to look at these things from a racial viewpoint.
>
> The distinguished etcher admits most of these things himself, but says: "While few of the Negro artists used subjects of Negro life the approach is no different than that of the white painters." How can it be? We Americans of both races know and live the same life, except that the Negro encounters racial restrictions.

Johnson was strongly seconded by Winifred Russell, painter and chairman of the art committee of the 135th Street New York Public Library in Harlem. "Negro art," said Russell, "as all art, is a product of time and environment. . . . Can the Negro artist be immune to the dynamic influences of education and environment? No. Should he restrict himself in style and subject? No. Should the Negro artist become universal in conception, motive, manner and appreciation? Yes."

There were some Negro painters and sculptors who took literally the advice of the racial apologists and without a clear conception of African decoration attempted to imitate in stilted

* William Auerbach-Levy, portrait-etcher.

fashion the surface patterns and geometric shapes of African sculpture. The early paintings and drawings and book illustrations of Aaron Douglas exemplify this weakness. The influence of African decoration on Douglas' mural style is apparent to the close observer. It emerges in flat and arid angularities and magnifications of forms which, though decorative, lack the dynamic effect one might expect from the dismemberment of a traditional art for the sake of rearranging the motifs thus plundered. Their representational value is almost negligible, while their modernism is dominant. However, it must be noted that Mr. Douglas' early style in its general effect bears but scant relationship to the powerful forms and religious message of African Negro art.

Fortunately, it was the structural aspect of African Negro art that intrigued two or three other Negro artists. They produced a few telling essays in several media. The most interesting of these were by Sargent Johnson, Richmond Barthé, and James L. Wells, detailed discussion of whose work appears in a later chapter. Generally, they created simpler and more apposite patterns—very mild analogies, indeed, to African shapes. Johnson in particular made splendid application of these lessons learned through research in the clearly defined and compact surfaces of his portraits in porcelain and terra cotta. Except for a few imitative masks that he made in metal, no other work by this artist approaches the vacant abstraction noticeable in many African masks, fetishes, and relief plaques. Indeed, the heads of "Sammy" and "Chester," two prize-winning pieces from Johnson's studio, are closer to Egyptian portraiture of the Amarna period than to Ivory Coast or Sudanese forms.

And so with Barthé and Wells; through a brief study of African forms they were able to deal more tellingly with the problem of form in their more serious work. After 1931 it was almost impossible to detect in the work of either of these artists a trace of the erstwhile African influence.

It is evident that all the propagandistic criticism of the New
Negro Movement failed to formulate an aesthetic program for
the Negro artist. The admonition to imitate the "ancestral arts"
could only foster academicism, and tended, moreover, to con-
fuse the special geometric forms of African sculpture with
specific racial feeling.[7] In view of the use of African forms made
by such European artists as Picasso and Brancusi, it is difficult
to understand why the falsity of this identification did not occur
to American Negroes. Picasso, Brancusi and others sought a tactile
essence that they associated with such concepts as design, archi-
tectonic structure, accented planes, and robust masses. And their
work was analogous to African art only in these terms; other-
wise it was concerned with the world in which they lived. Hence,
they did not try actually to identify themselves with the psycho-
logical directives behind African art, but only to assimilate its
forms to a personal philosophy of aesthetic surface.[8] In time their
discovery of African art forms was assimilated by Cubism.[9]

While unsound in its basic premise, the Negro art propaganda
did serve to confirm Negro writers and artists in their search
for local atmosphere, and one of its most valuable results came
from the suggestion that the Negro artists in all fields look for
those facets of life that had hitherto escaped the understanding
interest of the artist.

Still, the aggressiveness of the propaganda is difficult to under-
stand in view of the liberal principles of those who were then
subsidizing some of the work of Negro writers and artists. In
1924 the Amy Spingarn prizes were set up under the aegis of
The Crisis for "persons of Negro descent in order to encourage
their aptitude for art expression." They had the effect of singling
out for recognition those writers who had been working without
benefit of official or critical favor. Now the limelight was turned
on the work of Langston Hughes and Countee Cullen, on the
writings of Jessie Fauset and the paintings of Laura Wheeler
Waring and Edward A. Harleston. These were introduced to

the public as serious artists and as the awaited interpreters of the modern Negro. Not one of them then was a consciously "racial" artist, nor were they admonished to become so by the judges of the contest in which their offerings had been successful. However, the novels of Jessie Fauset and the paintings of Laura Wheeler Waring were more congenial to the Negro middle class than to the working class; whereas Hughes and Harleston interpreted the life of the masses.

In connection with these awards for "Negro Achievement in the Fine Arts," it is impossible to set forth a definite theory of the juries chosen by the Harmon Foundation. At times members of these juries did counsel the Negro artist to exploit the "racial concept," whatever that may be, and to strive for racial feeling.[10] But the work offered was not technically or subjectively homogenous. Both the absence in the Foundation officials of a dogmatism on this question and the breadth of the Negro artist's topical interest acted as a check on the preconceptions of the jury committees, so that in all the Harmon exhibits the competently mature was hung alongside the naïve and experimental, modernism was juxtaposed with sober traditionalism. One charge that can be brought against some of these exhibits displayed from 1927 to 1933 is that of a too liberal taste in subject matter and too little concern for execution. There was always an ample section of popular painting of the kind that unpleasantly suggests tawdry calendar landscapes and portraits. But fortunately, intelligent work nearly always dominated the shows. Artists from all parts of the country exhibited; the 1933 Harmon show even included work sent from Havana by a Cuban Negro artist.

These exhibitions were among the greatest stimuli to the artists of the New Negro Movement. The yearly prize awards prompted them to intense competition, and as a result some found a fine creative vein. The contributors to these shows fell largely into two main groups. The first comprised those artists

who had been at work before the New Negro Movement and who were of an older generation. The second group were those who typified the youth and interests of the new generation that was beginning to mature at the height of the period. The work of the second group will be considered in Chapter 7.

The older artists were easel painters. They concentrated on immediate and racial portraiture with few excursions into land-scape, figure-composition, and purely fanciful subjects. Their efforts conformed to the dominant artistic directives of the time. Yet as early as 1906 we can discover in their work that note of modernity which had begun to creep into Negro art.

Edward A. Harleston (1882-1931), a native of Charleston, South Carolina, and the son of an undertaker who operated a moderately prosperous business in that city, was one of the most noteworthy of those who ventured into portrait painting. He had received an excellent training at the Boston Museum School of Fine Arts, and while he had mastered the technics for safe and sane painting, these did not spoil his aptitude for doughty pic-torial statement. He always remained a close observer of human character and was unquestionably entitled to the Amy Spingarn prize for portraiture that he won in 1924.

Harleston's greatest successes in portraiture are the "Old Bible Student," "Negro Soldier," and the "Old Servant." These are at once authentic documents of Negro character and amazingly factual statements of social types. This is especially true of the "Old Bible Student," caught by the artist in an off-guard moment—the very facsimile of a type of elderly Negro now fast disappearing from southern communities. It would be incorrect to designate Harleston's portraiture as "conscious racialism." While his work is discerning and is nicely adjusted to the leading facts in each instance, it is doubtful that he shows any deeper appre-ciation of the ethnic factor in his subjects than did Winslow Homer and Eastman Johnson in their pictures of Negroes.

Harleston's art rests on a felicitous knack of catching the essential traits of personality and fixing them in a color framework of very appropriate key. As for subject matter, he was interested simply in what was real—even though it did happen to lie close at hand.

Laura Wheeler Waring's view of portraiture is somewhat different. Her portraits depend more upon atmosphere than practical psychology. Nearly always she reveals the social stratum from which her subject comes, and this is effectively supported by a closely studied color harmony, delicately brushed into the canvas. She does not allow us to be on intimate terms with her pictures unless we are willing to "think ourselves into" the life of the subject. Some of her paintings are on the border of expressionism; such "mental poetry" being noticeable in "The Coed" and "The Musician." Her reliance on nicely adjusted patches of cool color in "Anne Washington Derry" suggests a distant artistic kinship with Manet. However she is no mere sleight-of-hand artist, as is proved by her subtle studies of groups of boys' heads and the nobly detached double-portrait of a mother and daughter that she exhibited in the Harmon show of 1927.

What for Mrs. Waring represents true detachment of mind and delicacy of touch, becomes with Palmer Hayden prosaic mannerism coupled with a muted elegance of taste. While working as a janitor, this painter took the first prize in the Harmon exhibition of 1927. Later he lived abroad for more than a year. From time to time he was represented in various exhibitions sponsored by the Harmon Foundation.

Hayden prefers to paint his pictures in bleak, unfriendly tones, meticulously graduated. It is impossible to say whether he has a sense of color since all his paintings leave an impression of silvery, reticent value, an effect particularly unpleasing in his work involving figures, for then the usage suggests a debilitated kind of impressionism. Still, no one can deny the effectiveness and artistic correctness of his greenish-gray palette. Where applied to a study of sailing ships at sea or tied up in misty har-

bors, such color tonality seems perfectly appropriate and right. The sea and sailing ships are Hayden's preferred subject matter. Lately, however, he has tried to paint satirical pictures of Negro life in Harlem, and in these, including the one entitled "The Janitor Who Paints," we see a talent gone far astray. Not only are the forms in these works confused, but the application of the humor is ill-advised if not altogether tasteless. His "Midsummer Night in Harlem" is like one of those ludicrous billboards that once were plastered on public buildings to advertise the black-face minstrels.

Hayden's former painter friends, W. E. Braxton and Winifred Russell, have almost completely ignored racial subject matter. But Braxton has done some work in this genre because his colored patrons in Harlem demanded it. This explains his tragically abortive historical portraits of Negroes, such as the "Alexandre Dumas, Père," that now hangs over the stairway of the 135th Street Public Library in New York. In landscape painting Braxton was more at home, and his slashing, abrupt technic and explosive coloring are sufficient testimony to his ability to impart his plethoric enthusiasm to his canvases.

While Braxton escaped into the realm of trees and herbs, Russell chose the musty but mellow gloom of a library interior. Here was a Negro painter who reveled in smooth, resonant values. In the diversified textures of book-bindings and the highly polished and partly-covered surfaces of tables he found the artistic play that his mind craved. Certainly, Russell was the very prototype of the conventional still-life painter who, by quiet industry, might have gradually enlarged his milieu to include an entire room. His taste was not quite so reactionary, however. His paintings were those of a dreamer and ascetic. The colors he used to paint the grass and trees of his "Autumn" would be difficult to find in such simple arrangement and such intense saturation anywhere in nature. His is the work of a poet; it is interpretative

rather than imitative of nature. It is a pity there is so little of it to enjoy.

All the artists of the older group derived their point of view from Paris by way of the American schools that taught a synthetic phase of Impressionism or extended Manetesque naturalism. The paintings of Allan Freelon and Henry B. Jones of Philadelphia are the clearest demonstrations of this fact. But this observation is not an adverse criticism. Freelon is a belated Impressionist, employing a bright palette of separate hues of blue, gray, and brown to describe the coastal landscape of New England. But his intense love of nature and his forceful artistic drive enable him to find such fresh effects of color and action as to make his compositions both autochthonous and thoroughly enjoyable. At least, when his procedure is so inspired, the work shows greater freedom and spontaneity of interest. The same spirit has made Freelon one of America's most progressive art educators.

Jones in recent years has developed a less finical style. His drawing now is more direct without being either blunt or barren. His colors, suited to the new clarity of line, punctuate their rhythm with prismatic hues. It is also encouraging to note that this painter possesses that rare versatility which permits an artist to turn from illustration to creative painting without loss of personal conviction.

# CHAPTER VII

---

# The New Horizons of Painting

SINCE ABOUT 1930 American fiction and poetry has been inter-ested in the elementary materials of Negro life. Like the sociol-ogists, anthropologists, and other social scientists exploring American folklore and folk culture, the novelists and poets have been spading up the old ground of the southern professional folklorist. Writers like DuBose Heyward, Julia Peterkin, and Erskine Caldwell are exponents of this new objective realism, and they have been ably seconded by many Negro writers, Jean Toomer, Langston Hughes, Claude McKay, and Sterling Brown. In promoting this interest in the seamy side of Negro urban life, the influence of Carl Van Vechten's novel *Nigger Heaven* was great, though it may be an exaggeration to attribute the sudden literary preoccupation with Harlem to the single bold *geste* of that author. Certainly, the picture of the urban Negro as half-civilized and somewhat maudlin, whose feet itch for the open road and whose heart yearns for the easy life "back

102

home," does not derive wholly from the Van Vechten novel. This romantic notion has been corrected in the more rational and objective writings of the late Rudolph Fisher, especially in *The Conjure Man Dies;* by Langston Hughes in *The Ways of White Folks;* and more recently by Richard Wright in *Native Son.* By degrees, the Negro in the urban center as well as in the rural shambles has been given an individual and a collective soul and is now known to be a person of many more emotions than simple primitive joy and sorrow. All valuable exploration of Negro life results in the discovery of "real" types and obligates the artist to avoid those stereotypes that for years have been palmed off as portrayals of Negro character.

The pictorial and plastic interpretation of Negro life has been furthered by many circumstances: Negro "art" magazines containing stories, poems, and illustrations; such clever books as Miguel Covarrubias' *Negro Drawings,* and Winold Reiss' appealing charcoal and crayon studies of Negroes; and the presentation of Negro character in such plays as Eugene O'Neill's *Emperor Jones* and DuBose Heyward's *Porgy.* These delineations of the Negro have heightened the interest of painters and sculptors in the rich and varied patterns of the immediate scene, where the unself-conscious life of the Negro can be observed truthfully.

The intimacy of the character portrait, with its imperatives of likeness and normality, still challenged Negro artists, but the portrayal of the round of daily life offered the knottiest difficulties. The Negro artist was not yet a fully matured reporter and interpreter of the important social patterns of Negro life, but the new interests that surrounded him on every hand were exacting of his intellect and skill.

In mural and easel painting the Negro artist felt constrained to recognize racial subjects even when they were prejudicial to his social interests, and in some cases even when they forced grotesque or morbid conceptions on him. The conception of

mural painting as glorified illustration still hindered his progress but did not entirely cut off technical experiment or prevent the expansion and enrichment of the artist's compositional resources. For instance, we become aware of external changes in the work of Archibald Motley and Aaron Douglas before we notice the changes in the text. Whether these two artists are themselves aware of this drift is immaterial; the procedure followed by both, so far as the pertinent examples disclose, is quite self-conscious and wholly dependent on pre-established technical principles.

Douglas' mural style is the result of a rationalization of form. He has adopted a formula for Negro physical characteristics which depends on two effects of design: elongation and angularization. Moreover, his Negro forms appear to be linked with a context of primitive dance patterns. This peculiarity helps to animate the ideas projected by him on the walls of the Fisk University Main Library, the Harlem Y. M. C. A., and the more recently decorated lecture hall of the New York Public Library at 135th Street. The most exaggerated instances of this mannerism are found in Douglas' book decorations, for example, in *God's Trombones*. In this application of his style he evokes the quality of movement through abrupt changes of line and mass in a lateral direction, and these changes effectively complement the rays and arcs of light geometrically plotted and abstractly illuminated within the given shape.

There is little direct evidence of African influence in Douglas' schematic mural paintings or his book illustrations with their posturing figures. What we do find is a species of exoticism, fanciful and unpredictable rather than controlled, pointing to an effort to find an equivalent in design for the imagined exotic character of Negro life. Still, this geometric extravagance is present in devices used to suggest Negroid features and tropical locale. According to the Douglas formula, the eyes must be long slits of light, the facial angle must project very positively beyond the slender stem of the neck, and the spindling shanks and

wide shoulders must suggest the lithe and supple strength of the black savage or the primitive slave. The formula embraces even the portrayal of peasant and other laboring types of Negroes.[1]

Douglas seldom places the Negro in a normal and plausible domestic life except in his easel paintings. Most of his murals are based on themes from Negro history, and thus emerges the tendency to depict the Negro's past by emphasis on the progressive and peculiar features of his culture.[2] In his fondness for this treatment, he places the Negro, whether in Africa or in America, in a tropical setting or atmosphere. Even when he conceives the subject in a Western and metropolitan life, he surrounds it with a mystical and immaterial light suggesting the vapors that rise from a tropical swamp.[3]

In Motley's series of decorative paintings for his one-man show at the New Galleries in 1931, there is a less direct exoticism. The small canvases drew power from the naïvely romantic approach that the artist made to his subject matter. It is true, of course, that he had not been to Africa or even witnessed a demonstration of the activity represented in these paintings. The subjects concern voodooistic ritual, which is no longer strictly African. Yet the paintings have a verisimilitude. Like the jungle works of the *douanier* Henri Rousseau, most famous of modern "naïve" painters, they symbolize something of the rank vegetation and lurking terror of the jungle. And this symbolic character of the work enforces a clear pictorial scheme on the composition.

We do not need to assume that the artist had any intention other than to illustrate what he believed to be a phase or racial tradition pertinent to the cultural interests of the American Negro. The stark realism of the pictures, enhanced by distorted shapes of trees and the disproportionate bodies of the savages, comports with Motley's notion of the Negro's past.

Some may see in this series a race-consciousness, but the more

likely explanation of it is simply a short-lived enthusiasm of Motley for exotic subjects.[4] The jungle indeed has a metaphorical counterpart in his easel paintings of Negro city life. Thus, in "The Liar," "Chicken Shack," "Cabaret," "Saturday Night," and "Barbecue," he suggests a teeming slum life, rudely authentic, with pavement "dingies" loitering before the doors of dubious pleasure haunts, with "sweet backs," gamblers, street-walkers, and the variegated population of that world in a staccato pattern of interwoven silhouettes. Motley's preference for the wanton and the gross in Negro life is basically sincere; his interpretation of the swaggering, picaresque humor of the scenes has virtually no intent to caricature. This is proved by his portraits, which are straightforward and simple recordings of personality. The native ingenuousness of the "Snuff-dipper" harks back to some of the naïve portraits of the American "Primitives."

Recent mural painting by Negro artists is more diversified in text and more deliberately self-conscious. Much of its sophistication and some of its pedantry can be explained by the fact that the artists are just beginning to find themselves in this exciting medium. They are leaning over backward in an effort to avoid hackneyed design and drab color effects. They have worked largely under auspices of the Federal Arts Projects, which has provided both monetary and technical assistance.

Although race materials prevail in finished paintings by Negroes, spontaneous and arresting design is attained by few of them in mural art. Among the most satisfying designs are those undertaken at the Harlem Hospital, New York, by Charles Alston. These paintings, and those of his assistants in the same hospital, were for some time the subject of much bickering because they contained realistic portraits of Negroes! But the work is more provocative in design than in subject. The paintings are broken into a dichotomy of themes. On the one hand religion is pictured as the source and agency of primitive medicine; on the other, we have the history of modern medical

science. The great contributors to medicine are represented by busts and their contributions emerge as the trunk branches of medical science. The application of their discoveries is shown in two details, one picturing three surgeons at work with the use of anaesthesia, and the other, two doctors at work in the laboratory on chemical analyses.

The panel on primitive medicine, however, is the most stimulating. Its compositional scheme is quite original. It is a highly successful piece of complicated designing but suggests only remotely the compartmental treatment of the wall used by Thomas Benton, or the fadeouts and dramatic overlapping of forms invented by Orozco. The panel further has an awe-inspiring realism of motif. All the attitudes of the various figures have been chosen aptly; the expression of each face and the gesture of every hand are exactly suited to the artist's meaning.

The color scheme itself is as simple and unobtrusive as the tonal pattern of a Bushongo weaving. Some critics may find defects in arrangement. Perhaps even greater dynamic interest could have been worked into the panel by stricter simplification of the background; but, at most, this would have been experimental, not imperative.

Alston is a versatile artist; he has worked successfully at portraits, caricatures, compositional painting, and stone sculpture.[5] He brings an intense appreciation and earnest creative effort to all these media. Whatever the subject, Alston prefers not to weaken his medium or suppress the effect of a design in order to attain some half-understood and largely extraneous race-wit.

Vertis Hayes, also working in the Harlem Hospital, likewise has been concerned with a general humanistic content. He deals more directly with Negro subject matter, or rather with the history of the Negro. He was a pupil of Jean Charlot, the Mexican artist and pedagogue, but his conception of mural style and his manner of telling the story of the Negro are closer

to Aaron Douglas', his neighbor in New York City. However, this affinity is not derivative but accidental; and it is not complete. Points of similarity are limited to these: (1) acceptance of composition in a single hue as an indispensable element of mural decoration; (2) the wrenching of objects from their normal context to create composite scenes and localities; (3) the arrangement of events in Negro history in the stereotype of arbitrarily chosen cycles, rather than by documented episodes. As one writer suggests, "There is the Southern epoch—the picking of cotton and the planting of tobacco, tenderly described . . . and . . . on two narrow panels, a summary of the contribution of the Negro to African and American culture."[6] The resemblance stops here, for Hayes's murals are calmer and more gradual in effect and less insinuating in meaning than those of Douglas. Probably the reasons for this are his comparatively recent experience with mural design and his greater timidity in the face of the problems it offers.

The formal design employed by Sargent Johnson in his murals is a vigorous if derivative element in Negro mural art. Pardonably eclectic at times, Johnson has dipped for inspiration into the paint pot of the modern Mexican school, and has managed to achieve something of the suppleness of fancy and monumentality of design that we associate with Diego Rivera. Qualifying all these characteristics is a certain aptness of expression that invariably constitutes the principal charm of Johnson's porcelains. He leans definitely toward a formalistic compromise with realism, and this leaves his paintings somewhere between the symbolism of Gauguin's "The Yellow Christ" and the academic realism of Rivera's California frescoes.

It may be a merit of Johnson's art that it transcends racial interest; indeed it gives the double impression of uniqueness and audacity that one frequently gathers from the apt elliptical expressions of Negro folk poetry.

Hale Woodruff, one of the true geniuses of American paint-

ing, is rapidly making for himself a permanent place in art. He knows well how to depart from the customary or the banal. In two series of mural paintings he has brought to public attention subject matter that is unhackneyed and a style that has reached the height of fresh, energetically fluent individuality. In one series of panels in his brilliant, spirited style, Woodruff has come to grips with those desperate and grotesquely squalid conditions which afflict the lives of countless Negro families in rural Georgia. In another, he has set forth in dramatic fashion the heroism and conflicting tensions of the historic Amistad Case. The Amistad murals were done later than the other series. They show a slight divergence of style, but the personality of the artist is indelibly present in both.

What Woodruff learned from the Europeans has been minted in color and brilliant muscular composition. The attitude of this "northern" artist who migrated to the South in search of more stimulating race material, comes out clearly and effectively in his paintings. He has proved himself an expert narrator, whose style on occasions has the deft insouciance of Goya. Lately he has devoted much attention to the Negro rustics and their abodes in Georgia, with entertaining results in oils as well as in woodblock prints.

Woodruff carries the same graphic style and salty interest into his murals, which are a sharp commentary on the squalid conditions of the Georgia Negroes. The social meaning of such paintings as "Shantytown" and "Mudhill Row" seems to enhance their artistic significance. Woodruff has always demonstrated his ability to render the broad essentials of a scene and to make the most of a story; none of his expressionist experimentation has diminished this ability.

The superficial observer will not see much difference between Woodruff's paintings of Negro themes and those in the touristic series on Southern life done by Howard Cook, or in the murals of Thomas Benton. Yet the difference is great, and is in direct

ratio to the artist's understanding of his material. The student of Cook's interpretations of the peasant Negro will find himself engrossed by the technical virtuosity of the artist. His sweeping, gingerly rhythms and sharp staccato accents are prepossessing, but hardly original. The inflexible stylism of the man enables him to take all subjects in his stride. Hence, the values are those of pictorial journalism; they are a passing comment.[7]

Benton, a much traveled and stimulating painter, hardly gets closer to the intrinsic values of the Negro peasant subject. In his approach, which is almost entirely through the medium of oil-tempera, he employs all the symbolic devices of a skillful stage director. For example, he seizes on the typical gesture or most obviously expressive trait of a group activity, and by featuring it he establishes the thematic scheme of the whole picture. This is best observed in his illustrations of the ecstatic moments of Negro religious experience. Elsewhere he has used the same method to portray gambling and banjo-playing Negroes.

Benton's delineation of Negro physique runs to heavy, awkward, and even grotesque bodies with long, gesticulating arms and flexible aspect.[8] All this over-emphatic drawing, however, cannot kill the sense of drama that he unfailingly achieves. By extraordinary emphasis he succeeds in holding together most of his triangulated jig-walks to which he adds the flavor of a charming archaism of style.

Woodruff, for all his stunts and linear ecstasies, is more concise in expression than either Cook or Benton, both of whom, nevertheless, he slightly resembles in style. His picturizations of Negro life and *milieu* have a more authentic setting and evince a more intimate knowledge of the materials than Cook's most faithful renderings of sharecroppers. The points of view are different; Woodruff has made his notes a part of his experience, while Cook has been content to embroider on certain conceptions that he never quite absorbed.

These statements can be tested by anyone who studies the

Amistad murals. Where in all American art can one find a more remarkable grouping of black and white faces than in the second panel of this series, showing the slaves on trial at New Haven, Connecticut? Apart from the thorough research that the artist has expended on the costumes of the figures, there is also a variety of posture, gesture, facial expression, and grouping, that builds the "psychological motif" or the dramatic tension of the whole. It must be conceded that not only does Woodruff exhibit here a fine sense of design, but also shows himself gifted with the retrospective imagination that is as indispensable to the great mural artist as to the historian. The student of this work should not fail to note the wonderful unity of its design and the sustained effect of action and color-tonality. He should not miss the rich profusion of textures in the material accessories, all blended like a multicolored rainbow into a single structure of movement and expression. The entire series of panels are a delight to the eye and the imagination. And there is no doubt that in them Woodruff rises to the epic character of his subject. It is left to the spectator to determine whether he has fully exploited the pictorial possibilities of the theme.

Some would have the Negro artist smother his spirit at the moment it begins to soar into consciousness. These people seem to think that it is better for him to amble forever in the dim glades of formlessness where they imagine the primordial values of art lie. For them the Negro is without cultural or written history, and hence capable only of an "instinctual" art. Such an idea is not only foolishly romantic; it is clearly anti-cultural. So far it has not taken root in the minds of the younger Negro artists, for, as one Negro writer aptly puts it, they have also "achieved an objective attitude toward life. Race for them is but an idiom distilled from a universal experience, a sort of adding enriching discipline, giving subtler overtones to life, making it more personal and more intense." That at least is

what we gather from a study of the more important easel painters, who are chiefly concerned with their impressions of the life around them and their subjective transformations of it.

In the paintings of Malvin Gray Johnson (1896-1934) a full-rounded poetic note was struck. Johnson was born in Greensboro, North Carolina, of poor parents, but he spent the mature years of his life in New York City. The pessimism and abnegation of spirit demanded of the Negro artist never disheartened him. The really significant work of his short life began about 1929 when he developed a small series of canvases interpretative of the Negro spirituals. One of these, a prize painting of the Harmon exhibition of 1929, is a highly imaginative interpretation of "Swing Low, Sweet Chariot." Nine Negro figures in attitudes expressing astonishment, joy, or pain are grouped on the bank of a river. All manifest physical weariness and it is impossible to judge their ages. The awe-inspiring drama of death comes in the form of a great chariot drawn through the sky by three cloud-like white horses. Emotion suffuses this little canvas by virtue of the phosphorescent color and the crescendo of forms lifting easily from the ground upward.

However, this work does not equal technically his "Roll, Jordan, Roll," a painting that relies for its spiritual intimations on rhythmic waves of color horizontally distributed across the rectangle. The organization of the picture is in effect dynamic, but in structural essentials it is primitive. The artist presents in a symbolic way a pictorial analogy to the gentle swaying motion that characterizes the singing of the spiritual. It is the same feeling that is registered in a well-delivered "Negro" sermon of the chanted type, or in one such as inspired James Weldon Johnson's *Creation*. It is a feeling associated with a terrifying sense of spaciousness and the awful grandeur of catastrophic visions. On viewing this interpretation of one of the most

famous Negro spirituals, it is easy to believe that some of them barely cloaked a militant, threatening spirit.

Malvin Gray Johnson's portraits aim directly at the essence of the subject. About 1934, the year of his death, he experienced a new inspiration. He began to state in terse, pregnant patches of color his "vision," and this meant ridding himself of such secondary, distracting interests as the precise textural value of clothing and tricky lighting and composition effects—concerns which at best yield only a deceitful appearance of truth. The subjects he chose were usually from his own social stratum, the workers. His art always showed a great sympathy for them, as witness "The Sailor," "Meditation," "Ruby," and certain of the southern Virginia sketches and other titles.

With Malvin Gray Johnson's death Negro art lost much, for the promise of his last work was great. It is encouraging to note that the younger painters have not forgotten his example.

We have already mentioned James L. Wells in connection with that period of cultural regeneration known as The New Negro Movement. But it was not until 1931, when Wells won the First Harmon Award, that he received due recognition as a creative painter of easel subjects. The son of a minister, he has achieved in his paintings an effect of meditativeness and ecstatic revery, whether the works are religious paintings or landscapes. The drastically simplified forms of his Harmon prize picture "The Wanderers" appear almost at the beginning of this "becalmed" phase in which Wells has used refined, high-keyed color to increase the shining map-like density of his impasto.

Recently Wells has turned from scriptural texts to the more lyric and casual moods of landscape and still-life. In the latter he shows an ingratiating style and a charming color sense.

If in Wells we find some intimation of the Negro's poignant religious experience, this is present only by ironic inference in the paintings of William H. Johnson. Like Woodruff, Johnson

is a facile painter and possesses a thoroughly extrovert and aggressive character. And again like Woodruff, he has been influenced by the revolutionary art of certain modern European painters. He was enamored of Soutine and Vlaminck, and for a time his paintings considerably resembled those of the former artist.

Johnson's creative career has undergone two major changes of style. Technically, his first and more typical style is immediate and dynamic. He distorts forms, unnaturally bends and twists trees, hills, houses, and figures to realize the gripping vortices of his pictures. Sometimes, in a slashing attack on the vertiginous lines of his sketch, he lets a color plane or tone stroke slip out of place, destroying the immediate surface unity, as in "Sunset." It is in such convulsed painting that he most strikingly recalls Soutine. Johnson does not suggest emotion: he analyzes it. With crazily teetering planes and tortuously scrawled lines, he strives for a personal and sardonic interpretation of character. His self-portrait and the inimitable "Sonny" are examples of such effort. In these the portrayal of Negro character moves into the realm of skeptical science. "Sonny" might be any adolescent Negro who has been brutalized and made a gibbering idiot by poverty, ignorance, and neglect. In the self-portrait the artist may mean to show his own frustration in a hostile environment and his resentment typified by an expression of wild defiance.

In his second and more recent style, Johnson is intrigued equally with composition based on the human figure and with still-life. His new style developed out of his interest in prehistoric and primitive art, and this, we are convinced, is its all-too-apparent fault. The slat-like, angular grotesques that he invents are hardly more than flat symbols for the human figure. Their general effect is that of Bushman art; their most modern counterpart may be the gnome-like, two-dimensional figures that crowd the registers of certain Abyssinian manuscripts. Even

though we welcome the gain in bright, charming color to which this change of style opens the way, it is difficult to understand why any American artist in this day of confusion should elect to be unintelligible. The singular and cryptic nature of Johnson's work sets it apart from anything else in the studios of the Negro artists.

Further documentation of race-types through the medium of the portrait takes place in the work of John Wesley Hardrick of Indianapolis and William A. Cooper of Charlotte, North Carolina. Both are almost exclusively portrait painters. Hardrick has to his credit, however, a few landscapes of unusual freshness and vigor. The over-ripe realism of these artists as portraitists seems oddly prosaic by contrast with these landscapes.

A lyrical interlude to the passionate exploration of Negro genre is the work of Lois Mailou Jones, a Boston artist who since 1930 has been a teacher of art at Howard University. Miss Jones has always been a proficient student of art technics, particularly of those in the service of pure design; but recently she has given much time to oil painting, a medium in which she received most of her instruction at the *Académie Julien* in Paris. Thus far her painting has been in the tradition, but not in imitation, of Cézanne. The analytical method of the mature Cézanne has been useful to countless students of painting, because it is a way of seeing—a fact with which many critics agree. Essentially, of course, a way of seeing cannot be imitated. Miss Jones wishes to confirm Cézanne but at the same time to add an original note of her own. Her success is manifest in such specimens as the scintillating "Still Life" recently shown at the Pennsylvania Academy of Fine Arts. She has a commanding brush that does not allow a nuance of the poetry to escape. Sensuous color delicately adjusted to mood indicates the artistic perceptiveness of this young woman.

Recognition of Miss Jones's unusual powers as a landscape painter has come from white as well as Negro colleagues and judges. Two instances of such recognition are the "honorable mention" at the Negro Exposition in Chicago and the Robert Woods Bliss Award in the Annual Exhibition of the Washington Society of Fine Arts in 1941.

Samuel Brown of Philadelphia deals quickly and boldly with problems of portraiture as well as composition. This young artist proved his merit as an employee of the Work Projects Administration regional office in Philadelphia. In the national exhibition of paintings executed under the Public Works Administration and held at the Corcoran Gallery of Art in 1934, Brown displayed a watercolor of a Negro charwoman. Many judged the work shockingly amateurish and extremely grotesque. Others, including the exhibition officials and Mrs. Franklin D. Roosevelt, singled it out for special and favorable comment. The artist, far from considering his use of exaggeration and emphasis inappropriate, declared that his eye would not permit him to depart from the normal except when compelled! Brown uses distortion as a naturalistic device to evoke the feeling of pain, anguish, suffering, or struggle. This is clearly shown in his striking watercolors of lynchings, and in his painted tirades against the exploitation of labor.

Brown was the only Negro artist included in the Paris exhibition of American art collected and arranged by the Museum of Modern Art of New York. "Mrs. Simpson," a portrait, was chosen, a work that had won marked favor in the "New Horizons" exhibition of WPA art held at the Museum of Modern Art in 1936. Brown takes great and deserved pride in his dexterous handling of the aniline dyes that form the color base in this picture; he has developed in this medium several superior portraits and a number of fine abstract paintings.

Young talents are being recruited constantly to the ranks of the Negro artists. Most of them have been given their first chance to work on equal terms with white artists through the WPA Federal Arts Projects. But trained artistic performance and professional success have also been fostered elsewhere. Opportunities for good and extensive training in the arts have increased fifteen-fold for Negroes during the last ten years.[9] And in that period some of the promising young men and women have made their start.

There were many white art instructors engaged by the Work Projects Administration to whom the younger Negro artists are indebted. Here, however, their good influence must be taken for granted, for the programs of all art schools, black and white, are largely dominated by the methods and even the philosophy of the white man who controls them. Except in outstanding cases, the white contribution is anonymous, and greater recognition is due the Negro artist-teachers in W.P.A. work, or those who have been forwarding parochial art programs. Through them, we feel, the young Negro artist will be enabled to integrate race-feeling and race-culture with his heritage of citizenship and cultural interpenetration. Final emphasis, however, must be placed on the worth of inter-racial co-operation for youth in all areas of art educational effort.

No movement or organization typifies such emphasis more encouragingly than the Karamu House in Cleveland. It was founded in 1915 by Russell and Rowena Jelliffe, its present directors. In this institution, with its excellent staff of white and colored instructors and its strongly integrated four-arts program, we meet a highly successful experiment in the cultural education of the Negro into which racial differences have not intruded. On the contrary, creative and work opportunities are sought in a policy which, if followed on a national scale, would end the cultural ostracism of the Negro.

The aims of Karamu House are set forth in its own statement:

Karamu House of Cleveland has for a quarter of a century engaged in discovering and training the creative abilities of the American Negro, and directing them along four main channels: theatre, dance, music, and graphic and plastic arts and painting.

A program of social education is used to correlate these departments to each other and to the life of the community and the nation. . . .

Karamu House uses its arts program to accomplish two ends. First, the direction of the Negro's creative abilities into the main stream of American life, thus removing him from the isolation which has been so costly to initiative and ambition. Secondly, to enable the Negro to tell his own story to the community and the nation, making directly known his sufferings, his dissatisfactions, his aspirations, and his ambitions.

The studios of Karamu House are open to all; but since the middle of the 1930s there has arisen, as one would expect, a group of specialists—a "school of mature artists"—to whose productions some of the most important museums and galleries in the country have given exhibition space. The scope of this production is wide, embracing oil painting, watercolor, pastel painting, drawing in various media, print making and etching, lithography, and sculpture. Of the crafts, both enameling on metal and jewelry have been represented.

The directors of Karamu House have never "reached out for great outstanding talent" and "have started always merely with the interest of very ordinary run-of-the-mine people. . . ." But the discovery of talents like those of Charles Sallee, Elmer Brown, George Hulsinger, William E. Smith, Zell Ingram, and others has vindicated the institution's specific objectives and procedures.

In Karamu Artists, Incorporated, an auxiliary organization of artists and students of Karamu House, there is no attempt by the members to outrank one another; all are on a basis of equality. When opportunity permits, they collaborate on large

projects, and they are as interested in each other's success as in building a personal art not consciously imitative of a "school." Some of the older artists have had more experience in art technics than their confrères. Sallee, Smith, Ingram, Brown, and Hughie Lee-Smith have ranged through more than five media and have taken firm hold of each.

Sallee, with scholarship aid from Karamu House, completed four years of study at the Cleveland School of Art, and subsequently received a bachelor of arts degree from Western Reserve University. He has displayed much power as a creative painter, revealing himself in his easel paintings as a master of rhythm, so expert that the work is joyously animate. It is as though the artist found nothing but transporting gladness in life. For proof of this statement, examine his "Jitter Bug," "Time Out," or "Saturday Afternoon," "Cardplayers," and other works. We shall note a continuation of this spirit when we discuss his etchings.

Smith and Brown in their easel paintings incline rather steadily toward portraiture. The former has to his credit some excellent pieces of this kind and in addition some urban scenes. Two very effective paintings, shown by Smith at the Associated American Artists Galleries in January, 1942, were "Anderson," a portrait, and "Leaning Chimneys," about which the artist has written:

> The design of these leaning chimneys struck me. And each chimney seemed to have its own peculiar manner or quality, and to speak for the people huddled around the hidden stoves below. Some told me that gay and noisy people were below, others spoke of sad people, discouraged and with only a little hope left. Some were quarrelsome and bitter. These leaning chimneys seemed, somehow, out of joint and not at all as I wished they might be.

Both as to psychological make-up and artistic expression, Brown probably is the most interesting of this group. He was born in Pittsburgh, Pennsylvania, in 1909. "Family reverses

built for him a childhood of wandering and loneliness, culmi-
nating in a chain-gang experience when he was fourteen years
old." This hardship is said to have brought him to a "sudden
and harsh maturing." He came to Cleveland in 1929 and almost
immediately was rehabilitated at Karamu House. Later he was
on the WPA Federal Arts Projects and has recently completed,
with the assistance of Karamu House artists, an interesting
mural in the Cleveland City Club.

Other painters attached to Karamu House whose lives and
work are scarcely less interesting and who have attained no little
distinction are Fred Carlo, Curtis Tann, William Ross, and
Sterling Hykes.

In New York, Gwendolyn Bennett was the efficient head of
the WPA Harlem Art Center until 1941 when she was removed
because of her political convictions. Many white and Negro
youths enjoyed the advantages of the excellent instruction that
she and her staff offered, a training that was the equal of several
professional art schools in New York City. Herself a painter, Miss
Bennett wisely guided the promising talents under her charge.

Young Negro artists who have studied or taught at the Harlem
Art Center are Romare Bearden, whose work recently was repro-
duced in *Fortune* magazine; Norman Lewis, a commentator of
mordant wit on Harlem life; Ronald Joseph, foremost Negro
abstractionist painter; and Ernest Crichlow. Elba Lightfoot and
Georgette Seabrook, two young artist-decorators, are also products
of the Center.

In the South, Rex Goreleigh and Hale Woodruff`discovered
and guided several vigorous talents. Goreleigh, now at Palmer
Institute in Sedalia, North Carolina, has studied at the Art
Students League and in France under André l'Hôte. He has
been a successful and regular exhibitor, and his work reflects a
socio-political interest in the agricultural plight of the South
and the economic status of the Negro farmer. His "Plowin'" is

an effective illustration of a poor Negro farmer with a bony mule harnessed to his ancient plow turning up a vast acreage of aridity.

Frederick Flemister is the most notable painter in the group centering around Woodruff. He is a consciously naïve artist who produces paintings of extraordinary force, despite that he often resorts to stereotype subjects, imitates the forms and textures of bygone styles, and even grossly exaggerates human expression. The facility of his technic makes him almost a curiosity among the less experienced practitioners in the field. Such works as his "Madonna" and "Self-Portrait" must be seen to be fully appreciated.

Other interesting personalities of Woodruff's school are Robert Neal and Albert Wells. Each distinctly bears the mark of Woodruff's personal style and methods.

George C. Neal (1906-1938) of Chicago, an independent artist and thinker, was one of the leaders of Negro youth in art and virtually a martyr to his cause. The training he had had at the Art Institute of Chicago had stimulated his ideas and released his springs of pure aesthetic inspiration. He retained a firm grip on reality and mastered a heterogeneous culture, and hence was eminently fitted to lead those who worked with him. Chicago artists still speak of his qualities as a mentor. Neal died of pleurisy as a result of overwork, exposure, and probably malnutrition.

Few of Neal's paintings survived the fire that swept his studio at the time when his teachings were beginning to bear fruit in the productions of Charles Davis, Eldzier Cortor, and others. To Neal's credit, it is said that he aimed at the emancipation of the young Negro artist from academic technics and conservatism, and from the traditional sentimental modes of the Negro subject, so stultifying to the imagination. Several young artists now enjoying the patronage of discriminating art lovers benefited by Neal's wise counsel in artistic expression.

Chicago painters who have acknowledged their debt to Neal

are Cortor and Davis. His influence came less directly to others, such as Charles White, Earl Walker, Fred Hollingsworth, and Charles Sebree. Some of these have exhibited extensively and are known to a sizable public. We cannot discuss their work at length, but must call attention to the marvelously poetic paintings of Davis and Cortor. The mark of the mature and fecund artist is on them. They have added generously to the themes originated—or discovered—by the Negro artist. Their use of color to create or suggest mood will well repay the student of such effects. Charles Davis' "Victory at Dawn" was one of the most remarkable paintings produced in 1941.

Sebree shows a definite inclination toward the mystical and the ineffable in human life. His work is conceived in a mood of contemplation and recalls the mystical purity of Byzantine enamels or Russian icon painting.

Charles White and William Carter paint both landscape and figure very well, though White's preference is for the mural. Both scored tremendously in an exhibition of their work at the Howard University Gallery of Art in 1940.

John Carlis, Jr., also of Chicago, can lay claims to honors as an artist capable of combining the singular directness of a pictographic image with the atmosphere and soft, mellow charm of a Rembrandt portrait. His forte is the figure.

It would be possible to say much about the works of Bernard Goss, Henry Avery, Earl Walker, and Fred Hollingsworth. They are all united by a common bond of sympathy and aspiration, and nearly all of them are connected with the Chicago South Side Community Art Center, which was organized in 1941 by the WPA Federal Arts Projects for Illinois. This common interest brings them close together for exchange of criticism, for cooperation, and for joint exhibition. Such an arrangement has proved healthful for their work.

Negro art suffered another loss in the death in 1936 of Earle Richardson of New York City. Though trained at the National

Academy of Design, Richardson had his first opportunity to test and improve his talents through the WPA. He learned quickly to convey in his work the effect of gravity and power. As a designer he was uncanny. All his preparatory mural cartoons show an easy monumentality of design and breadth of organization seldom equaled in the work of other Negro painters. The early promise of his cartoon studies of Negro sharecroppers and of the fall of Crispus Attucks on Boston Common was prevented by death from reaching fulfillment.

Other Negro artists deserving attention are the veteran painter Frank J. Dillon, who also has designed and executed stained glass windows; Theresa Staats of Bordentown Manual and Industrial School, Bordentown, New Jersey; Allan Rohan Crite, a versatile craftsman who lately has turned to the illustration of Negro spirituals in the pictorial terms of the Italian Primitives; Joseph and Beauford Delaney of New York City; John W. Gore, of Pittsburgh, and Edward L. Loper of Wilmington, Delaware. Most of these painters can thank a reformed pedagogy in art in the eastern United States and in the Northwest for the soundness of their training and the vital character of their performances.

The future of the Negro painter is promising. No longer does he find himself handicapped by poor facilities for study. Moreover, the public attitude toward the Negro painter is changing rapidly from indifference to active encouragement. Comparative advantages for Negro students are now offered by both white and Negro-controlled schools. The Department of Art of Howard University, under the direction of Prof. James V. Herring, is an outstanding instance on the collegiate level.[10]

The opportunities afforded Negro painters and sculptors so far through the WPA Federal Arts Projects raise the hope that equal opportunities will soon appear through private and commercial patronage and that the prejudice and mistrust that have restricted the Negro artist and warped his milieu will be abolished.

# CHAPTER VIII

---

# The New Sculpture

RECENT NEGRO SCULPTURE, like Negro painting, is not completely racial; indeed, it is difficult to see how anyone could expect it to be. American Negro life is not antithetical to American national life as a whole. The Negro way of life is permeated with American manners, and the Negro mind is responsive to American ideals. Whether or not the Negro realizes these ideals, he is first and always an American, whatever his cultural past in Africa may have been.

We have already cited some of the social and aesthetic problems confronting the artist. Since the late 1930s these problems have been set in a cultural context that is now part of the Negro's heritage, and this has put the "tremendous civilizing values of Negro art" to a severe test. The almost general exclusion of Negro artists from exhibitions sponsored by whites has prevented a wide public understanding and appreciation of Negro art. The public usually does not see the work of the Negro

placed against that of the white man. Therefore, if there are really important differences between American Negro art and American white art, such differences can be determined only with some difficulty. Critics have stumbled under the preconception that the Negro formally would produce a simple, peasant art, rude, inarticulate, and commensurate with the Negro's social position and degree of "civilization."[1]

It is difficult to reconcile this presumption—wholly unscientific —with the responsible and progressive cultural position held by some Negro artists today, or with the sound educational efforts being made by Negro schools in behalf of a wider appreciation of art.

Sculpture is a *métier* most taxing on both the imagination and skill of the artist. Here subject matter properly seems of less importance than the artistic result. The correct procedure for the sculptor is to adapt subject matter to the material, not the reverse—to "remove the excess material." The lesson all sculptors should learn is the one taught in the great though anonymous African Negro woodcarvings and cast brasses, not the falsehood passed on by the academic naturalism of the Nineteenth Century.

The values of true sculpture, in any nationality, easily may rise superior to the vagaries of popular art. Sculpture is on the level of popular art when it is merely whimsical, humorous, or descriptive. But when it touches upon human pathos, religious emotion, philosophical meaning, or the nobler human feelings, it is nearer the great sculpture of all times. And such states of mind are familiar to most of the Negro sculptors with whom we deal here. Without exception they have known poverty, physical toil, prejudice, the sting of indifference, even hatred, and the thirst for success.

From a rapid survey of their work it appears that the more fundamental problems of sculpture have attracted these Negro artists. Concessions to popular demands, to academic tradition, or to the aesthetic nostrums of a clique have been slight. The

Negro sculptor, neither academic nor extremely radical, has held firm to his feeling for the object and the suitability of it to the material. If the Negro sculptor is to be described in any set terms it must be as a "normalist," since he has kept a conscious balance between feeling and nature.

Richmond Barthé was introduced as a sculptor without previous announcement to a gathering at the Chicago Women's City Club in 1927, and since that time he has persisted in serious, sensitive, and significant production. Though he has maintained a special interest in race themes and race portraiture, the genre has never become an obsession with him. In his early studies Barthé showed some grasp of plastic feeling, as revealed particularly in the plasters entitled "Head of a Tortured Negro," "Mask of a Boy," and "West Indian Girl." His related studies of figure motifs, such as "The Breakaway," a piquant sketch of a cabaret dancer, and "The Blackberry Woman," are proof of a deft hand and a memory that retains the essential elements of a given action. Barthé's handling of nude Negro physique proclaims his gift for natural plastic feeling. He allows the typical slenderness of the Negro body to become subtly elongated, but without distortion. This device is plausible but not unique. The German sculptor, Georg Kolbe, has used such emphasis in his representations of male Negro subjects, as, for example, the bronze "Somali Negro" of the Dresden Museum. The same thing is found in the "Ancestor" carvings of certain African tribes.

The theatre has great attraction for Barthé. Up to the present he has discovered most of his themes there, beginning with such literal character studies as "The Comedian." The series includes portrait busts of Phillips Holmes, John Gielgud, Katherine Cornell, and ranges through such interpretations as "Chorale," posed by Harold Kreutzberg; concluding with a large frieze recently completed on a theme from *The Green Pastures* and intended for an exterior wall of the Harlem River Project, in

New York City. On this project Barthé has collaborated with two white sculptors, Heinz Warneke and Frederick Barbarossa. This long frieze is entirely architectonic; it yields almost nothing to realism or the representational. Its figures, extremely uniform, are arranged in staggered groups. In such a formalized composition, constrained by the surrounding architectural field, race idiom necessarily has been sacrificed to the more universally human traits. In as controlled a way as possible, the sculptor has wished to suggest the emotional crisis experienced by the black "Hebrew Children" when they are told that their journey to the Promised Land is near its end. Their attitudes are variously grave, weary, skeptical, despondent, and resigned.

In a few pieces of small statuary Barthé proves himself one of the most sensitive modelers of all American sculptors. Neither technical flaw nor artistic failing mars the three small bronzes "The Harmonica Player," "Shoe Shine Boy," and "The Boxer" (now at the Metropolitan Museum of Art). These are so close to perfection of statement that their effect on the spectator is transporting. Never elsewhere has the sculptor better suited means to mood or pose to action. These works suggest both grace and strength, while they portray as much the fine tension of the artist's spirit as the infinitely subtle and gradual modulations of the supple contours of the forms.

This same transcendent spirit is found in the sculpture of Sargent Johnson. However, his work leans more to the decorative side, and his talent is more precisely that of a ceramic artist. The greater part of his production has been in glazed terra cotta or porcelain. Ingenuousness is the dominant factor in his portraits and figure studies, a characteristic agreeable with but not inherent in Negro personality. Frequently, this simplicity and cherubic innocence of expression is found in his studies of children. It is very apparent in the heads of "Chester" and "Sammy" and, of course, in the more typical "Pearl." Perhaps nothing more diverting can be found in all Negro art than these

completely self-forgetful studies of Johnson. In the "Pearl" he seems to catch the essence of infancy, its plump beauty and helpless, expectant expression.

Hope and ambition are never deadened by poverty, and poverty was life's second gift to Augusta Savage; talent was its first. On these she has built an admirably useful career as sculptor, teacher, and organizer. In all three fields her work is of remarkable interest, but here we are concerned only with her sculpture.

Because Miss Savage has been so unsparing of her time and strength in the cause of art education, she has lost valuable hours that otherwise would have been devoted to her own creative efforts. Her rich experience and keen observation at times have become crystallized in detached and sophisticated judgments, more of a credit to her disinterestedness as an instructor than to her powers as a creative artist. From 1929 to 1932 there occurred a leveling off in her production. This was the result of the influence of studies abroad when she set aside her own convictions to learn technics and to carve subjects that communicate a certain *joie de vivre*—but which also happen to be trivial. Not until she returned from Europe did she recapture the moods in which she created "Gamin" and the remarkable head of W. E. B. DuBois, now in the 135th Street New York Public Library—two productions that are truly masterful. Despite her versatility in other crafts, Miss Savage's forte is serious sculpture. Examples are her "The Abstract Madonna," exhibited at the Annual Exhibition of Women Painters and Sculptors of America; "Realization," a composition still in clay, involving two large figures; followed by her commissioned design for an appropriate sculptural interpretation of American Negro music for the New York World's Fair.[2] "Realization" symbolizes the pained bewilderment of the persecuted Negro peon whom despair has bereft of all consolation. Another large group of mother and

child sustains this brooding and profound mood of Miss Savage's work.

A sculptor of firmer concentration and more fluent temperament is Elizabeth Prophet, artist-in-residence at Atlanta University. Since her student days at the Rhode Island School of Design, Miss Prophet has attracted much interest by her stark, aggressive portraits in wood. Without exception her subjects have been Negroes, and usually they reflect the super-personal trait of the individual. The pride of race that this sculptor feels resolves itself into an intimation of noble conflict marking the features of each carved head. Especially is this true of "Congolaise," a wood-carved head purchased for the Whitney Museum of American Art. A variation appears in "Head of a Negro," which has been reproduced many times in various periodicals and catalogues. These pieces are typical of Miss Prophet's terse style, founded on a happy union of elemental mood and massive forms.[3]

Two young modelers whose recent performances encourage us to expect future contributions of importance from them are William Artis of New York City and Clarence Lawson of Chicago. They are alike in that both have sought stimulating contact with the people, and both have sought to convey in their modeling a sense of the divine in human character whether the features were those of a Negro newsboy or a Negro waitress.

Lawson has been particularly successful with heads of Negro women. Indeed, there is a slight affinity between his conception of such portraiture and that of Charles Despiau, the French modeler of exquisitely philosophical portrait busts. Of course Lawson's work is less mature and certainly less finished in form and surface than Despiau's. Nevertheless, the same nuance of feeling is present. Lawson, too, knows how to simulate a general motility of effect in his portraits; that is, he manages to convey a sense of posture in such a way as to suggest the habitual gait of the subject, or a manner of affecting poise or an air of self-sufficiency. The "heaviness" of Lawson's work is perhaps ex-

plained by his youth and extreme eagerness. He has great depths of emotion and it is possible that he will march to the foremost rank of American sculptors.[4] If he can achieve this through direct racial portraiture, his triumph will be almost unique among Negro artists.

Spirituality, temperament, the fleeting but revealing thought that molds a face, are sometimes the artist's only reason for painting a portrait or carving a head; and if such problems preoccupy him, his work at least will be sincere—not formally vacant or excessively erudite. This may be the best approach to the modeling of William E. Artis, for deft as his hand admittedly is, technic alone could never account for the sympathetic humor and shrewd observation of the tender lyricism in his heads of children. His portraits are based on the sure designer's instinct that lives in every good ceramist. Otherwise it is impossible to explain those abstractedly sensate masses, ovals, and irregular concavities, and key-shaped forms that coalesce in his work into the expression of the features and the characteristic modulations of the head.

Less sophisticated than Sargent Johnson, Artis leans more decidedly toward naturalism—an influence, possibly, of his first teacher, Augusta Savage. But this makes his art no less appealing; in fact, his results gain thereby in structural sense, variety of textures, and meaning. And for this we may be grateful, remembering that the tendency to design often carries the power to depose nature. One lack in Artis' work, however, cannot escape us: the marked limitation of his point of view. The artist can readily remedy this by producing a variety of subjects, perhaps by looking to active moments of human experience for his material. But even if Artis should fail to enlarge the scope of his art, he will nevertheless hold a significant place as one of our most sensitive modelers, thanks to the memorable quality of his children's portraits.

Several advocates of better race relations in America have

said that with the understanding and appreciation of each other's achievements, aims, history, and the philosophy of a common life, the white man and the black man could work together harmoniously and share equitably the fruits of their labor. A symbol of this aspiration is found in the monument to Leonidas Merritt, discoverer of the iron range of the Mesabi Hills in Minnesota. This monument was created by Robert Crump of Minnesota. He is the second Negro artist to receive a commission to make a public monument commemorating the services or deeds of a white man.* While public statuary commemorating the achievements of Negroes has been executed by white sculptors, rarely has the reverse been true.

Crump was born in York, North Dakota, and was educated in Iowa and Minnesota. In the latter state he took art training under the auspices of the Federal Arts Projects. His first adult creations were in oil. Later he began to study clay-modeling, and in a short time he completed an assortment of figurines inspired by *The Canterbury Tales*. This, his first major undertaking, was so favorably regarded that the work was reproduced several times and distributed among the public schools of St. Paul.

The ten-foot high statue of the powerful Leonidas Merritt, one of the "seven iron men" of whom Paul de Kruif writes so entertainingly, shows the rapidity and thoroughness with which Crump learned the fundamentals of sculpture. The work looms on Iron Mountain in Minnesota as a symbol of white confidence in black ability.[5]

Of all the younger Negro sculptors there is only one whose work unites passion and massive strength. Henry Bannarn, one of the least egotistical of artists, is one of the few Negro sculptors whose mastery of the material entitles them to take liberties with it. Bannarn's finest work appeals to the most discriminating

* Richmond Barthé's relief medallion portrait of Arthur Brisbane, newspaper editor and columnist, on Fifth Avenue, New York City, was, I believe, the first such public commission.

taste in the art world; and whether it be such a lowly theme as "The Scrubwoman" or such an epic theme as the "Head of John Brown," the boundless strength of the primitive wells up in the work.

Bannarn's manner of composing gives to his strident forms the sensitive mood of an intelligent and reflective being, so that he confronts us with the extraordinary union of animal strength and intellectual beauty. Whatever crudity there is in his forms strikes one (except when they are obviously inept) as a logical concomitant of the entire conception. This is notable in "The Head of John Brown." Here the artist has considerable textural variety; the beard has been scored and gouged until it assumes a texture appropriately contrasting with the smooth design of the face. The scraggly wildness of the beard has been tempered by the suppression of the abundant hair that crowned the head of the subject. In this piece Bannarn more than justifies his right to be daringly original.

In the same vein of monumental and lofty production is the work of Alice Elizabeth Catlett, one of the brilliant graduates of the Department of Art of Howard University. She won the first prize for sculpture at the Negro Exposition in Chicago in 1940, with "Mother and Child," a marble produced when she was a graduate student at the University of Iowa. The simple, rotund massiveness of the work exemplifies good taste and soberly thoughtful execution. It avoids those pitfalls of sentimentality and over-elaboration into which have fallen so many academic bores who pumice the marble until it resembles a pin cushion more than a work of art. The negroid quality in "Mother and Child" is undeniable, and the work has poise and a profound structure. It is a pity that this young woman has had so few opportunities to continue her work in stone.

Hardly less talented than Bannarn and Catlett are Joseph Kersey of Chicago and Selma Burke, an instructor in sculpture at the Harlem Art Center. Kersey is especially noteworthy

because of his long career as a professionally exhibiting artist and his enviable record as art teacher at the University of Chicago Settlement House, Hull House, and the South Side Settlement, Chicago. As an interpreter of racial subjects, Kersey exercises the forebearance and good taste one would expect of an artist who in temperament and approach to sculpture recalls Luca della Robbia of the Renascence. In his diversification of surface through the use of polychromy and lining and flecking, Kersey is interesting; and, indeed, in this respect he may be included among the more versatile of North American ceramists.

Selma Burke has devoted most of her time to teaching sculpture. Thoroughly trained at home and abroad, she is a clever draftsman and has learned much from sketching animal forms in clay. The skill thus acquired has served her well in evoking the images of her subjects in stone and keeping the outline fresh until realized. There is an idealistic intent in her sculpture, a quality readily seen in such works as "Lafayette" and "Salome," which were exhibited at the McMillen Galleries in New York City in November, 1941.

The youngest but not the least accomplished of the Negro sculptors is Zell Ingram of Cleveland. Born in Carrothersville, Ohio, he came to Cleveland at the age of ten and soon after became a member of Karamu House. He first showed interest in puppet-making and manipulation and in time became a fine puppeteer. He broadened his knowledge of the theatre through his studies at Karamu House and learned to design and build stage sets, and even took part in several plays. In late adolescence he developed his talent for modeling and went to New York City to study under Richard Davis. He also studied for a short time at the Art Students League of New York.

Ingram's growth as a sculptor was slow. He still has only few pieces of work to his credit. But this fact is a poor standard by which to judge his abilities, for from the beginning his modeling and wood carving have shown a self-conscious perfection of

which only the mature artist is capable. He is intrigued with the inherent beauty of the human figure, and strives to develop its underlying geometric principle to the limits of abstraction. His exceptions to this approach and to the essentially formal solution of plastic problems are few. We may term this predilection either formalistic or primitivistic since the results usually are the same. Brancusi, influenced by African Negro sculpture, is regarded by some critics as an emulation of the primitive artist. But the process by which Brancusi arrived at the marvelous simplicity and concrete geometry of his sculptures is purely intellectual and self-critical. So it is that Ingram by progressive drastic revisions of his forms brings them at last to a unity in which meaning and object are one.

The process we have described is, of course, the normal procedure of the good sculptor. He perceives and strives to realize simple, primitive images—forms in their symbolic essence. The sculptor who does not see his work in this way is liable to err on the side of naturalism or to mistake literalism of text for poetic appeal. In Ingram we have a Negro sculptor who through natural inclination conceives and executes in the more refined terms of his medium, and is uncompromising in his effort to discipline the subjective element in his art. His work is clearly in the modern trend of American sculpture, and it is to be hoped that he will be able to resume his creative career, following his army service, with the same subtle intelligence, artistic integrity, and emotional control that up to now have distinguished his productions.

# CHAPTER IX

---

# Naïve and Popular Painting
# and Sculpture

WHERE IS THE PERSON who has not known some "natural" or untrained artist? Perhaps he is an acquaintance in some rural community, making a living in a simple occupation, but on occasion indulging a little-understood desire to render the forms he sees in the world around him. There is such an "eccentric" in every town, and the cities know them by the dozens; but not all, of course, are of equal talent and courage. We cannot attempt to explain the gift of these remarkable men and women; we only know that their work at its best seems to unveil reality before our eyes. The bewitching prose-poetry of their art throbs with the unsophisticated wisdom of the folk who, as Richard Wagner said, "alone create art."

These untutored works of painting and sculpture interpret nature with a childlike innocence of vision. They so far transform even the simple facts of nature that the artistic genius of the truly naïve is tantamount to a vision of the object that he

re-creates. The naïve artist sees the world intuitively; from a physical point of view, his intuition effects instinctively a truncation of the visual field in a simplified precision, definition, and refinement of spatial relations. In short, under his hand the creations of both nature and man take on eternal form and ideal qualities.

But whether its source is memory or observation, the pictorial fantasy of the unsophisticated artist is microscopic. Popular art is an art of detail—even of narration—since it usually brings into a single field a diversity of materials that appeal first to the sentiments and then to the compositional instinct of the artist.

There are several Negro artists in this category. Their work is completely ingenuous but stable. That curious flatness and deceptive suggestion of haphazardness mark their productions as strongly as they do the work of the artists who created that marvelous tradition in American art known as its "primitive" phase. Their art is that of the common people, not simply because they themselves belong to the masses, but also because their ideas typify the form-world of a social group not used to aesthetic contemplation. We must pass over the early Negro painters and modelers of this century; there exist brief biographical sketches of John Spencer Jackson, Lottie Wilson Moss, B. E. Fontaine, Aedina White, and others among these "natural" artists. Their successors, the living popular artists, may occupy our attention here.

There is no necessary racial strain in naïveté; the art of the naïve is essentially the product of a mental process that views the world in terms of a certain type of symbolism.[1] What this symbolism is, no one can say precisely. We know only that it apparently reduces to types, that is, to types in the simile of the artifact, but never quite so simple in form or function. In painting the bison or in making a weapon, the stone-age man adjusted the form or appearance of the object as well as he could to his conception of its function with regard to his own

needs and interests. His philosophy of life was expressed equally in the cave mural and in the hunting weapon. Similarly, the modern naïve intelligence appraises both animate and inanimate forms and places them boldly within or against a unifying framework of values. The resultant forms are ideational, patterned symbols, or forms wholly satisfying to our sense of abstract design if not to spatial reality. In this respect the painting of Everett Johnson is naïve. However, it is a type of painting that rises above the "instinctual" level, since the artist has sought his subject matter in "real" experience. In his picture the "Eagle" Johnson simply has striven to express *his* vision of an eagle (its form adapted from a wooden image) rising from a sunlit sea. The elements are represented in a half-symbolic way; the painter has created his own conventions meaning *sea* and *eagle*. He is not under the compulsion of the realist painter, or of the expressionist who consciously distorts forms. The paradox of such painting is that its creators usually believe they are uncompromisingly objective and factual. This attitude of Johnson's reminds us of such works as Jan van Eyck's "Adoration of the Lamb" where the juxtaposition of related but non-coincidental happenings is bound up with a simple, episodic, and non-atmospheric scheme of representation.

It may be even more suggestive to compare this Johnson painting with one of D. P. Peyronnet's marines. The latter's "The Open Sea,"[2] for example betrays the same laborious but effective interest in texture. Both have interpreted the sea as a mass of corrugated crevices, fantastically controlled by a gentle undulant rhythm. The pink clouds in the sky are likewise original and completely devoid of the nuances of mood or season in which sophisticated landscape painters often take delight. The absence of such subtleties, indeed, may be the reason why the two paintings evoke such true aesthetic response.

In sculpture the naïve artist is sometimes limited by an obdurate material, but the same general observations apply. An

example among American Negro "primitives" is the work of William Edmondson, a stonecutter, discovered in 1937 by a friend of the Museum of Modern Art and exhibited in that museum later the same year. The work, wrought in rude blocks of roughly carved stone, effects a synthesis from the association of a few salient facts that are merely the unrefined symbols of an extremely naïve idea. The meaning of "The Preacher," for example, depends on the drastically pure visual power of the artist. There are no concessions to sensuous knowledge, accepted beliefs, or the other trappings of the worldly-minded artist.

Edmondson himself regards his work as "revealed" in the sense of an apocalyptic vision. This is true at least of such of his scriptural subjects as the "Small Angel," "The Doves," "Mary and Martha," and certain designs for tombstones. The forms of his work are extremely personal and restricted, while its subjects are extra-personal and to a degree arbitrary. He says of his own art:

> I see these things in de sky. You cain't see 'em but I can see 'em.
> Mary and Martha, the preacher and that bird—no, that ain't no pigeon, that's a big old sea bird. All them things I saw in de sky—right up there jus' like you see them clouds.
> God give me this thing.[3]

Such ideas are of the utmost significance for the understanding of Edmondson's art. They explain the paucity of content and the relative concentration of feeling yielded by his several carvings. Like children's drawings they hardly disengage themselves from the conceptual limits of pictorial imaginings. They are stammerings of the imaginative intelligence; yet as the artist tells us, they are perfectly clear to him (in their richest and most satisfying associations), but unclear to us except as symbols of half-articulated meanings familiar to the race-mind.

The works of Horace Pippin are almost the painted analogues of these rustic figures by Edmondson. True, they are of superior

craftsmanship, but that may be owing to an important difference in inspiration. Many of Pippin's subjects are recollections of his experiences in the First World War. They are painted reminiscences, haltingly given. It is doubtful, however, that a great disparity exists between the intuitions of the one artist and the "reflections" of the other. Pictorial memory in its attempt at wholeness of integration may make use of intuition. Hence we are forced to believe that by academic standards the paintings of Pippin and the carvings of Edmondson fall short of the representational because of their technical inefficiency. Pippin assures us that only his first picture gave him any trouble in its realization. In succeeding works he has been able to set down his thoughts more adequately. "The Ending of the War, Starting Home" was his first. To a trained eye this picture does seem to be less fluent and spontaneous than "Shell Holes and Observation Balloon, Champagne Sector," a work that equals any surrealist masterpiece by Dali or De Chirico in its suggestion of topographical ruin, plastic space, and the sadness of a deserted world.

It is also significant that Pippin regards art as unteachable; that is, that the secret of one's art cannot be conveyed to a pupil.[4] This statement must be taken as revealing the untraditional and quasi-visionary way in which Pippin himself conceives his pictures. In order to teach an art, some basic technical and critical principles must be admitted. These are totally beyond the ken of a naïve artist who works on the self-sufficient grounds professed by Pippin. In the first place, he is self-taught; in the second, his subjects are often taken from memories removed from the present. His point of view, therefore, is an exclusive one; yet a glance will show that his work is not wholly independent of the teachable principles of color perspective, abstract balance within a rectangle, or simple geometrical arrangements in space. Still, it is not to be expected that he should understand the theory underlying these effects; if he did,

it is unlikely that he would work any longer in an unsophisticated manner.

The term "popular art" probably cannot suffice to characterize the painters and sculptors we shall discuss next. That term has been associated too long with the art produced and accepted by the masses (notably by the peasant class in many countries), which art through rapid adaptation and diffusion has become synonymous with the "folk." We are on surer ground when we define popular art to mean the kind that is produced largely by self-taught craftsmen and which in theme and development is on the level of good folk art. In this way we can account more easily for the superior work of those "naïves" who have been "discovered" and encouraged by sympathetic laymen.

A clear instance is found in the work of John T. Hailstalk, a First World War veteran and now a laundry-owner in Harlem. This painter has been setting down his impressions of both suburban and rural landscape. His results are astonishingly simple isometric schemes conforming in every way to the tradition of popular art. To show the range and character of Hailstalk's paintings, we need only refer to the well-known productions of the Americans, Hicks, Pickett, and John Kane or to the more self-conscious and more skillful "popular masters" of today, such as the French Louis Vivin and André Bauchant. On the surface it may appear that Hailstalk is devoid of any sense of accurate sensuous objectivity. His subjects represent the research of a purely documentary mind, itemizing with beautifully naïve candor the facts of a given local scene.

Hailstalk, nevertheless, often shows amazing accuracy of vision with regard to the forms of human and animal figures that he relates, not atmospherically but through flat decorative schemata, to the "fundamental setting." Sometimes he carries this plotting of figures and spaces a little too far, as in a recent study of a typical American real estate subdivision. But we cannot quarrel with the delightfully fanciful and even humorous

portrait that he has given us of a farm. The firm, clean-cut impression of this small painting owes much to the geometrical orderliness imposed upon the yards and alleys of eastern American farms.

Hailstalk has individuality. It is this quality that lifts his work above the level of much American folk art, such as that found on the smoke-stained walls of cheap cafés, painted by some anonymous amateur who might have been avid to do landscapes in the grand manner. Hailstalk's painting betokens well-organized and truthful observation. It embodies part of the visual record of a mind that has a common knowledge which it uses with confidence and science. The structural veracity of the houses in his paintings proves this. Their forms are both typical and pleasing.

Even among the popular painters there are virtuosi. Sometimes it is youthful enthusiasm, a spirit of adventure that imparts a driving force to the artist who brooks no obstacle. Jacob Lawrence is a very young artist and a promising one. He is gifted with an unfettered imagination that loves to release itself through the laconic force of abstract symbols. Only since 1940 has attention been drawn to his painting. His teachers long ago agreed that he was an "original" and was not to be cramped with formal exercises in drawing and painting. Subsequently, the critics have confirmed this view and admitted that he has a pronounced talent for abstract design, coupled with a rare sense of humor.

Lawrence works principally in tempera, a medium adapted to the two-dimensional patterns in which he sees his subjects. So neatly and circumspectly does he use this medium that it takes on the firmness and brilliance of surface that one would look for in a Persian tile or an Italian fresco. He makes little use of perspective, but composes his pictures—more like children's illustrations than conventional adult paintings—in graded levels or bands painted one above the other.

While Lawrence's forms have great simplicity of outline, his figures, according to anatomical pronouncement, would be dubbed "amorphous," so that with his super-posed levels of compositional space (redolent of the realistic, multiple-action stage setting) they heighten the general effect of informality and arbitrariness. There is no painting by Lawrence in which the form is completely unrecognizable; he may give us only the bare essentials for recognition of the object, but its identity is nevertheless easily established.

Freshness of vision is the most charming quality in this artist's work. He sees the world anew for us. He has retained, from his age of innocence, that wholesomeness of comment that marks the effort of an unspoiled artist. When we turn to his long series of not less than forty plates in sparkling tempera, illustrating the exploits of Toussaint L'Ouverture, we are struck with the fact that so simple a technic can mobilize such power of color and movement. His art is founded on reality. It includes the vivid moments of actual experience as well as those vicariously gleaned through reading. The publication by *Fortune Magazine* of his "Negro Migration" and the joint purchase of this series by the Museum of Modern Art and the Phillips Memorial Gallery indicate a growing national recognition of his work.

It would seem scarcely possible that popular art could move further in the direction of synthesis without becoming sophisticated, if we had not the work of Leslie G. Bolling and Thurmond Townsend. Bolling is a wood-carver of long experience, while Townsend has but recently begun to model in clay. Bolling began in 1928, using the shed in the yard of his home as a studio for spare time use. His earlier carvings were, of course, rather crude specimens of self-guided effort. The subjects were in nearly all cases stoutish female nudes for which the artist employed no models. He made it a habit, however, to observe the forms of women whom he saw in the streets, and this practice gave an increasing skillfulness to his hand and keenness

to his eye. "Salome" is one of the most interesting examples of this period, but his high peak of accomplishment in this course is such studies as "Half-Moon" and "The Dancer"—works that carry the whittler to the place where his jackknife gratifies every wish.

Bolling's studies of Negro laundresses are now famous. He has named them appropriately "Sister Monday" and "Sister Tuesday." They fit perfectly into the genre of popular art. They are not interpretations or free-readings in the sense of caricature. They are purely descriptive and hence unprepossessing. Like the rambling canvases of Hailstalk, they are concerned only with the typical aspects of their subjects, and this fact explains their internal consistency. In such respect they are in a direct line with the naïve revelations of Edmondson; featureless simplicity enhancing their power to typify. Furthermore, the seriousness of Bolling's work inheres in this character, for otherwise its commonplace content would degrade it to the lowest level of folk art where excessive naturalism of form destroys all meaningful expression. Much imported peasant art is on that level.

Townsend's work also is on the plane of a popular art enlarged in value by an experienced and controlled technic. He too is self-taught, but occasionally makes use of the model. This is important in that both he and Bolling strive to make their work resemble the subject. But we cannot call Townsend's subjects trivial (as Bolling's often are) for nearly all are bust portraits of living persons. Townsend's characteristic lies in understatement; he portrays the features of a face in inverse ratio to their actual importance. To the inflexible eye such understatement means artistic ineptitude, but we must take into account the self-containedness of the work, its unity of effect, and its evident plastic integration. So while Townsend's portraits fall short of convincing likeness, they gain in formal interest.

Bolling and Townsend have had their work shown and compared with that of more sophisticated artists. They are hard

workers and devote all the time possible to the improvement of technic. Townsend still divides his time between his duties as cook in a restaurant and clay modeling. Bolling has given some time to the teaching of jackknife carving. Both have won the recognition of responsible art officials in Richmond and Dallas. Should these artists continue to improve their respective technics and to enlarge their repertories, they doubtless would move from the ranks of the naïve popular artist to those of the sophisticate. There are many who will regret this change, should it occur, for among the self-conscious practitioners are too many who use brush and chisel in grave and ponderous—and sometimes stultifying—ways. But we may hope that this precious naïveté which is the greatest gift of the artist may always remain with them and direct their vision to purity and strength. In American art the tradition of naïve intuition has been responsible for many excellent achievements. It is inspiring to note that there are Negro artists whose natural gifts privilege them to further this tradition.

# CHAPTER X

# Progress in the Graphic Arts

THE POPULARITY of wood-engraving and lithography in Nineteenth Century Europe came partly as a response to the demand for inexpensive transcriptions of masterpieces of painting at a time when duplicate printing was becoming general. The precision of form and tone afforded by these processes compensated for the scarcity of color facsimile prints.[1] The same explanation accounts for most of the American work on wood, stone, and metal plate prior to the introduction of the power printing press. In this pre-mechanical age the craftsman was subjected to the drudgery of reproductive engraving. A reaction came, however, in the renascence of hand-made and hand-printed engraving that did not copy but was in itself an original work of art. The artist then merely chose a medium familiar to the public in which to express his creative ideas—ideas that formerly, through commercial engraving, he had restricted to the less popular media of painting and sculpture.[2]

This is a general statement as to the progress of the graphic arts in Nineteenth Century America, though it ignores the good lithographic stone work of Currier and Ives and other firms using color lithography. However, our comment is accurate as far as it refers to Negro artists of the second half of the Nineteenth Century and the first decade of this century—no Negro artist attempted an etching, engraving, lithograph, or block-print until after the First World War. And it is true that the contemporary Negro print-maker had not heard of Patrick Reason or Robert Douglass, Jr., until the reproduction of their work in the 1930s.

Today, however, there are many Negro print-makers, some of whom are excellent illustrators of books and magazines. Curiously enough, some of these print-makers "discovered" for themselves, one may say, the various branches of the graphic arts through periodical literature. In such publications as *The Crisis, Opportunity, The Messenger,* and *The Brownies Book,* and a few occasional periodicals published by Negroes, there formerly appeared the pen and ink drawings of John Henry Adams, Laura Wheeler Waring, Hilda Wilkerson (Mrs. Schley Brown), Marcellus Hawkins, and others. Their work usually was in tempera or in pen and ink. It belonged to the era just preceding that of the de-commercialization of the Negro illustrator and which virtually supplanted him by photography and stereotyped-page decorations.

Yet, it was because of the popularity of the pen and ink drawing that the artists in the late 1920s were prepared to try the related technics of etching and wood-block engraving. This transition period from mechanically reproduced line drawings to the etched or engraved plate and hand-cut wood blocks occurred between 1922 and 1928, and is characterized by the decline of the florid technics of pen and ink and tempera, and the rise of illustrator's copy from etched plates or the wood-block imprint. But there was no corresponding improvement in

the illustrator's remuneration, since Negro periodicals generally paid nothing for the artist's work. Often the artist, after executing an entire series of plates, would be left with them on his hands, having no dealer, periodical or clientele through which to dispose of them.

Through the resourcefulness of the late Arthur Schomburg, a Negro collector of books and prints, the etchings of Albert Smith (1896-1940) and W. E. Braxton (1878-1932) found a public in the branches of the Negro collection bearing Schomburg's name in the 135th Street New York Public Library. Now one finds in this collection etched portraits of famous Negroes done by Smith to the order of his patron. But such interest in the work of the Negro print-maker was rare in the 1920s.

This misfortune by no means afflicted Negro artists alone, for in the late 1920s and during the depression white artists saw the price of fine prints decline rapidly and constantly.[3] Yet the Negro artist should not have lost all support, as the Negro print-maker was the heir of that tradition of close association with the Negro press which we may term "race illustration." From 1910 to 1920 Negro illustrators were tied in more closely than they are today with the interests of the race. They had a public, and were able to indoctrinate through the cartoon and the illustrated text. The emphasis of the Negro editor, of course, was on the text, but the Negro artist could gain converts through the appeal of line and tone.

Smith and Braxton were among the first Negro draftsmen to make use of the etching press. Smith was perhaps the first Negro in America to make an etching. He studied the medium with William Auerbach-Levy, a master of portrait-etching, and he twice won prizes in American exhibitions.[4]

The content of Smith's etched compositions shows him to have been struck with the humorous minstrelsy that many writers and artists have emphasized as typical of Negro peasant life. This etcher was a musician, and while living in Europe

partly supported himself by singing in cabarets and at parlor socials. Hence, his *fantasia* on the good-natured vagabondage and fish-fry high-jinks of the story-book Negro peasant is understandable.

Apart from the slightly heavy quality of his work, Smith shows a true feeling for beauty in the etched line and such vaporous play of light and shadow as only a modern etching can achieve. Critics may complain that his figure drawing too often sacrifices clarity of meaning to atmosphere, and truthfulness of action to grotesque humor, but the intense subjectivity of his work gives it a place in American etching.

Schomburg also bestowed favor on the work of Braxton, who began to produce etchings shortly after Smith had exhibited his first *fantasia*. He also was prevailed upon to transcribe into another medium the portraits of famous Negroes, among them Alexander Dumas, *père*, Toussaint L'Ouverture, Booker T. Washington, and Frederick Douglass. For those who most appreciate the work of the Negro etcher, however, these potboilers will be superseded by those paintings and etchings that have their source in Braxton's own impressions of human personality, society, and nature.

Braxton may be called the first expressionist among Negro etchers. His work is altogether spontaneous and inspirational in a direct, communicative way; to those who knew him his style must seem a perfect reflection of his impetuous temperament. One must not expect to find in his work precise drawing and meticulously compartmentalized tone. The artist's unreflected impressions and emotions are found in the muscular interplay of lines and masses uncompromisingly bitten into the plate. The effect of his drawing is kinetic.

Negro etching has not followed a steady course; neither has its subject matter. This is shown by the work of Allan Freelon, whose paintings we have discussed earlier. Freelon, possibly the most versatile of this little group of etchers, has worked

in several branches of the art. He has produced dry-points, soft-ground etchings, and aquatints. Throughout this range he has preserved a uniform quality of expression. The tonal atmosphere of his prints is low-keyed in most of his production, but the variety of tints that he achieves is delightful to one who knows and loves etching. The difference in the technical approach and effect of his etchings and his paintings offers an interesting study in aesthetic values and in the psychology of the artist as well.

Successful etchings also have been made by William Mc-Knight Farrow of Chicago, an employee of the Art Institute. While on the whole his prints have only a small aesthetic import, he has produced two prize-winning etchings. In 1928 he won the Eames MacVeagh Prize for etching at the Chicago Art League, and in 1929 he took the Charles P. Paterson Prize. His work has been shown in one of the large print exhibitions held by the Graphic Arts Division of the New York Public Library, and also in the International Prints Exhibition, usually held at the Chicago Art Institute.

Since about 1937 there has been less production by the important Negro etchers. The one instance of a promising attack on the problem of social description and interpretation is that of a group of Karamu House artists. Charles Sallee, the leader of this group, tries to place the Negro subject in characteristic relation to the typical urban life of a northern city. Probably he was influenced in his approach by the emphasis placed on the American scene by the Index of American Design of the Work Projects Administration. Although Sallee expresses this attitude without conspicuous brilliance, his work contains ample proof of a shrewdly observant eye, a steady and selective hand, and a craftsmanship that has mastered every possible gradation of the cross-hatched tint. The current popular versions of Negro dancing have caught Sallee's eye, and he has given evidence of this interest in his "Jumping Jive" and "Boogie Woogie." Also he has committed eloquently to the plate other social

phenomena as in his striking compositions "Wrecking Crew," "Used Cars," and "Post-Setters."

Hughie Lee-Smith and Elmer Brown, other members of the Karamu House group, have not produced as much etching as has Sallee, but they have ability and promise and it is likely that Brown will reach again the soaring height of his fine "Wrestlers," that was included in the Karamu House exhibit at the Associated American Artists Galleries in January, 1942.

There stands an interesting coterie of wood-block engravers intermediate between this group of etchers and a young group of lithographers; and it is within that coterie that we may see one day the finest fruit of Negro work in the graphic arts. Wood-block engraving is an exacting medium and there are few masters of it among Negro artists, but those who have persisted have produced, in a dozen years, prints that stand comparison with the best.

The "dean" of Negro print-makers is James L. Wells. He took up the art of wood-block engraving as early as 1927. Prior to that he had been successful with linoleum cuts, a medium which only a few gifted artists have raised to the level of serious print-making. Excellent examples of his work have been given the titles "African Fetish," "African Fantasy," "The Sisters," "Vision of Ethiopia," and "Primitive Boy."

Wells is very successful in the use of white line to obtain effects of drawing or intaglio, as witness "Negro Farmer," an early example stamped from soft wood-block. He is equally at home with effects of three-dimensional modeling, employing contour lines against the shroud of dark masses of tone. No part of his work escapes the influence of a marvelously fluent compositional sense that is always obedient to the moderate temper of the artist. On seeing some of Wells's black and white prints in an exhibition at J. B. Neumann's Gallery in New York, the art critic F. E. Washburn Freund declared:

> ... Wells has the rhythmical feeling of his race that makes him create spontaneously in old Negro forms. His art therefore combines individual naïveté with the accumulated wisdom of old and ripe tradition.

Confirmation of this opinion is found in nearly every block-print this artist has made. From the piquant "Spies in Canaan" to "Tam o' Shanter" and the recent landscape pieces that recall the detailed landscape background of the "Tam o' Shanter," Wells has preserved his moderate fluent style and those overtones of poetic melancholy that distinguish his prints and paintings.

Hale Woodruff, Wilmer Jennings, and their satellites are interested in a different set of values, so that when we have examined their work we shall have canvassed the entire so-called "Atlanta School." Jennings is the only one of Woodruff's pupils who in black and white has retained his own personality while taking over the technical virtues of his master. But this comment is not derogatory to Woodruff's teaching; if there were more like him in Negro colleges and high schools, training in the appreciation and practice of art would advance faster.

We have already discussed Woodruff as a painter. The same thoroughness of method, power of design, and individuality of result are present in his numerous block-prints. One of the most prolific of Negro artists, he seems to have found the medium of the print especially congenial to his ideas and work habits. There are few masters of the block-print today who surpass him in the ability to produce novel effects of design involving both figure and architecture. Of course, we cannot overlook the fact that in building his system of crucially disposed forms he has relied heavily on his knowledge of French Cubism and its Expressionist extension; but the synthesis is Woodruff's own, and it is so distinctly personal that there is no possibility of confusing it with that of an artist of another school.

Woodruff's debt to Cubism can be seen in "Three Musicians," and to Expressionism in "By Parties Unknown," a pictorial

diatribe against lynchers. But in these pieces he is also genuinely himself, and they bespeak his final emancipation from those external styles on which other prints of the same series depend.

Jennings, Woodruff's brilliant pupil, is by all odds the most facile craftsman among all Negro wood-block engravers. He has made a deep study of the technics of both wood and steel-engraving, and therein reflects that healthy interest in technical research that today underlies the sound experimentation and even the personal styles of some good American artists. This trend must be distinguished from pedanticism which, if encouraged, would inevitably prove damaging. No worthy artist, of course, would wish simply to imitate the meticulous habits of the engraver-copyist. Jennings merely has sought to make his work more articulate of value and more satisfying in theme by reverting to some of the line-patterns invented by the old engravers for purposes of tinting. There is no segment of his engravings that has not been "textured," but the result is a unified effect and vigorous design. In short, there is hardly a wood-block print by this artist that is not full of sensible expression, and certainly none that is not soundly composed. Jennings' first important prints were produced from 1935 to 1938.

Again we turn to Karamu House for Negro print-making of outstanding quality. Here William E. Smith is one of the dominant personalities. The titles of his prints are like the titles of poems, and we may surmise that he has been influenced by the poetry of Langston Hughes.[5] And we are sure that Richard Wright's *Native Son* has loomed large in his consciousness of the social scene, since Smith has made a print of the same title.

By focusing attention on the possibility for portraiture in Negro life, Smith has learned to catch the characteristic pose or gesture in which the sad or contemplative, glad or bitter, mood of impoverished Negro youth finds expression. He has cut a long series of such subjects on linoleum blocks, and they are

delightfully free of that extravagance of technic which sometimes seduces the print-maker at the expense of his style.

A refreshing directness of perception marks the prints of Fred Carlo. In his use of the graver, burin, and knife, Carlo may not possess the urbane ease of Smith, but there is no 'doubt of his ability to reveal the pictorial essentials of his impressions and to transpose them effectively into the block-print. Indeed, all the Karamu House group have maintained a high consistency against mere technicalism in this art. They prefer to err on the side of naïveté than of technic. In a self-conscious artist of keen intellectual powers such as Zell Ingram, this reaction toward simultaneity of effect deserves special mention. These artists are able to control their medium without endangering that all-important quality of freshness which one expects of original art.

Relatively few Negro artists have attempted lithography, and none of them has consistently produced fine prints. The explanation of this scant effort probably is to be found in the greater expense as compared with other methods of print-making. To produce fine quality prints it is necessary to own or to have access to a lithographic press and a number of printing devices. Very few Negro artists have access to such properties.

To the writer's knowledge there are only three Negro print-makers who have sufficient command of lithography to be able to produce fine prints and to instruct others in the medium. They are James L. Wells, Hughie Lee-Smith, and Robert Blackburn. Of these, Wells alone has turned out prints that adequately suggest the varied tonal range of the lithographic stone. In his industrial scenes Wells prudently has adapted the lower registers of velvety gray tones to render the smoky atmosphere of the steel mill and the power plant, thus achieving interesting silhouette and compact massing to the benefit of pattern.

Whereas the industrial prints of Wells are "built up" tonally, those of Lee-Smith employ much white and light gray space, bounded by supple, wiry line and occasional patches of dark-

gray tone. Lee-Smith does not so much neglect as ignore the ambient on which the general effect of Wells's cubic masses depends. We see this clearly in "Artist's Life,"[6] an animated print in which texture is supplanted with the interweaving of contour lines of the forms. Lee-Smith takes huge delight in his expert ability as a draftsman, and for him line and form are the essence of the picture. Into this mold he pours all the exciting experience that his mind can call up—sometimes with startling results. His work, for all its hyper-realistic quality, is never pre-consecrated or dull.

The pencil and the grease crayon in drawing often yield effects similar to those produced through lithography. No apologies need be made for what several Negro artists offer in these media. Two exponents of these technics are Elmer Simms Campbell, a leading illustrator and caricaturist for *Esquire* magazine, and Henry (Ol') Harrington, who for several years has drawn an amusing feature entitled "Dark Laughter" in Negro newspapers.

Campbell is a nationally known illustrator. He is equally clever at the political and the humorous or satirical pictorial comment. His success as an illustrator-caricaturist for *Esquire* has been phenomenal. He moves from the media of pen and ink and pencil to water color with remarkable skill and ease. Without commenting on the quality of his wit, we may say that in spontaneity and vim his drawing often outruns it, for if his humor ever fails to make his point, his drawing never lacks verve. Campbell deserves special mention for his illustrations of Langston Hughes's *Popo and Fifina*, and for his excellent water-color sketches of Haitian street scenes which were published in *Esquire* following Campbell's brief sojourn in Haiti.[7]

Harrington has a lightness of touch and fluidity of line that remind one of Campbell's drawings in pen and ink. He does not make use of the same richly contrasting blacks and whites that give sparkle to Campbell's work, but his drawing shows an easy

certitude of line and richness of memory. He is a pictorial humorist and a test of his talent is his ability to impart to his conversational pieces a true-to-life feeling despite the exaggera- tion required by humor.

Another draftsman who merits comment is Charles White of Chicago. A master of the crayon, White gives his figures a large, sculptural roundness that seizes and holds the attention until the social message has been understood.

Purposely reserved until the last is the exceptional art of Dox Thrash of Philadelphia. Thrash was a member of the Graphic Art Sketch Club of Philadelphia where he had the opportunity to advance his studies under the guidance of Earl Hortor, a white artist well-known for his etchings. A long experience of art study and creative effort lay behind Thrash. His services in the First World War made it possible for him to obtain extensive training at the Chicago Art Institute where he had been a pupil of Seyffert and Poole. As a Government employee he was free to experiment with the various processes of graphic reproduction.

One day it occurred to Thrash that the fine dust of the carborundum stone might be utilized in the production of those soft, deep values that are lost to every medium but the copper-plate mezzotint. He saw the possibilities of this material as the basis for an art print. Through months of experimentation he developed what is now known as the "Carborundum print," through an entirely new graphic process that makes easier the use of combination plates in printing.[8] The carborundum print has a distinct quality of its own; its gamut of tone passes all the way from white to the deepest and most sonorous blacks. It suggests a dark magic of atmosphere, and this makes it especially suitable for those night effects and dramatic contrasts of black and white that Thrash uses.

His prints are among the best in this medium. They cover a wide range of subjects, portraits, landscapes, and some interest-

ing shadowy vignettes of Philadelphia slum areas. "My Neighbor," "Boats at Night," "Ridge Avenue," and "Deserted Cabin" are a few of the titles. In each work the slaty tones are managed well. It is indeed fortunate that Thrash is a fine artist since the medium requires expert draftsmanship.

Thus the sporadic efforts of the Negro artist in the graphic arts have borne extraordinary fruit at last in the remarkable work of Dox Thrash. The question "What Negro artist has risen above the level of the ignorant peasant?" can be answered decisively with the achievement of this single contributor to the artistic printing processes in America.

In this and other instances the Negro artist has shown his ability to improve the instruments of art as well as his capacity to make creative use of them. This resourcefulness and practical quality of the Negro artist undoubtedly stem from the same source of wisdom as his appreciation of the tremendous usefulness of the graphic arts. The Negro artist uses the etching needle, the graver's burin, and the lithographic stone as an electoral candidate would use the public address system to reach the masses of people directly and effectively. It is inconceivable that the art of any race should attain ageless perfection of form or richness of content without the nurturing ministrations of an appreciative audience. It is the writer's belief that through the less exclusive channels of drawing and the graphic arts, in short, through the inexpensive media of pictorial art, the Negro artist has begun the conquest of a hitherto reluctant public.

APPENDIX

NOTES

BIBLIOGRAPHY

JAMES A. PORTER CHRONOLOGY

SELECTED PORTER BIBLIOGRAPHY

INDEX

# APPENDIX: MEMORABILIA OF THE EARLY
# NEGRO ARTIST

*The following articles gleaned from early anti-slavery newspapers are mainly items of curious interest. The career of Robert Douglass, Jr., was so exceptional, however, that it has been deemed advisable to reprint these contemporary references to him. Moreover, it will not be easy for the general reader to avail himself of the rare periodicals from which these items were taken.*

### ROBERT DOUGLASS, JR.

### (1809-1887)

During our stay [in Philadelphia] we paid several visits to a young artist of color, whose talents at portrait painting are well worthy of commendation. His name is Robert Douglass, Jr. and his shop is in Arch Street, near the Delaware. He has painted several likenesses which are said to be striking. Two of them we know to be so. Mr. Douglass is a disciple of Sully from whom, although having but very few advantages, he has received the highest commendations. (The editor), in *The Emancipator* V. II (New York, July 20, 1833), p. 47.

Likeness of William Lloyd Garrison. We have received several copies of a lithographic likeness of this devoted champion of the oppressed. It is executed by a colored man whose card will be found in another column [of this newspaper]. To us it seems a striking resemblance.

Of Mr. Douglass, we have previously spoken, and feel happy again in commending him as a young man of genius and sterling moral worth, to that patronage he so well deserves. *The Emancipator* V. I (New York, September 14, 1833), p. 79.

*Letter of Robert Douglass, Jr. to "Friend Gay," sent from Kingston, Jamaica in 1848.*

Friend Gay:—

We arrived here safely after a very tolerable voyage. I was much impressed with the beauty, as seen at a distance, of the high mountains of this island, their great elevation being, I am told, eight thousand feet above the level of the sea. One, in particular, resembled a giant reposing, his profile distinctly visible against the soft light of the evening sky, the mist surrounding his capacious brow giving the idea of a proper-fitting night cap. On landing, we found the city of Kingston exceedingly hot and dusty, and the walking scarcely endurable.— The great numbers of the lower order running to and fro, almost all black, formed a striking feature. Most of them were chanting some air or ditty, which upon listening to, I discovered to be a hymn. I was impressed with their

devotion and inclined to believe that a population so fond of sacred music must certainly be a very honest one—We must have had dealings with the exceptions, however, for we found some of them great rogues. The next thing that made a deep impression upon us was the exhorbitant charge made for everything—board, lodging, and the products of commerce. Alcohol, which I make use of in my business, and which, I have purchased at home for 60 cents the gallon, costs me here $1 the pint— and all other articles are in proportion. There are many Daguerreotypists here, principally American.—Some succeed—others do not.

One cannot walk the streets without meeting groups of the unfortunate Coolies who have been so deluded by this Government, and so disappointed in their expectations. They are quite black, with regular features, slender figures, hair exceedingly black and straight; the men mostly wearing a mustache upon the upper lip, and turban upon the head, which with their entire picturesque costume, make them objects of interest to strangers. Notwithstanding the failure of the scheme for cultivating the lands by their employment, there are many who clamor for the importation of African laborers to till the earth; but it is the opinion of men who know something of the country that if the native laborers were paid just wages, the planters would have no reason to complain.

Hard times is the universal cry here, and there are not many amusements.—A company of amateur actors give occasional representations in the theatre, but I am told they are not much patronized. There have been a series of religious meetings lately held in this city, which have been numerously attended—and a large portion of the people seem devoutly inclined. Parties are frequent, and generally pass off with much enjoyment. Music is a favorite study, and many of the ladies and gentlemen sing well, and play upon some instrument—the guitar, flute, or pianoforte. I have been to several such entertainments, which were concluded by hymns and a prayer. The lower classes are fond of amusing themselves by the beating of drums, singing and dancing, keeping up such a perfect discord that it was exceedingly difficult to get any sleep. One of the candidates was white, and the other colored, and I have been told that more allusion was made to the complexion by the friends of the different parties than on previous occasions.

I was much amused by an orator in favor of the white candidate, who displayed his talent just under my window. He was quite black, and attended by two black companions, all three wearing badges of blue paper, the orators of the colored candidate being arrayed in yellow badges.

"I tell you what, my friends," said the orator, "I gwoine to vote for dis bucra, case he so plenty good for de poor blackee." (Hear! Hear! shouted the attendants.)

"Him have great lub for we, and if he be agin mare, dat bring plenty good time for we." He continued speaking for half an hour; but as no one but his attendants stopped to hear, he took up his line of march, continuing his address as he proceeded. The white candidate was re-

elected, it was said, because his friends had gone to most expense in the bribing of voters.

I have had a pleasant excursion since my residence here to Port Royal. A large party of us left Kingston in the evening, in two boats, one of them belonging to the missionary schooner "Dove", and commanded by the Captain. We took the passage called the "Ponds", which abound with little islands, with a bright moon to guide us—such a moon as is only to be found in the tropics. The scenery was novel and interesting, and the water so beautifully transparent that we could see every object at the bottom, and the fish swimming to and fro in pursuit of each other or in search of food. In a narrow passage our boat was aground for a few moments, but our rowers, part of the "Dove's" crew, athletic Africans, with their faces ornamented, or disfigured, rather, with horizontal cicatrices, apparently produced with hot irons, jumped out and pushed the boat along until we again floated freely. We slept that night at Port Royal, in the Mansion House.

The next morning, very early, we started for a large cave in the opposite mountain. We made fast our boats at the entrance of the cave, and having stationed the crew to keep away the sharks, or notify us of their approach, we took a splendid bath in the sea—We breakfasted afterwards within the cave. This is very properly considered a great natural curiosity. It is lighted up by an immense aperture at the top of the mountain, to which we clambered to a great height, and amused ourselves by rolling down large stones and pieces of rock. We remained here a considerable time, and then went to Green Bay, where we saw the tomb of Louis Caldy, who was swallowed up by the great earthquake which destroyed Port Royal in 1692, and by another shock thrown out into the sea; he escaped by swimming, and lived many years afterwards to tell the story.—Thence we went to Fort Augusta, an immense work to defend Kingston. We were amazed at the solidity of the fortifications, the size of the cannon of the most improved construction, the quantity of shot and shell, and other implements of "horried war." The intelligence of the black who showed and explained the works, his language, and the readiness with which he gave correct answers to questions appertaining to gunnery, and other matters connected with the use of the terrible engines we were contemplating, pleased, as well as surprised, our whole party, one of whom, a missionary, informed us that this man, so well informed, and a companion of his, were formerly great drunkards, but had now reformed and taken the pledge. We then sailed some miles up the Ferry river, a beautiful stream, with moody banks, peopled by innumerable squadrons of crabs, who watched our passage from the entrances to their habitations, but disappeared in a moment if we approached them. Some were of such gaudy colors that it required little imagination to liken them to those crabs in office—military crabs. They retreated so quickly that we could not get a shot at them.

Women were beating and washing clothes in many places which we passed, and I shall not soon forget the picturesque beauty of this charming river. We took a bath in its waters, and ate our bread and cheese,

beef and oranges, with increased relish. On returning to Kingston, we had no occasion for oars, but with a gentle breeze sailed back to the "Dove", where we took tea. The bell was rung for divine service, to which all hands were assembled. When services were over, we made our way to our respective dwellings, well pleased with our jaunt.

I have a commission to take a number of views of missionary stations, which are to be engraved. I leave Kingston in a few days on this service, which will give me the opportunity of seeing more of the Island.

In conclusion, permit me to return thanks for your kindness in forwarding me several numbers of the National A. S. Standard (*National Anti-Slavery Standard*). Always interesting, I find them peculiarly so in this foreign country, furnishing as they do, authentic information of the progress of the great cause. I hail their arrival with much pleasure, and peruse them with the greatest enjoyment.

I remain yours truly,
Robert Douglass, Jr.

*Letters written by Edmonia Lewis to Mrs. Maria W. Chapman—(In Boston Public Library).*

Rome, Italy
February 5, 1867.

My dear Mrs. Chapman:

I have just received your very kind and encouraging letter. I feel like working motch [much] harder and with new zeal. You were quite right in your criticism and as soon as I have the group all modelled I will send you another photograph. I shall work until this group is given to Mr. Garrison who has don [done] so motch [much] for the race, if every black man in the United States would give a penny each I could very soon be able to do my part. I will not take anything for my labor. Mr. Garrison has given his whole life for my father's people and I think that I might give him a few month's work. Thee corst [cost] of the group and pedestal will be one thousand dollars. I will give two hundred dollars which was given me in Boston before I leaft [left] him by Mr. Bowditch and Mr. Loring. Now, if I can only have sent me five hundred within the next two months (March and April) I will be able to get the work so fare [far] advanced as to be able to be presented to our motch [much] valued friend on the first day of January, 1868.

Hoping that you will excuse this very bad letter, I am my dear Mrs. Chapman.

Care Freebos and Co.
Rome, Italy.

Your most humble friend,
Edmonia Lewis.

Rome, Italy
August 6, 1867.

My dear Mrs. Chapman:

I have been remodelling my Freedman over from your kind criticism. I have made a motch [much] better work of it. I shall send you another

photograph of it soon and I hope that before the end of the year, 1868, it will [the group] be in the hands of dear Mr. Garrison who has indeed been the friend of the poor slave. I hope dear Mrs. Chapman that you will forgive me for troubling you so often. Hoping this may find you in good health, I remain

| | |
|---|---|
| Care of Freebos and Co. | Yours very sincerely, |
| Rome, Italy. | Edmonia Lewis. |

# NOTES

## CHAPTER I

[1] Ulrich B. Phillips, *American Negro Slavery* (Appleton, 1918), Chapter IV.

[2] In this connection compare the conclusions of J. A. Tillinghast, *The Negro in Africa and America* (Macmillan, 1902), pp. 135-49, and W. E. B. DuBois. *The Negro Artisan* (Atlanta University Press, 1927), pp. 14-24. The former is only concerned with his personal opinion, which is quite definitely biased; while the latter presents us with factual data objectively studied.

[3] See Melville J. Herskovits, *Acculturation, The Study of Culture Contact* (T. S. Augustus, 1938), pp. 1-32.

[4] Marcus W. Jernegan, *Laboring and Dependent Classes in Colonial America, 1607-1783* (University of Chicago Press, 1931), p. 8.

[5] *Ibid.*, p. 14.

[6] Reprinted by A. C. Prime in *The Arts and Crafts in Philadelphia, Maryland and South Carolina, 1721-1785*: Gleanings from Newspapers (The Walpole Society, 1929), pp. 11, 79.

[7] Reprinted by George F. Dow in *The Arts and Crafts in New England, 1704-1775* (Topsfield, Mass.: Wayside Press, 1927), p. 6.

[8] See *Proceedings of the Massachusetts Historical Society, 1866-1867* (Boston: Published for the Society by Wiggins and Lunt, 1867), Vol. IX, p. 199.

[9] *Ibid.*, p. 213.

[10] Malcolm Parks, "Going Strong after 226 Years," *The New York Sun* (August 23, 1938).

[11] *Ibid.*

[12] Jernegan, *op. cit.*, p. 135.

[13] *Ibid.*, p. 43.

[14] Victor S. Clark, *History of Manufacturers in the United States* (McGraw-Hill, 1929 ed.), Chapter 1, p. 221.

[15] Alice M. Earle, *Home Life in Colonial Days* (Macmillan, 1899), pp. 183, 188.

[16] R. B. Pinchbeck, *The Virginia Negro Artisan and Tradesman* (Richmond, Va.: William Byrd's Press, Inc., 1926), pp. 20-23.

[17] Frances B. Johnston, and T. T. Waterman, *The Early Architecture of North Carolina* (University of North Carolina Press, 1941).

[18] *Alabama: A Guide to the Deep South* Compiled by Workers of the Writers' Program of the Work Projects Administration in the State of Alabama (Richard R. Smith, 1941), pp. 143, 149.

[19] Ulrich B. Phillips, "Plantation and Frontier, 1649-1863," in *A*

*Documentary History of American Industrial Society* (Cleveland: A. H. Clark Co., 1910), Vol. II, p. 304.

[20] *Historical Sketchbook and Guide to New Orleans and Environs.* Edited and compiled by several of the leading writers of the New Orleans press (New York: Will H. Coleman, 1885), p. 10.

[21] Mrs. Philip Werlein, *The Wrought Iron Railings of le Vieux Carré* (New Orleans: by Mrs. Philip Werlein, 1925).

[22] Gerald K. Geerlings, *Wrought Iron in Architecture* (New York: Scribner's, 1929), p. 146.

[23] *Historical Sketchbook and Guide to New Orleans and Environs, op. cit.,* p. 9.

[24] Letter to the writer from Professor Lota L. Troy, Director of the Art School, H. Sophie Newcomb College, Tulane University, New Orleans, Louisiana.

[25] Reprinted by Ulrich B. Phillips in "Plantation and Frontier" *loc. cit.,* p. 358.

[26] See Mrs. Philip Werlein, *op. cit.,* also an article entitled "The Negro's Art Lives in His Wrought Iron," *New York Times Sunday Magazine* (August 8, 1926).

[27] Henry C. Castellanos, *New Orleans As It Was. Episodes of Louisiana Life* (New Orleans, 1895), pp. 294, 300.

[28] *New York Times Sunday Magazine* (August 8, 1926).

[29] *Louisiana: A Guide to the State* Compiled by Workers of Writers' Program of the Work Projects Administration in the State of Louisiana (Hastings House, 1941), p. 176.

[30] For an accurate and voluminous description of this ironwork consult Albert Sonn, *Early American Wrought Iron* (Scribner's, 1928), Vol. I, pp. 3, 7; Vol. III, pp. 230, 234. Also S. S. Labouisee, "The Decorative Ironwork of New Orleans," *Journal of the American Institute of Architects* (October, 1913), Vol. I, No. 10, pp. 436-440.

[31] *Alabama: A Guide to the Deep South, op. cit.,* p. 149.

[32] J. Hall Pleasants, *Joshua Johnston. The First American Negro Portrait Painter* (Baltimore: The Maryland Historical Society, 1942).

## CHAPTER II

[1] James A. Porter, "Versatile Interests of the Early Negro Artists . . ." *Art in America and Elsewhere* (January, 1936), Vol. XXIV, p. 16. The actual date of the birth of Robert Douglass, Jr. was not known at the time this article was written. It is now quite certain, however, that he was born a few years earlier in the century than was Patrick Reason.

[2] Anna B. Smith, "The Bustill Family," *The Journal of Negro History* (October, 1925), Vol. X, p. 64.

[3] From an article probably written by the editor, Benjamin Lundy, in *Genius of Universal Emancipation* (1933), Vol. III, No. 4, p. 59.

[4] In the *Emancipator*, (July 20, 1833), Vol. II, p. 47.

[5] W. W. Brown, *The Black Man, or, Haytian Independence* (pub. by the author, 1869), pp.. 206-7. Inquiries have been placed concerning this portrait of Geffrard but no information has as yet been obtained.

[6] Gilbert H. Barnes and Dwight L. Dumond, *The Letters of Theodore Dwight Weld, Angelina Grimké Weld and Sarah Grimké, 1882-1844* (Appleton-Century, 1934), Vol. 1, p. 483.

[7] In the *Pennsylvania Freeman* (August 22, 1844), New Series, No. 16.

[8] D. M. Stauffer, *American Engravers upon Copper and Steel* (The Grolier Club, 1907), Part I, p. 216.

[9] The portrait of Granville Sharp was published in 1835 as the engraved frontispiece to Lydia Maria Child's *The Fountain for Every Day in the Year.*

[10] *See* vignette on letter in the Schomburg Collection, New York City: Lewis Tappan to Theodore Sedgewick, June 16, 1841. *See also:* Frontispiece: *The Fountain for Every Day in the Year* by Mrs. Child (New York: R. G. Williams, for the American Anti-Slavery Society, 1836), No. 3.; *The Liberty Bell,* by the Friends of Freedom (five lines of quotation), published for the Massachusetts Anti-Slavery Fair, 1837.

[11] Daniel A. Payne, in his *Recollections of Seventy Years,* mentions that he has in his "Album of 1832" a copy of the slave print which was given him by Lewis Tappan. The possibilities are that he was mistaken in the date of this tiny work. William Lloyd Garrison, in a ringing speech made before an English audience at Exeter Hall in London, 1833, employed the following phrases: "What exclamation have you put into the mouth of the African captive, kneeling in his chains with his face turned imploringly heavenward? It is this—the most touching, the most irresistible: Am I Not A Man And A Brother? . . . noblest device of humanity." This address was in celebration of the emancipation jubilee in the British West Indies. Slavery was abolished in that region in 1807. See *William Lloyd Garrison, 1805-1879. The Story of His Life Told By His Children* (Century, 1885), Vol. I, p. 370.

[12] Suzanne La Follette, *Art in America* (Harper, 1929), p. 65.

[13] Charles A. Bennett, *History of Manual and Industrial Education Up to 1870* (Peoria, Ill.: The Manual Arts Press, 1927), pp. 431-33.

[14] Frances M. Trollope, *Domestic Manners of the Americans* (New York: Howard and Wilford Bell, 1904), p. 311. (Reprint.)

[15] *Register of Trades of Colored People in the City of Philadelphia and District* (Philadelphia: Merrihew and Gunn, printers, 1838), p. 7.

[16] Eslanda Robeson, *Paul Robeson, Negro* (Harper, 1930), p. 12.

[17] The title of only one of these paintings has been given by the artist. That one is called "Whiting Fishing." The rest may be identified as "Portrait of a Baby," "Landscape with Tree," and "Portrait of Abraham Lincoln."

[18] John Cromwell, "An Art Gallery and Museum not in the Guide Book," *New National Era,* (October 1, 1874), Vol. 37, p. 2.

[19] Porter Butts, *Art in Wisconsin* (including the catalogue of the 1926 Wisconsin Centennial Art Exhibition) (Madison, Wisconsin: The Madison Art Association, 1936), p. 12.

[20] Wendell P. Dabney, *Cincinnati's Colored Citizens* (Cincinnati, Ohio: The Dabney Publishing Co., 1926), pp. 89-93. The data given in this sketch of Duncanson's life do not allow us to confirm the suggestions of the letter. The single point of agreement is the fact, mentioned in both sources, that Duncanson was self-taught.

[21] "The Land of the Lotos-Eaters, painted by R. S. Duncanson," *The Art Journal* (London: January 1, 1866). A note in the same number on a painting of Bierstadt has the following to say: ". . . a landscape by an American artist named Bierstadt, the subject of which is a passage of scenery from the Rocky Mountains. The more important works that have come across the Atlantic to us have been principally landscapes and that of which we have now to speak has not been surpassed by any of its predecessors. American artists work according to a scale larger than is usual to us in Europe. The grandeur of their scenery so impresses the mind, as to induce a feeling that justice can be done to it only in large pictures . . ." (p. 190).

[22] *Cohen's New Orleans Directory for 1854* (New Orleans: Office of the *Picayune*, 1854), p. 234. We find Daniel Warbourg listed as a stone mason, his shop located on "St. Louis n [ear] Bassin." This directory was published two years after the departure of Eugene Warbourg for Europe.

[23] An advertisement printed in the *Repository of Religion and Literature* indicates that the early Negro Church was not the least of those agencies which sought to provide a liberal education for the Negro. *See* Benjamin T. Tanner, *An Apology for African Methodism* (Baltimore: 1891), p. 59.

[24] See *Repository of Religion and Literature* (Baltimore: May, 1862), Vol. 14, No. 5, pp. 113, 114.

[25] W. W. Brown, *The Black Man* (New York: Thomas Hamilton, 1864), p. 199.

[26] Lately presented to Howard University by their former owner, Mrs. Gregoria Fraser Goins.

[27] H. W. French, *Art and Artists in Connecticut* (Boston: Lee and Shepherd, 1879), p. 155.

## CHAPTER III

[1] W. C. Nell, *Colored Patriots of the American Revolution* (Boston: Robert F. Wallcutt, 1885), p. 318.

[2] J. N. Arnold, *Art and Artists in Rhode Island* (Providence: Rhode Island Citizens Association, 1905), p. 38.

[3] *Ibid.,* p. 37.

[4] *Providence Star* (April 24, 1876). Quoted by W. W. Brown in *Rising Sun* (Boston: A. G. Brown, 1884), p. 478.

[5] Two small paintings by Bannister have recently been added to the collection contained in the Howard University Gallery of Art, Washington, D. C. They afford an excellent insight into the artist's method of building up his treatment of landscape.

[6] Freeman Murray, *Emancipation and the Freed in American Sculpture* (Washington, D. C.: The author, 1916), p. 21.

[7] This legend goes as far back as the letter of Laura Curtis Bullard to the *New National Era* (May, 1871), Vol. II, No. 17, p. 1.

[8] The facts of this case as related by John Mercer Langston in *From the Virginia Plantation to the Nation's Capitol* (Hartford, Conn. American Publishing Co., 1894), p. 171 *et seq.* are almost unbelievable. They lead us to suppose that this experience must have put an early end to Edmonia Lewis' studies at Oberlin. Langston served as legal counsel to Edmonia Lewis in this case.

[9] Although the date of her death has very recently been given by a well-known writer as 1890, the present writer has not been able to learn what actual documents support that date.

[10] Laura C. Bullard, *loc. cit.,* p. 1.

[11] *New National Era* (May, 1873), Vol. IV. (Published in Washington, D. C.) This brief communication gives the destination of the bust as Yale College rather than Harvard College.

[12] See the *National Anti-Slavery Standard* (1868), Vol. XXVIII, No. 30.

[13] We can suggest something of Tuckerman's enthusiasm for Edmonia Lewis' art only by quoting his own words: ". . . Miss Lewis is unquestionably the most interesting representative of our country in Europe. Interesting not alone because she belongs to a condemned and hitherto oppressed race, which labors under the imputation of artistic capacity, but because she has already distinguished herself in sculpture, not perhaps in its highest grade, but in its naturalistic, not to say the most pleasing form. The criticism made of most American sculptors in Europe is that they gravitate too much toward what is called the classical in style with a constantly increasing tendency. It may be reserved for the youthful Indian girl in the Via della Frezza . . . through a success that may well be founded and which certainly will be well earned to indicate to her countrymen working in the same field, a distinctive, if not entirely original style in sculpture which may ultimately take high rank as the American school . . ."

## CHAPTER IV

[1] D. A. Payne, *op. cit.,* p. 241.

[2] W. S. Scarborough, "Henry O. Tanner," in *The Southern Workman* (December, 1902), p. 662.

[3] Verbally from the artist. See also W. R. Lester, "Henry O. Tanner, noted Philadelphian," in *The North American*, third section (August 30, 1908, published in Philadelphia). This writer mistakenly states that the funds were derived from an auction sale of the paintings.

[4] W. R. Lester, "Henry O. Tanner, Exile for Art's Sake," *Alexander's Magazine* (Boston: December 15, 1908), p. 69.

[5] Quoted by W. R. Lester from the *Paris Figaro* in *loc. cit.,* p. 77.

[6] G. P. DuBois, "Art by the Way," *International Studio* (March, 1924), Vol. LXXVIII, p. 322.

[7] John Daniels, *In Freedom's Birthplace, a Study of Boston Negroes* (Houghton Mifflin, 1914), pp. 201, 202. The writer states that "There is an interesting and worthy organization in this field. The Boston Art Club formed in 1907. The fact that its officers are waiters and kitchen workers shows against what odds the Negroes are striving for some of the finer things. This club held its first exhibition, consisting of 120 paintings and drawings, in the autumn of 1907 . . ."

[8] M. A. Majors, *Noted Negro Women, Their Triumphs and Activities* (Chicago: Donohue and Henneberry, 1893), p. 218.

## CHAPTER V

[1] J. W. Gibson and W. H. Crogman, *The Colored American from Slavery to Honorable Citizenship* (Naperville, Illinois: J. L. Nichols, 1902), pp. 233, 234, 235, 255, *et seq.*

[2] W. E. B. DuBois, *The Souls of Black Folk. Essays and Sketches* (Chicago: McClurg, 1904), p. 41 *et seq.*

[3] Sterling A. Brown, *The Negro in American Fiction* (Washington, D. C.: The Associates in Negro Folk Education, 1937), pp. 92 ff.

[4] John Daniels, *In Freedom's Birthplace, a Study of Boston Negroes* (Houghton Mifflin, 1914), pp. 201-2.

[5] James D. Allen, *The Negro Question in the United States* (International Publishers, 1936), pp. 151 ff. It should be mentioned that the manifesto of the Niagara conference did recognize an imperative demand for "well-equipped trade and technical schools for the training of artisans."

[6] William D. Crum, "The Negro at the Charleston Exposition," *The Voice of the Negro* (1904), Vol. I, No. 8, p. 331; and Emmett J. Scott, "The Louisiana Purchase Exposition," *loc. cit.*, Vol. I, No. 7, pp. 309 ff.

[7] Giles B. Jackson and D. Webster Davis, *The Industrial History of the Negro Race in the United States* (Richmond, Va.: The Virginia Press, 1908).

[8] W. O. Thompson, "Collins and DeVillis—Two Promising Painters," *The Voice of the Negro* (1905), Vol. VI, No. 10, pp. 687 ff.

[9] Florence L. Bentley, "William A. Harper," *The Voice of the Negro* (1906), Vol. III, No. 11, p. 118.

[10] This statement is meant to convey the fact that these two artists were first and last interested in their immediate surroundings. They neglected neither American landscape nor the social aspects of the life of their day. Among their subjects were studies of farming, the activities of the local waterfront, horse-racing, and hunting. These subjects were sufficiently popular in type to interest artists like George Luks, Robert Henri, John Sloan, William Glackens, and others who constituted the so-called "Ashcan" school of American art, toward the beginning of our century.

[11] W. O. Thompson, *loc. cit.*, p. 687.

[12] Mary D. MacLean, "Richard Lonsdale Brown," *The Crisis* (1912), Vol. II, No. 6.

[13] If further evidence of the general poverty of Negro artists of the time were needed, it might be found reflected in the writings of Dr. W. E. B. DuBois, who published a scathing rebuke to the Negro public for its neglect of Richard Lonsdale Brown and May Howard Jackson. See *The Crisis* (1902), Vol. XXIV, No. 1, p. 8.

[14] *Catalog of the Negro Arts Exhibit*, held at the New York Public Library, 103 West 135th Street, August 1 to September 30, 1921.

CHAPTER VI

[1] The points of reorientation suggested by Dr. DuBois were five: (1) Economic co-operation, (2) a revival of art and literature, (3) political action, (4) education, and (5) organization. These he regarded as the basis of constructive effort in the struggle for "political equality, industrial equality and social equality" . . . "Only in demand and in persistent demand," he said, "for essential equality in the modern realm of human culture can any people show a real pride of race and a decent self-respect . . ." See "The Immediate Program of the American Negro," *The Crisis* (1915), Vol. V, No. 6, pp. 210-12.

Of course it cannot be shown that this appeal evoked any direct response on the part of the Negro; but it is significant that almost from this date forward, the Negro of all classes demonstrated a more progressive attitude toward general social problems as well as toward such special phases of the cultural life as art and literature. This shift in Negro affairs was reflected in the pages of *The Crisis* and other Negro magazines established after 1915.

[2] The late Dr. Benjamin Brawley in his book entitled *The Negro Genius*, characterized the chief representatives of the renascence of Negro literature as the "New Realists," and located their formative influence in the much-ridiculed social program of Marcus Garvey. The present writer has not been able to verify Dr. Brawley's observation that Garvey's influence on Negro literature was "tremendous." The assistance and encouragement rendered it by such practical thinkers as W. E. B. DuBois, Kelly Miller, James Weldon Johnson, and later, Alain Locke, were both longer-continued and more effective.

[3] Alain L. Locke (editor), *The New Negro, An Interpretation* (Boni, 1925).

[4] *Ibid.*, pp. 262, 264.

[5] George S. Schuyler, "Negro Art Hokum," *The Nation* (1926), Vol. CXXII, No. 3180, p. 662.

[6] Langston Hughes, "The Negro Artist and Racial Mountain," *The Nation* (1926), Vol. CXXII, No. 3181, pp. 662-4.

[7] This doctrine was preached by Dr. Locke in several places. See *The New Negro*, p. 267; also *see* "The Art of the Ancestors," *The Survey* (1925), Vol. LIII, No. 11; "The American Negro as Artist," *The Amer-*

*ican Magazine of Art* (1931), Vol. XXIII, No. 3, p. 218; and lately, in *Negro Art, Past and Present* (Washington, D. C.: Associates in Negro Folk Education), p. 61.

[8] The fundamental primitivism of various movements in modern painting has been exhaustively treated by Robert J. Goldwater in his recent book, *Primitivism in Modern Painting* (Harper, 1938).

[9] Robert J. Goldwater, *op. cit.*

[10] Howard Giles, a Harmon juror, in a brief statement published in the Harmon catalogue for the exhibition of 1933, says the following:

> In musical composition and poetry, especially the former, the Negro has contributed a poignant mystical note that constitutes our one claim for national expression of great significance in the Arts; at least so we are told by the musicians of Europe, an opinion with which I am inclined to agree. Because of that agreement it was regrettable to find so few examples in the works submitted that in this sense noted were racial.

## CHAPTER VII

[1] The evidence for this analysis is plentiful in a mural painted on one of the walls of the billiard room, Harlem YMCA, West 135th Street, New York City, and in the superimposed panels of the lecture hall, West 135th Street Branch Public Library, New York City.

[2] If Negro-made art has any special iconographic content, it is this limited cycle of historical episodes which has been treated in the same generalizing fashion by William Edouard Scott, Vertis Hayes, and others. See the more detailed analysis of Vertis Hayes's paintings.

[3] This statement refers with great objectivity to the tonal property of Aaron Douglass' library panels mentioned above, as well as to his book illustrations for *God's Trombones*, by James Weldon Johnson.

[4] Motley's paintings have been pointed out by several white writers as exemplary instances of racial art. Admitting his approach to Negro subject matter to be original, though over exuberant, the present writer cannot tell whether these commentators mean an essentially racial psychology, or the mere predominance of the Negro subject. *See* Worth Tuttle, "Negro Artists Are Developing True Racial Art," *The New York Times* (Sunday, May 14, 1933).

[5] An excellent example of his work in stone was exhibited for the first time in the Contemporary Negro Art Show, held at the Baltimore Museum of Art, February, 1939.

[6] *See* article by Ruth Green Harris on "Four of the New Federal Arts Projects Murals" in *The New York Times* (Sunday, January 2, 1938).

[7] For good reproductions of Howard Cook's paintings, *see Magazine of Art* (January, 1942), Vol. 35, pp. 4-10.

[8] This point is well illustrated in Benton's prints, "Lonesome Road" and "Frankie and Johnny," published in *A Treasury of American Prints*, Thomas Craven, editor (Simon and Schuster, 1939), Plates 5, 7; but *see*

also *Art in America in Modern Times,* Holger Cahill and Alfred H. Barr, editors (Reynal and Hitchcock, 1934), Figure 47; and Peyton Boswell's *Modern American Painting* (Dodd, Mead, 1940), p. 70.

[9] *See* James A. Porter, "Art Reaches the People," *Opportunity, Journal of Negro Life* (1939), Vol. XVII, No. 12, p. 375.

[10] *See* Ruby M. Kendrick, "Art at Howard University," *The Crisis* (1932), Vol. XXXIX, No. 11, p. 348.

## CHAPTER VIII

[1] An illuminating article touching on this general question of segregation within the culture was published by Dr. Meyer Schapiro under the title: "Race, Nationality and Art" in *Art Front* (March, 1936).

[2] If any vindication of this artist's craftsmanship were needed, it would certainly be found in her plastic group symbolizing Negro music, which was prominently installed at the New York World's Fair. Of this group, a reproduction has been published in *The New York Times, World's Fair Section* (Section 8, March 5, 1939), p. 54.

[3] See *Opportunity, Journal of Negro Life* (1930), Vol. VIII, No. 7, p. 204.

[4] This artist's transcriptions of human personality raise his work to the level of important social art. It was this aspect of his work that persuaded the writer to profess the same conviction in his article on "Negro Art and Racial Bias," *Art Front* (June-July, 1937).

[5] See *Opportunity, Journal of Negro Life* (1941), Vol. XIX, No. 10, p. 309.

## CHAPTER IX

[1] Until recently, there existed an influential point of view supporting the thesis that the arts of aboriginal peoples, of children, and of the naive were on the same psychological level. But writers who have attempted to formulate this theory have valued their hypothetical insights above the trustworthy data of psychology. In order to make their material fit their concepts they have erected, in some cases, dubious categories for primitive and prehistoric arts into which they have lumped also certain phases of children's art. See, for example, the famous book of Lucien Lévy-Bruhl, *La Mentalité Primitive* (Paris: Alcan, 1922).

[2] For a reproduction of this work, consult *Masters of Popular Painting, Modern Primitives of Europe and America* (The Museum of Modern Art, 1938), plate 48.

[3] From an article entitled "At God's Command," in *Art Instruction* (1938), Vol. II, No. 3, p. 30.

[4] See the biographical sketch in *Masters of Popular Painting . . . op. cit.,* p. 125.

## CHAPTER X

[1] Frank Weitenkampf, *American Graphic Art* (New York: Macmillan, 1924), pp. 118-123, 152 *et seq.*

[2] *Ibid.*, pp. 126-133.

[3] It was chiefly the strong depression of the market for fine prints that caused a large group of American artists to seek a remedy through an organization for pooling of prints and the promotion of sales. The Associated American Artists Galleries in New York City was born of this action.

[4] *See* "Albert Alexander Smith," *Opportunity, Journal of Negro Life* (1940), Vol. XVIII, No. 7, p. 208.

[5] *See* catalogue of the *Exhibit by Karamu Artists*, Associated American Artists Galleries (January, 1942).

[6] Alain L. Locke, *The Negro in Art,* (Washington, D. C.: Associates in Negro Folk Education, 1940), p. 120.

[7] *See Esquire, The Magazine for Men* (April, 1938), Vol. IX, No. 4, p. 63.

[8] *See* "Carborundum Tint, a New Print-Maker's Process," *Magazine of Art* (November, 1938), Vol. XXXI, p. 643.

# BIBLIOGRAPHY

*General Reference Books*

*The Boston Directory Embracing the City Record, a General Directory of the Citizens, and a Business Directory, July 1860* (Boston: Adams, Sampson and Co., 1860, 1861, 1867).

Clement, C. E., and Hutton, Laurence, *Artists of the Nineteenth Century and Their Work* (Boston and New York: Houghton Mifflin. 1907).

Evans, Charles, *American Bibliography. A Chronological Dictionary of all Books, Pamphlets and Periodicals Printed in the United States of America from the Genesis of Printing in 1639 down to and Including the Year 1820* (Chicago, Ill.: Privately Printed for the Author by the Blakely Press, 1903-29).

Fielding, Mantle, *Dictionary of American Painters, Sculptors and Engravers* (Philadelphia: Printed for the Subscribers, 1926).

Frankhauer, Mary E., *Biographical Sketches of American Artists* (Lansing, Michigan: Published by the Michigan State Library, 1924).

Johnson, Allen and Malone, Dumas, editors, *The Dictionary of American Biography* (New York: Scribner's, 1931).

Johnson, Rossiter and Brown, John H., editors, *The Twentieth Century Dictionary of Notable Americans* (Boston: The Biographical Society, 1904).

McGlauflin, Alice C., editor, *Who's Who in American Art* (Washington, D. C.: The American Federation of Arts, 1935).

*The National Cyclopedia of American Biography* (New York: James T. White, 1892-1926).

Sprague, William B., *Annals of the American Pulpit; or, Commemorative Notices of the Distinguished American Clergymen of Various Denominations, from the Early Settlement of the Country to the Close of the Year Eighteen Hundred and Forty-Five* (New York: Carter and Brothers, 1858).

Stauffer, David M., *American Engravers upon Copper and Steel* (New York: The Grolier Club, 1907).

Taft, Lorado, *The History of American Sculpture* (New York: Macmillan, 1903).

Thieme, Ulrich and Becker, Felix, *Allgemeines Lexikon der Bildenden Künstler von der Antike bis Zurgegenwart* (Leipzig: Seeman, 1907-34).

Wilson, James G., and Fiske, John, editors, *Appleton's Cyclopedia of American Biography* (New York: Appleton, 1900).

175

## Books and Pamphlets

Alabama: *A Guide to the Deep South*. Compiled by Workers of the Writers Program of the Work Projects Administration in the State of Alabama (New York: Richard R. Smith, 1941).

Allen, James D., *The Negro Question in the United States* (New York: International Publishers, 1936).

Allen, Richard, *The Life, Experience and Gospel Labours of the Rt. Rev. Richard Allen, to Which is Annexed the Rise and Progress of the African Methodist Episcopal Church in the United States of America. Written by Himself* and Published by His Request. (Philadelphia: F. Ford and M. A. Riply, 1880).

Andrews, Charles C., *The History of the New York African Free Schools. From their Establishment in 1787 to the Present Time* (New York: Printed by M. Day, 1830).

*The Annual Report of the American and Foreign Anti-Slavery Society, Presented at New York, May 7, 1850: With the Addresses and Resolutions* (New York: American and Foreign Anti-Slavery Society, 1850).

Appleton, Nathaniel, *A Discourse Occasioned by the Death of the Rev. Edward Wigglesworth, D.D.* (Boston, New England: Printed by Richard and Samuel Draper, and Thomas and John Fleet, 1765).

——, Nathaniel, *The Origin of the War Examined and Applied in a Sermon Preached at the Desire of the Honourable Artillery Company in Boston, June 4, 1733, Being the Day of Their Election of Officers* (Boston: Printed by T. Fleet, for Daniel Henchman, Over Against the Brick Meeting-House in Cornhill, 1733).

Arnett, Benjamin, editor, *The Budget: Containing the Annual Report of the General Officers of the African Methodist Church of the U. S. of A.* (Dayton, Ohio: Christian Publishing House, 1881).

Arnold, John N., *Art and Artists of Rhode Island* (Providence: Rhode Island Citizens Association, 1905).

Barbadoes, F. G., editor, *Catalogue of the First Industrial Exposition by the Colored Citizens of the District of Columbia* (Washington, D. C.: R. O. Polkinhorn, Printer, 1887).

Barnes, Gilbert H., and Dumond, Dwight L., *Letters of Theodore Dwight Weld, Angelina Grimke Weld and Sarah Grimke, 1822-1844* (New York: Appleton-Century, 1934).

Bennett, Charles A., *History of Manual and Industrial Education up to 1870* (Peoria, Ill.: The Manual Arts Press, 1927).

Bird, M. B., *The Blackman; or, Haytian Independence* (New York: Published by the Author, 1869).

Boswell, Peyton, Jr., *Modern American Painting* (New York: Dodd Mead, 1939).

Brawley, Benjamin G., *The Negro Genius* (New York: Dodd Mead, 1937).

——, Benjamin G., *The Negro in Literature and Art in the United States* (New York: Dodd Mead, 1934).

Briggs, Samuel, *The Essays, Humor and Poems of Nathaniel Ames, Father and Son, of Dedham, Massachusetts, from Their Almanacs, 1726-1775, with Notes and Comments by Samuel Briggs* (Cleveland: 1893).

Brooks, Charles H., *A History and Manual of the Grand United Order of Odd Fellows in America* (Philadelphia, 1893).

Brown, Sterling A., *The Negro in American Fiction* (Washington, D. C.: The Associates in Negro Folk Education, 1937).

——, Sterling A.; Davis, Arthur; Lee, Ulysses, editors, *The Negro Caravan, Writings by American Negroes* (New York: The Dryden Press, 1942).

Brown, William Wells, *The Blackman* (New York: Thomas Hamilton, 1864).

——, William Wells, *The Rising Sun; or, The Antecedents and Advancement of the Colored Race* (Boston: A. G. Brown and Co., 1876).

Butts, Porter, *Art in Wisconsin* (Madison, Wisconsin: The Madison Art Association, Wisconsin Centennial Committee and the University of Wisconsin Division of Social Education, 1936).

Cahill, Holger and Barr, Alfred, Jr., editors, *Art in America in Modern Times* (New York: Reynal and Hitchcock, 1934).

Cahill, Holger, *New Horizons in American Art* (New York: The Museum of Modern Art, 1936).

——, Holger; Gauthier, Maximilien and others, *Masters of Popular Paintings; Modern Primitives of Europe and America* (New York: The Museum of Modern Art, 1938).

Castellanos, Henry C., *New Orleans as It Was. Episodes of Louisiana Life* (New Orleans: Graham, 1895).

Child, Lydia Maria, *The Fountain for Every Day in the Year* (New York: Published by R. C. Williams for the American Anti-Slavery Society, 1836).

——, Lydia Maria, *The Fountain for Every Day in the Year* (New York: Printed for John S. Taylor, 1846).

Clark, Victor S., *History of Manufactures in the United States* (New York: McGraw-Hill, 1929).

*Cohen's New Orleans Directory for 1854* (New Orleans: Office of *The Picayune*, 1854).

Craven, Thomas, editor, *A Treasury of American Prints* (New York: Simon and Schuster, 1939).

Dabney, Wendell P., *Cincinnati's Colored Citizens* (Cincinnati: The Dabney Publishing Co., 1926).

——, Wendell P., "Duncanson", in *Ebony and Topaz, a Collectanea* (New York: National Urban League, 1927).

Daniels, John, *In Freedom's Birthplace, a Study of Boston Negroes* (Boston: Houghton Mifflin, 1914).

Delaney, Martin R., *The Condition, Elevation, Emigration and Destiny of the Colored People of the United States, Politically Considered* (Philadelphia: Published by the Author, 1852).

——, Martin R., *The Niger Valley Exploration Party* (New York: Thomas Hamilton, 1861).

Desdunes, Rodolph, *Nos Hommes et Notre Histoire. Notices Biographiques Accompagnées de Réflexions et de Souvenirs Personnels* (Montreal: Arbour and Dupont, 1911).

Dow, George F., *The Arts and Crafts in New England, 1704-1775* (Topsfield, Massachusetts: Wayside Press, 1927).

DuBois, W. E. B., *The Philadelphia Negro; a Social Study* (Philadelphia: Published for the University [of Pennsylvania] 1899).

——, W. E. B., *The Souls of Black Folk. Essays and Sketches* (Chicago: McClurg, 1903).

——, W. E. B., *The Gift of Black Folk* (Boston: Stratford Publishers, 1924).

Dunlap, William, *History of the Rise and Progress of the Arts of Design in the United States* (Boston: C. E. Goodspeed, 1918).

Earle, Alice M., *Home Life in Colonial Days* (New York: Macmillan, 1899).

Ferris, W. H., *The African Abroad; or, His Evolution in Western Civilization, Tracing His Development Under Caucasion Milieu* (New Haven: The Tuttle, Morehouse and Taylor Press, 1913), Vol. 2.

Frazier, E. Franklin, *The Free Negro Family: A Study of Family Origins Before the Civil War* (Nashville, Tenn.: Fisk University, 1932).

French, H. W., *Art and Artists in Connecticut* (Boston: Lee and Shephard, 1879).

Friends of Freedom, *The Liberty Bell by the Friends of Freedom* (Boston: For the Massachusetts Anti-Slavery Fair, 1837).

Garnet, Henry H., *A Memorial Discourse Delivered in the Hall of the House of Representatives, Washington, D. C.* (Philadelphia: Jos. M. Wilson, 1865).

Garrison, William L., *William Lloyd Garrison, 1805-1879. The Story of His Life as Told by His Children* (New York: Century, 1885), Vol. 2.

Geerlings, Gerald K., *Wrought Iron in Architecture* (New York: Scribner's, 1929).

Gibson, J. W., and Crogman, W. H., *The Colored Man from Slavery to Honorable Citizenship* (Naperville, Ill.: J. L. Nichols, 1902).

Goldwater, Robert J., *Primitivism in Modern Painting* (New York: Harper, 1938).

Handy, James A., *Scraps of African Methodist Episcopal History* (Philadelphia: A. M. E. Book Concern).

Herskovits, Melville J., *Acculturation: The Study of Culture Contact* (New York: T. S. Augustus, 1938).

Hilyer, Andrew F., *The Twentieth Century Union League Directory* (Washington, D. C.: Union League, 1901).

*Historical Sketch Book and Guide to New Orleans and Environs.* Edited and compiled by several leading writers of the New Orleans Press (New York: Will H. Coleman, 1885).

Isham, Samuel, *The History of American Painting* (New York: Macmillan, 1927).

Jackson, Giles B., and Davis, D. Webster, *The Industrial History of the Negro Race of the United States* (Richmond: The Virginia Press, 1908).

Jernegan, Marcus W., *Laboring and Dependent Classes in Colonial America, 1607-1783* (Chicago, Ill.: University of Chicago Press, 1931).

Johnson, James W., *God's Trombones: Seven Negro Sermons in Verse* (New York: Viking Press, 1927).

——, James W., *Black Manhattan* (New York: Knopf, 1930).

Johnston, Frances B., and Waterman, T., *The Early Architecture of North Carolina* (Chapel Hill: University of North Carolina Press, 1941).

Kendall, Johns, *History of New Orleans* (New York: William Lewis, 1922).

Keppel, Frederick P., and Duffus, R. L., *The Arts in American Life* (New York: McGraw-Hill, 1933).

Kletzing, Henry F., *Progress of a Race* (Atlanta: J. L. Nichols and Co., 1897).

Lafollette, Suzanne, *Art in America* (New York: Harper, 1929).

Langston, John M., *From the Virginia Plantation to the National Capitol* (Hartford, Conn.: American Publishing Co., 1894).

Lewis, Sarah, "An Appeal to American Women on Prejudice Against Color" in *Proceedings of the Third Anti-Slavery Convention of American Women* (Philadelphia: Thompson, 1839).

Locke, Alain L., editor, *The New Negro: An Interpretation* (New York: Boni, 1925).

——, Alain L., *Negro Art, Past and Present* (Washington, D. C.: Associates in Negro Folk Education, 1940).

——, Alain L., *The Negro in Art. A Pictorial Record of the Negro Artist and of the Negro Theme in Art* (Washington, D. C.: Associates in Negro Folk Education, 1940).

Loguen, Jermain W., *The Rev. J. W. Loguen, as a Slave and as a Freeman; a Narrative of Real Life* (Syracuse, New York: J. G. K. Truair and Co., 1859).

Long, John Dixon, *Pictures of Slavery in Church and State; Including Personal Reminiscences, Biographical Sketches, Anecdotes* (Philadelphia: Published by the Author, 1857).

*Louisiana: A Guide to the State.* Compiled by Workers of the Writers' Program of the Work Projects Administration in the State of Louisiana (New York: Hastings House, 1941).

Majors, Monroe A., *Noted Negro Women, Their Triumphs and Activities* (Chicago, Ill.: Donohue and Henneberry, 1893).

*Massachusetts Artists Centennial Album* (Boston: J. A. Osgood and Co., 1875).

Massachusetts Historical Society. *Proceedings, 1866-1867* (Boston: Published for the Society by Wiggins and Lunt, 1867).

May, Samuel, *The Liberty Catalogue of Anti-Slavery Literature* (Philadelphia: Published by the Author, 1852).

*Minutes of the Adjourned Session of the Twentieth Biennial American Convention for Promoting the Abolition of Slavery, and Improving the Condition of the African Race, Held at Baltimore, Nov. 1828.* (Philadelphia: Samuel Parker, 1828).

Minton, Henry M., *Early History of the Negroes in Business in Philadelphia* (Nashville, Tenn.: A. M. E. Sunday School Union, 1828).

Mossell, Nathan F., *The Work of the Afro-American Woman* (Philadelphia: George S. Ferguson, 1908).

Murray, Freeman, *Emancipation and the Freed in American Sculpture* (Washington, D. C.: Published by the Author, 1916).

*The Negro in Chicago, 1779-1929* (Chicago: The Washington Intercollegiate Club of Chicago, 1929).

Nell, William C., *Colored Patriots of the American Revolution* (Boston: Robert F. Wallcutt, 1855).

Nicholas, Charles L., "Printers of the Eighteenth Century: Isaiah Thomas"; in *The Club of Odd Volumes* (Boston: 1912).

Payne, Daniel A., *Recollections of Seventy Years* (Nashville, Tenn.: A. M. E. Sunday School Union, 1888).

Pennsylvania Anti-Slavery Society. *Fifteenth Annual Report Presented to the Pennsylvania Anti-Slavery Society, by Its Executive Committee. October 25, 1852. With the Proceedings of the Annual Meeting* (Philadelphia: Anti-Slavery Office, 1852).

Peterson, Edward, *History of Rhode Island* (New York: John S. Taylor, 1853).

Pinchbeck, R. B., *The Virginia Negro Artisan and Tradesman* (Richmond: William Byrd's Press, Inc., 1926).

Pleasants, J. Hall, *Joshua Johnston, the First American Negro Portrait Painter* (Baltimore: The Maryland Historical Society, 1942).

Phillips, Ulrich B., *American Negro Slavery* (New York: Appleton, 1918).

Prime, A. C., *The Arts and Crafts in Philadelphia, Maryland and South Carolina, 1721-1785: Gleanings from Newspapers* (Baltimore: The Walpole Society, 1929).

*Proceedings of the Third Anti-Slavery Convention of American Women, Held in Philadelphia, May 1, 2, 3, 1839* (Philadelphia: Printed by Merrihew and Thompson, 1839).

Porter, James A., "Henry O. Tanner" (essay) in *The Negro Caravan* (New York: The Dryden Press, 1942).

*Register of Trades of Colored People in the City of Philadelphia and Districts* (Philadelphia: Merrihew and Gunn, 1838).

*Religious Paintings by Henry O. Tanner* (a brochure by an unknown author).

Reuter, Edward B., *The American Race Problem* (New York: Crowell, 1938).

Richings, G. F., *Evidences of Progress Among Colored People* (Philadelphia: Geo. S. Ferguson Co., 1899).

Robeson, Eslanda, *Paul Robeson, Negro* (New York: Harper, 1930).

Rollin, Frank S., *Life and Public Services of Martin R. Delaney* (Boston: Lee and Shephard, 1883).

Scruggs, Lawson A., *Women of Distinction* (Raleigh, N. C.: L. A. Scruggs, 1893).

Simmons, W. J., *Men of Mark, Eminent, Progressive and Rising* (Cleveland: Revel, 1887).

Sonn, Albert, *Early American Wrought Iron* (New York: Scribner's, 1928).

Stuart, Charles, *The Life of Granville Sharp* (New York: American Anti-Slavery Society, 1836).

Tanner, Benjamin T., *An Apology for African Methodism* (Baltimore: 1867).

Thomas, Isaiah, *The History of Printing in America with a Biography of Printers, and an Account of Newspapers, to Which is Prefixed a Concise View of the Discovery and Progress of the Art in Other Parts of the World* (Worcester, Mass.: From the Press of Isaiah Thomas, Isaac Sturtevant, Printer, 1810).

Trollope, Frances M., *Domestic Manners of the Americans* (New York: Howard and Wilford Bell, 1904).

Tuckerman, Henry T., *Book of the Artists: American Artist Life, Comprising the Biographical and Critical Sketches of American Artists: Preceded by an Historical Account of the Rise and Progress of Art in America. With an Appendix Containing an Account of Notable Pictures and Private Collections* (New York: Putnam, 1882).

Warren, Francis H., *Michigan Manual of Freedmen's Progress* (Detroit: Freedmen's Progress Commission, 1915).

Werlein, Mrs. Phillip, *The Wrought Iron Railings of Le Vieux Carre* (New Orleans: Published by the Author, 1925).

Wheatley, Phillis, *Poems on Various Subjects, Religious and Moral* (London: Printed for A. Bell, Bookseller, Aldgate; and Sold by Messrs. Cox and Berry, King Street, Boston, 1773).

Williams, James, *Narrative of James Williams, an American Slave; Who was for Several Years a Driver on a Cotton Plantation in Alabama* (New York: The American Anti-Slavery Society, 1838).

Wilson, Joseph, *Sketches of the Higher Classes of Colored Society in Philadelphia. By a Southerner* (Philadelphia: Merrihew and Thompson, 1841).

Woodson, Carter G., *A Century of Negro Migration* (Washington, D. C.: The Association for the Study of Negro Life and History, 1918).

——, Carter G., *Free Negro Owners of Slaves in the United States in 1830 Together with Absentee Ownership of Slaves in the United States in 1830* (Washington, D. C.: The Associated Publishers, 1924).

Wyman, Lillie B., and Arthur C., *Elizabeth Buffum Chace, Her Life and Its Environment* (Boston: W. B. Clarke, Co., 1914).

*Periodicals*

Adams, John Henry, "A Study of the Features of the New Negro Woman" (Rough Sketches), *Voice of the Negro*, V. I (August, 1904), pp. 323-26.
——, John Henry, "The New Negro Man" (Rough Sketches), *Voice of the Negro*, V. I (October, 1904), pp. 447-52.
"At God's Command," *Art Instruction*, V. II (March, 1928), p. 30.
Barnes, Albert C., "Negro Artist and America", *Survey Graphic*, V. LIII (March, 1925), p. 669.
——, Albert C., "Negro Art, Past and Present", *Opportunity, a Journal of Negro Life*, V. IV (May, 1926), p. 148.
Bentley, Florence L., "William A. Harper", *Voice of the Negro*, V. III (February, 1906), pp. 85, 118-22.
*Brush and Pencil*, V. VI (Chicago, Ill.: June, 1900), p. 97.
*The Crisis*, V. I (February, 1911); V. VII (January, 1914); V. XXVII (April, 1924).
Crum, William D., "The Negro at the Charleston Exposition", *Voice of the Negro*, V. I (August, 1904), p. 331.
*Current Literature*, V. XLIV (January, 1908), p. 55; (October, 1908), pp. 405-8.
DuBois, Guy Pène, "Art by the Way", *International Studio*, V. LXXVIII (March, 1924), p. 322.
DuBois, W. E. B., "The Immediate Program of the American Negro", *The Crisis*, V. V, No. 6 (1915), pp. 210-212.
*Dunbar News* (New York: December 30, 1931), p. 1.
"Eighteenth Century Slave Advertisements", *Journal of Negro History*, V. I (April, 1916), pp. 182, 187.
Herring, James V., "The Negro Sculptor", *The Crisis*, V. XLIX (August, 1942), pp. 261-62.
——, James V., "The American Negro as Craftsman and Artist", *The Crisis*, V. XLIX (April, 1942), pp. 116-18.
Hood, Richard, "Carborundum Tint, a New Print-Makers Process", *Magazine of Art*, V. XXXI (November, 1938), p. 643.
Holbrook, Francis C., "A Group of Negro Artists", *Opportunity, a Journal of Negro Life*, V. I (July, 1923), pp. 211-13.
Hughes, Langston, "The Negro Artist and Racial Mountain", *The Nation*, V. CXXII, No. 3181 (1926), p. 662.
Kendrick, Ruby M., "Art at Howard University", *The Crisis*, V. XXXIX (November, 1932), p. 348.
Labouisse, S. S., "The Decorative Ironwork of New Orleans", *Journal of the American Institute of Architects*, V. I (October, 1913), pp. 436-440.
"The Land of the Lotos-Eaters, Painted by R. S. Duncanson", *The Art Journal*, new series, V. V (London: January 1, 1866), pp. 174-77.
Lawrence, Jacob, ". . . And the Migrants Kept Coming; A Negro Artist Paints the Story of the Great American Minority", *Fortune*, V. XXIV (November, 1941), pp. 102-109.

Lester, William R., "Henry O. Tanner, Exile for Art's Sake", *Alexander's Magazine* (Boston: December 15, 1908), pp. 67-9.

MacChesney, Clara T., "A Poet Painter of Palestine", *International Studio*, V. IV (July, 1913), pp. XI-XIV.

MacLean, Mary D., "Richard Lonsdale Brown", *The Crisis*, V. III (April, 1912), p. 255.

Moore, William H., "Richmond Barthé—Sculptor", *Opportunity, a Journal of Negro Life*, V. VI (November, 1928), p. 334.

*The National Reformer*, V. I (Philadelphia: September, 1839), p. 143.

Porter, James A., "Art Reaches the People", *Opportunity, a Journal of Negro Life*, V. XVII (December, 1939), pp. 375-76.

——, James A., "Four Problems in the History of Negro Art", *Journal of Negro History*, V. XXVII (January, 1942), pp. 9-36.

——, James A., "Malvin Gray Johnson", *Opportunity, a Journal of Negro Life*, V. XIII (April, 1935), pp. 117-18.

——, James A., "Negro Art on Review", *The American Magazine of Art*, V. XXVII (January, 1934), pp. 33-38.

——, James A., "Versatile Interests of the Early Negro Artist", *Art in America and Elsewhere*, V. XXIV (January, 1936), pp. 16-27.

——, James A., "The Negro Artist and Racial Bias", *Art Front* (March, 1936), p. 8.

Rankin, J. A., "The Aesthetic Capacity of the Afro-American", *Our Day*, V. XIII (Boston: July, August, 1894).

Scarborough, William S., "Henry O. Tanner", *The Southern Workman*, V. XXXI (December, 1902), pp. 661-70.

Schuyler, George, S., "Negro Art Hokum", *The Nation*, V. CXXII (June, 1926), p. 662.

Scott, Emmett, J., "The Louisiana Purchase Exposition", *Voice of the Negro*, V. I (August, 1904), p. 309.

*The Slave's Friend*, V. I, No. 10 (1836), p. 15.

Smith, Anna B., "The Bustill Family", *Journal of Negro History*, V. X (October, 1925), p. 64.

Smith, Lucy E., "Some American Painters in Paris", *The American Magazine of Art*, V. XVIII (March, 1927), p. 134.

Tanner, Henry O., "The Story of the Artist's Life", *World's Work*, V. XVIII (January, February, 1909), pp. 11661-6; 11769-75.

Thomas, Edward M., "Art", *Repository of Religion and Literature*, V. IV (Baltimore: 1862), pp. 113-14; 130-31; 150-52; 189-90.

Thompson, W. O., "Collins and DeVillis—Two Promising Painters", *Voice of the Negro*, V. II (December, 1905), pp. 687 ff.

Wesley, Charles H., "Henry O. Tanner, the Artist—an Appreciation", *Howard University Record*, V. XIV (April, 1920), p. 299.

## Newspaper References

"The Black Man After the Passage of the Civil Rights Bill", V. I, p. 129, bound volume of newspaper clippings in the possession of John Cromwell, Washington, D. C.

*The Boston Sun*, February 4, 1900.
*Cincinnati Daily Gazette*, November 24, 1865.
*Cincinnati Enquirer*, December 21, 1934.
*The Colored American*, V. I (July 8, 1837), p. 27.
——, V. II (March 3, 1838), p. 26.
——, V. II (June 16, 1838), p. 65.
*The Emancipator*, V. I (New York: September 14, 1833), p. 79.
——, V. I (New York: September 21, 1833), p. 83.
——, V. II (New York: July 20, 1834), p. 47.
——, new series, V. V (November, 1835).
*Freedmen's Journal*, V. I (January, 1865), p. 16.
*The Freedmen's Record*, V. II (Boston: April 1866), p. 69.
——, V. III (Boston: January 1867), p. 3.
Freeman, P., "Origin, History and Hopes of the Negro Race", *Frederick Douglass' Paper*, V. VII (Rochester, N. Y.: 1854), p. 6.
*Genius of Universal Emancipation*, third series, V. III (Washington, D. C.: February 1833), p. 59.
Harris, Ruth G., "Four of the New Federal Arts Projects Murals", *The New York Times*, January 2, 1938.
H. B. L., "The Negro's Art Lives in His Wrought Iron", *New York Times Sunday Magazine*, August 8, 1926.
Lester, W. R., "Henry O. Tanner, Noted Philadelphian Here After Triumphs as a Painter in Europe", *The North American,* 3rd Section (Philadelphia: Sunday, August 30, 1908).
"Letter from Robert Douglass", *The North Star*, V. I. (1848).
*The Liberator*, V. VI (Boston: January 2, 1836), p. 4.
*The Liberator*, V. XVI (August 21, 1846), p. 146.
*The Massachusetts Gazette and Boston Weekly News Letter*, December, 1773.
*The New York Herald Tribune*, April 16, 1852.
*Pennsylvania Freeman*, new series, No. 16 (August 22, 1876).
*Progressive American Colored Weekly* (New York: September 28, 1876).
Tuttle, Worth, "Negro Artists Developing True Racial Art", *New York Times*, May 14, 1933.

# JAMES A. PORTER CHRONOLOGY

## Compiled by Constance Porter Uzelac

1905    On December 22, James Amos Porter was born in Baltimore, Maryland, to John and Lydia Porter, the youngest of seven children—two girls and five boys—John F., Jessie R., Margaret, Robert Peck, Esther, and William H.

1919    He enrolled in Armstrong Manual Training School of the District of Columbia, from which he graduated in 1923.

1921–22    He served as art editor of "The Spark," the Armstrong newspaper.

1922    He was awarded the second prize in the Holcombe Memorial Contest for his freehand drawing design for a memorial to Lt. Leroy Holcomb[e], a graduate of Armstrong who was killed in action at Menthysis, France, in 1918.

1923    He enrolled in Howard University's Department of Art on a scholarship.

1927    On June 10, he received his Bachelor of Science degree in art, cum laude, from Howard University. In September, he was appointed instructor in drawing and painting in Howard University's Department of Art and Architecture.

1929    In January, he received an honorable mention from the Harmon Foundation for a work of art. On January 15, a charcoal portrait of "Cyril Bow" appeared as a frontispiece in *The Survey*, volume 61, number 8, January 15, 1929. On May 1, he was inducted into Kappa Mu Honorary Society, Howard University.

1930    Porter's first one man show of his drawings and paintings was held at the Howard University Gallery of Art. His paintings that were exhibited were as follows:

> Young Woman Holding a Jug (#1); Old X (#2); Lafayette Square at Executive Avenue (#3); Tapestry: Light-Worshippers (#4); Still Life (#5); Masquerade (#6); Kite Flyers (#7); The Red Cap (#8); 7th Street Wharves (#9); French Maid (#10).

The drawings that were exhibited are as follows:

> Young Negro (#11); Master Harrison Brown (#12); An Ideal Head (#13); Dr. Emmett J. Scott (#14); Mrs. J. A. Porter (#15); Mr. Cyril

Bow (#16); Lydia (#17); Mr. Cecil Cohen (#18); Ernest Smith (#19); Abstract Portrait (#20); Study for a Mural (#21); Water Color Drawing (#22)

1931  In April, Porter was a delegate to the annual convention of the American Federation of Arts, Brooklyn, New York, where he represented Howard University.

1932  Porter exhibited in a one man show at Hampton Institute Library, Hampton, Virginia, for two weeks beginning April 20, 1932.

1933  On February 20, he was awarded the Arthur A. Schomburg Portrait Prize of $100 for "Woman Holding a Jug," which appeared on the cover of the Harmon Foundation exhibition catalog.

1935  On July 1, Porter received a fellowship from the Scholarship Institute of International Education to study medieval archeology at the Institute d'Art et d'Archéologie, Sorbonne, France, where he studied from July 1 to August 10. He was awarded a $400 scholarship under a grant offered by the College Art Association in conjunction with the Carnegie Foundation. He also received a Rockefeller Foundation Travel Grant.

1937  In February, he completed the Masters of Arts degree at New York University.

1943  *Modern Negro Art* was published by the Dryden Press.

1945–46  He was awarded a Rockefeller Foundation Travel Grant to study Cuban and Haitian museum holdings and artists.

1948  Porter's paintings and drawings were exhibited from February to March 1948 at the Barnett Aden Gallery, Washington, D.C.

1949  An exhibition of Porter's works entitled "James A. Porter: An Exhibition of Recent Paintings" was held from May 24 through July 4 at the Dupont Theatre Art Gallery, Washington, D.C. Paintings exhibited were as follows:

Paintings: Bay of Port-au-Prince (#1); Haitian Donkey Driver (#2); Haitian Market Women (#3); Late Afternoon Mean Leogane (#4); Calabash Merchant (#5); Avenue Dessalines, Port-au-Prince (#6); Peasants Resting, Kenskoff, Haiti (#7); Haitian Girl (#8); Shadow-play at Kenscoff (#9); Moonlight Over the National Gallery, Haiti (#10); In a Cuban Bus (#11); Farm at Saratoga, N.Y. (#12); Church of the Visitation, Schuylerville, N.Y. (#13); Garden at White Sulphur Springs, N.Y. (#14); Spring in Central Park (#15); Key Bridge, Washington, D.C. (#16); Man With Mask (#17); Lethal Nocturne (#18); Sharecroppers (#19); Still Life (#20). Pastels: Haitian Vendors at Port-au-Prince (#21); Flirtation (#22). Drawings: For the Children (#23); Straw Hat (#24); The Knockdown (#25); Monumental Mother (#26).

1953　Porter was appointed head of Howard University's Department of Art and director of the Art Gallery. In May he was promoted to associate professor of art at Howard University.

1955　Porter was awarded a fellowship to attend the Belgian Art Seminar in the History of Art by the Belgian American Educational Foundation and the Belgian Ministry of Education. He studied at Rubens House, Antwerp, and the National Center for the Study of Flemish Primitives, Brussels, from July 4 to August 27, 1955.

On October 23, Porter received an Achievement in Art Award from the Pyramid Club, Philadelphia, Pennsylvania, "for his Achievement in Art in Writing and Painting" in Washington, D.C., for "Girl in Shattered Mirror."

1961　In the summer, Porter studied fresco mural painting at the Instituto Allende, San Miguel De Allende, Guanajuato, Mexico.

1963–64　He was on sabbatical from Howard University and received a *Washington Evening Star* Faculty Research Grant of $2500 to study art and architecture. He visited Nigeria, Ghana, Sierra Leone, Senegal, Ivory Coast, Togo, and Egypt.

1965　An exhibition entitled "Retrospective Exhibition: Paintings of the Years 1954–1964" was held at the Howard University Gallery of Art, Washington, D.C., from January 22 through February 26, 1965. Thirty-three paintings were exhibited including the following:

Self-Portrait (#1); Inter-Racial (#2); Africa in America (#3); Artist's Studio Table (3); Junkyard Symphony (#5); Man with Ukelele (#6); Two Idols (#7); Dismounted Spirit (#8); Street Scene (#9); Ballo in Maschera (#10); Crown of San Miguel de Allende, Mexico (#11); Portrait of Anne Cooke (#12); Toromaquia (#13); Hommage à Baga et à Senoufo (#14); Woman with Cat (#15); Bundu and the Two Natures of Exú (#16); Approach to Bar Beach, Victoria Island, Lagos (#17); Yemajá, Goddess of Waters (18); Vision at Ibaden (#19); Victoria Island, Lagos (#20); Porteuse (#21); Independence Building from Lagos Lagoon (#22); Wall of Zaria (#23); Cherubim and Seraphim, Lagos (#24); Ferry to Tarkwa, Lagos (#25); Lagos, WharfSide of the Lagoon (#26); Storm Over Jos, Nigeria (#27); Fisherman's Village. Onoho Road, Lagos (#28); Eyo Masquerade, Lagos (#29); View of Ebute Metta from Lagos Cemetery (#30); Spirit on a Stick (#31); Tempest (#32)

1966　On March 17, he was one of twenty-five recipients to receive the National Gallery of Art Medal Award for Distinguished Services to Education in Art. The ceremony was held at the White House on the twenty-fifth anniversary of the founding of the National Gallery of Art, and the awards were presented by Mrs. Lyndon B. Johnson.

1969　*Modern Negro Art* was reprinted in hardback and paperback, with a new preface by Porter, by the Arno Press/New York Times.

1970   Porter died in Washington, D.C., on February 28 at Howard University Hospital.

1992   On October 15, the Howard University Gallery of Art presented "James Porter, Artist and Art Historian: The Memory of the Legacy." *Modern Negro Art* is reprinted by Howard University Press.

# SELECTED PORTER BIBLIOGRAPHY

## A Selected Bibliography of the Published Writings of James A. Porter

Compiled by Constance Porter Uzelac

*Books and Monographs*

*Modern Negro Art.* New York: Dryden Press, 1943.
*Laura Wheeling Waring; An Appreciational Study.* Washington, D.C.: Howard University Gallery of Art, May 1949.
*Modern Nego Art.* With a new preface by the author. New York: Arno Press and the New York Times, 1969.

*Articles*

"Versatile Interests of the Early Negro Artist." *Art in America* 24 (September 1931): 210–20.
"Roots of Culture." Letter to the Editor, *The New York Times* (December 27, 1931).
"Negro Art on Review." *American Magazine of Art* 27 (January 1934): 33–38.
"Malvin Gray Johnson, Artist." *Opportunity* 13, no. 4 (April 1935): 117–118, with portrait of the artist.
"Versatile Interests of the Early Negro Artist: A Neglected Chapter of American Art History." *Art in America and Elsewhere* 24, no. 1 (January 1936): 16–27.
"Self-Portrait of the Late Malvin Gray Johnson." *Opportunity* 17, no. 5 (May 1939): 134.
"Art Reaches the People." *Opportunity* 17, no. 12 (December 1939): 375–76.
"Four Problems in the History of Negro Art." *Journal of Negro History* 27, no. 1 (January 1942): 9–36.
"Henry O. Tanner." *The Negro Caravan.* Edited by Sterling Brown, et. al. New York: Dryden Press, 1942.
"American Negro Art." *Encyclopedia of the Arts.* Edited by Dagobert O. Runes and Harry G. Schrickel. New York: Philosophical Library, 1946.

"Picturesque Haiti." *Opportunity* 24, no. 4 (Fall, October-December, 1946): 178–180, 210.

"Progress of the Negro in Art During the Past 50 Years. Negro Artists Gain Recognition After Long Battle." *Pittsburgh Courier* (July 29, 1950), 2–7.

"Expressionist Trends in Afro-Cuban Painting. *Midwest Journal* 3 (Winter 1950–51): 11–22.

"Robert S. Duncanson: Midwestern Romantic-Realist." *Art in America* 39, no. 3 (October 1951): 99–154.

"Introductory Statement." *Paintures, 1937–1951* Lois Mailou Jones. Tourcoing: France: Presses Georges Frere, 1952. Portfolio of 112 plates.

"A Further Note on Robert S. Duncanson." *Art in America* 42 (October 1954): 220, 221, 235.

"The Negro in Modern Art." *The New Negro Thirty Years Afterward: Papers Contributed to the Sixteenth Annual Spring Conference of the Division of the Social Sciences, April 20–22, 1955.* Washington, D.C.: The Graduate School, Howard University Press, 1955.

"The Trans-Cultural Affinities of African Negro Art." *Africa Seen by American Negroes.* Preface by Alioune Diop, president, Societe Africaine de Culture; introduction by John A. Davis, president, American Society of African Culture. New York: Standard Press and Graphics, 1963. Second printing of Special Edition of *Presence Africaine* under title *Africa Seen by American Negroes*, Dijon: Presence Africaine, 1958.

"The Prodigious Picasso." *The Howard University Magazine* 11, no. 2 (January 1960): 16–19.

"The American Negro Artist Looks at Africa." *Pan-Africanism Reconsidered.* Edited by The American Society of African Culture. Berkeley and Los Angeles: University of California Press, 1962.

"One Hundred and Fifty Years of Afro-American Art." *The Negro in American Art.* An exhibition co-sponsored by the California Arts Commission. Los Angeles: University of California: Dickson Art Center, 1966, 5–12. (This essay originally appeared in *Presence Africaine.* It was retitled and edited by the author for this exhibition publication.)

"L'Art Afro-Americain contemporain." *Colloque: Fonction et signification de l'Art Negre dans la vie du peuple et pour le peuple* (30 Mars-8 Avril). 1ᵉʳ Festival Mondial des Arts Negre Dakar. 1–24 Avril 1966. Rapports: Tome 1. Paris: Editions Presence Africaine, 1967, 451–468.

"Art, with Comments by James Porter." *Black Talent Speaks.* Edited by Charles M. Weisenberg. *Los Angeles FM & Fine Arts* 8, no. 1 (January 1967).

"Negro Artists Gain Recognition After Long Battle." *The Negro in Music and Art.* Edited by Lindsay Patterson, 251–256. New York: International Library of Negro Life and History, 1967.

"Afro-American Art at Flood-tide." *Arts and Society* 5, no. 3 (Summer-Fall 1968): 257–71.

"Contemporary Afro-American Art." *Colloquium: Function and Significance of African Negro Art in the Life of the People and for the People.* 1st World Festival of Negro Arts, Dakar. Paris: Editions Presence Africaine, 1968.

"African Art from Prehistory to the Present." *The Negro Impact on Western Civilization.* Edited by Joseph S. Roucek and Thomas Kiernan, 467–87. New York: Philosophical Library, 1970.

"Contemporary Black American Art." *The Negro Impact on Western Civilization.* Edited by Joseph S. Roucek and Thomas Kiernan, 489–503. New York: Philosophical Library, 1970.

"Edmonia Lewis." *Notable American Women.* Edited by Edward T. James, et al., 397–399. Cambridge: Belknap Press of Harvard University, 1971.

## Book Reviews

*The Negro in Art: A Pictorial Record of the Negro Artist and of the Negro Theme in Art.* Edited by Alain Locke. Washington, D.C.: The Associates in Negro Folk Education, Inc, 1940. *Journal of Negro History* 26 (April 1941): 261–64.

## Introductions to Books and Forewords to Catalogs

*Portfolio of Reproductions of Paintings.* Lois Mailou Jones. Paris, 1952.

*Eighteen Washington Artists.* Introductions by James A. Porter and Agnes Delano. Washington, D.C.: Barnett Aden Gallery, 1953.

"The Legacy of 'Pop Hart.' " *Catalog of a Retrospective Exhibition of Paintings, Prints and Drawings by George O. "Pop" Hart, 1868–1933.* Washington, D.C.: Howard University Gallery of Art (October 1956).

*Norma Morgan.* Washington, D.C.: Howard University Gallery of Art, January 1960.

*Ten Afro-American Artists of the Nineteenth Century; An Exhibition Commemorating the Centennial of Howard University, February 3-March 30, 1967.* Catalog prepared by James A. Porter. Washington, D.C.: Howard University Gallery of Art.

"The Art of Charles White: An Appreciation." *Images of Dignity: The Drawings of Charles White.* Foreword by Harry Belafonte, introduction by James Porter, commentary by Benjamin Horowitz. Los Angeles: Ward Ritchie Press, 1967.

# INDEX

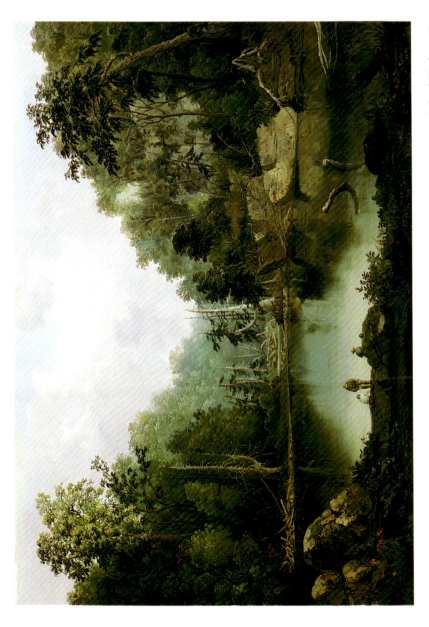

Robert S. Duncanson. *Blue Hole, Little Miami River*. 1860. Oil. 29¼ x 42¼. Cincinnati Art Museum. Gift of Norbert Heerman and Arthur Helbig.

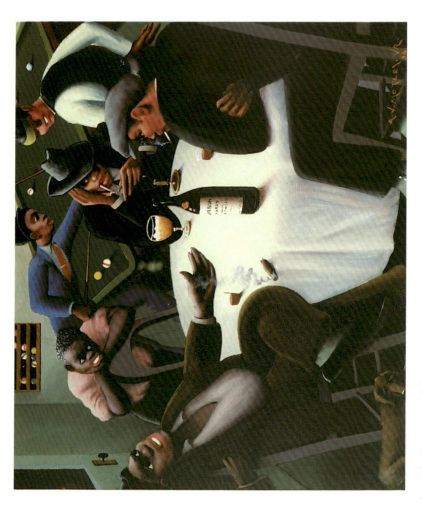

Archibald Motley. *The Liar*. 1934. Oil. 32 x 36. Treasury Department, Federal Art Project. The Howard University Gallery of Art, Permanent Collection, Washington, D.C.

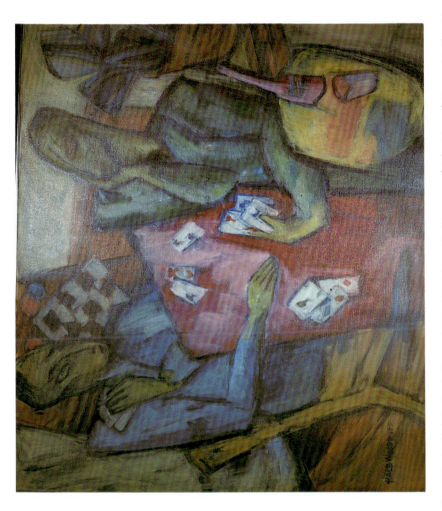

Hale Woodruff. *The Card Players*. 1930. Oil. 36 × 42. Courtesy of John H. and Vivian D. Hewitt.

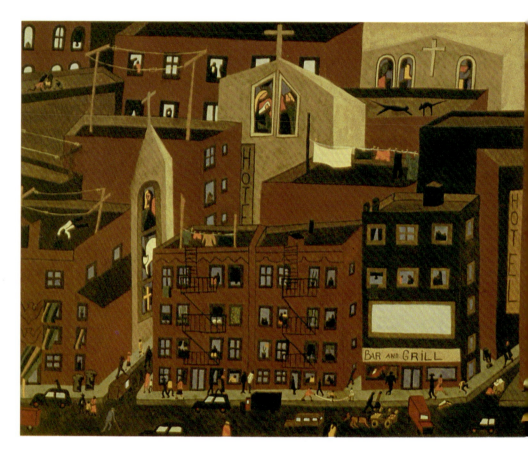

Jacob Lawrence. *Harlem* (also known as *Rooftops*) from the series *Harlem*.
1942. Gouache. 14 × 21.
Collection of Drs. Camille O. and William H. Cosby, Jr.

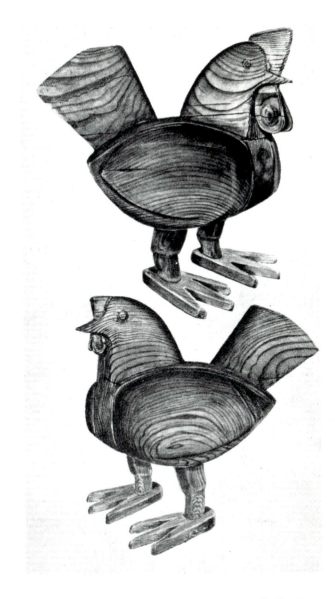

*Left:* Hardwood cane. Made by Henry Gudgell (slave) in
Missouri. 1863. Recorded in Missouri. Copyist: Edmonia R.
Lorts. *Above:* Carved hen and chicken. Made by a slave of
Jean LaFitte. 1800–1814. Scaled drawings.

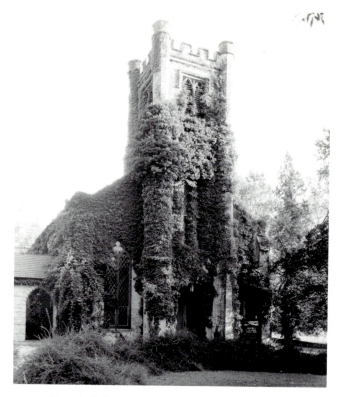

Chapel of the Cross, Chapel Hill, North Carolina.
Erected by slaves. 1842–1846.

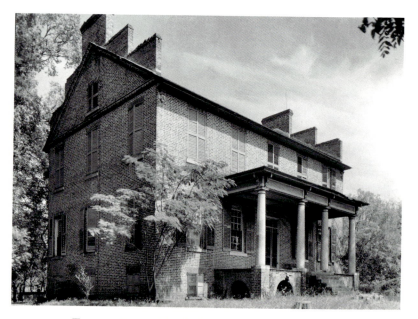

Torrance House, Mecklenburg County, North Carolina.
Erected by slaves. 1831.

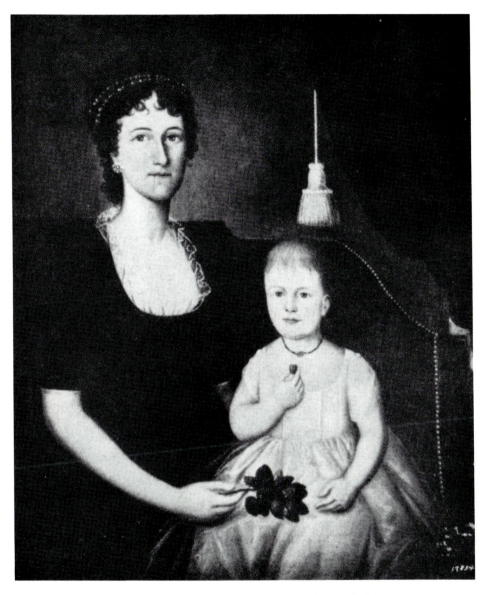

Joshua Johnston. *Mrs. Andrew Bedford Bankson and Child.*
c. 1780. Oil. Courtesy Virginia Montgomery Johnston.

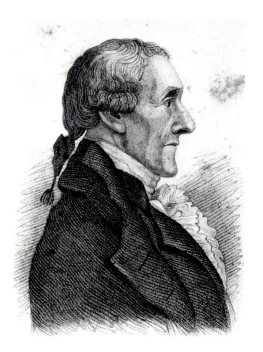

Patrick Reason.
*Granville Sharp.* 1835.
Engraved portrait.
From A *Memoir of Granville Sharp*
by Charles Stuart
(New York:
Anti-Slavery Society,
1836). Courtesy
Moorland-Spingarn
Research Center,
Howard University,
Washington, D.C.

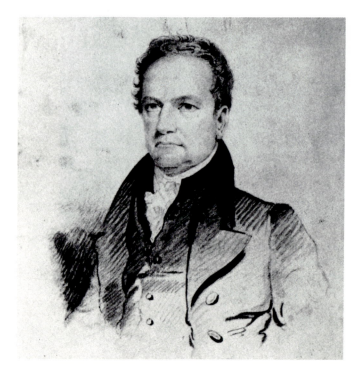

Patrick Reason.
*DeWitt Clinton.*
1835. Pencil Drawing.

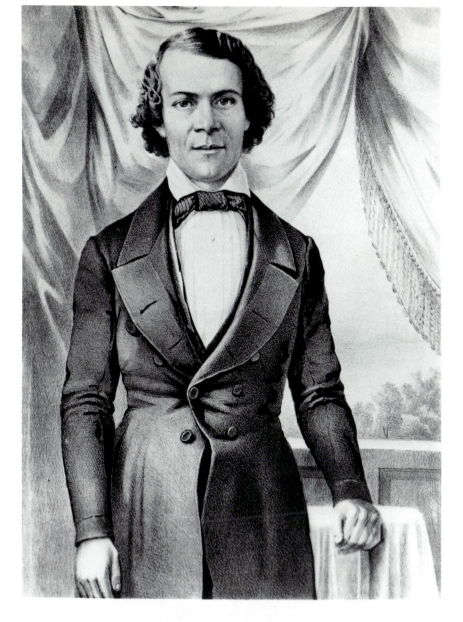

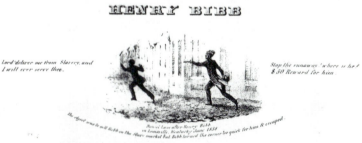

HENRY BIBB

Lord deliver me from Slavery, and
I will ever serve thee.

Stop the runaway where is he?
$50 Reward for him.

Patrick Reason. *Henry Bibb.* 1847. Lithograph. Henry P. Slaughter
Collection, a part of Atlanta University, Special Collections, Atlanta
University Center, Woodruff Library, Atlanta University.

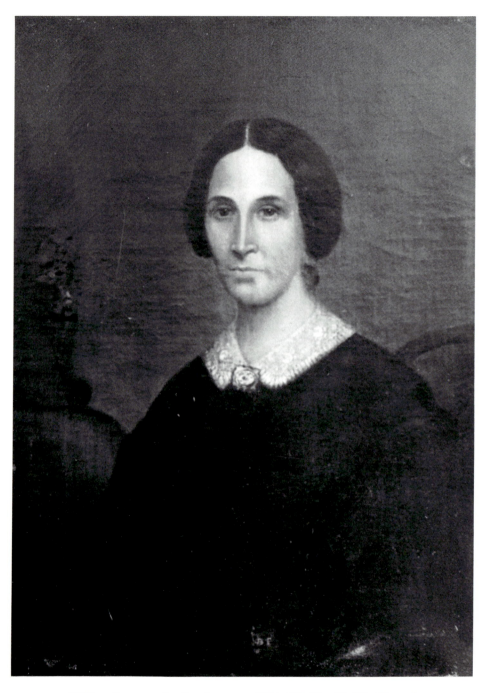

William Simpson. *Caroline Loguen*. c. 1854. Oil. 35 x 30. The Howard
University Gallery of Art, Permanent Collection, Washington, D.C.

*Facing page:* Edward M. Bannister, American, 1828–1901, *At the Oakside
Beach.* c. 1877. Oil on canvas. 8″ x 12″. Museum of Art, Rhode Island
School of Design; Bequest of Isaac C. Bates.

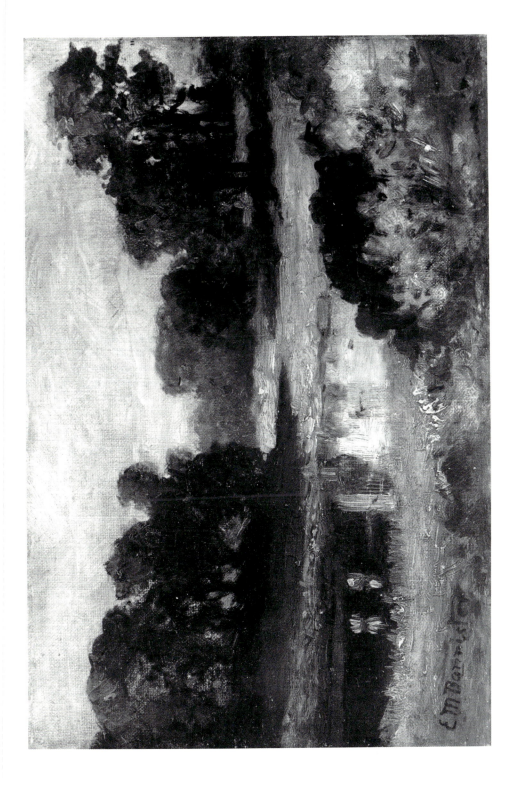

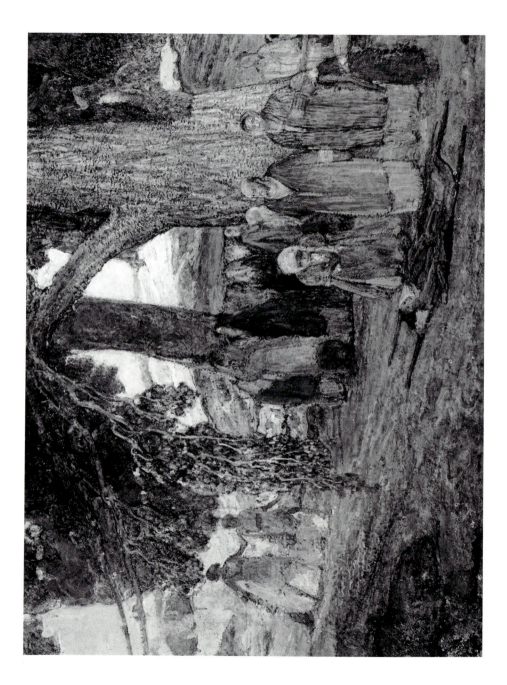

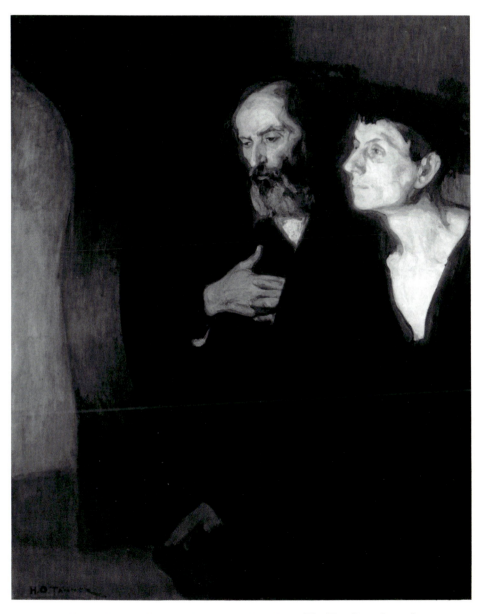

Henry Ossawa Tanner, American, 1859–1937, *The Two Disciples at the Tomb*, c. 1906. Oil on canvas. 129.5 x 105.7 cm. Robert A. Waller Fund, 1906.300. © 1992 The Art Institute of Chicago. All Rights Reserved.

*Facing page:* Henry Ossawa Tanner. *Disciples Healing the Sick.* 1930–1935. Oil and tempera.

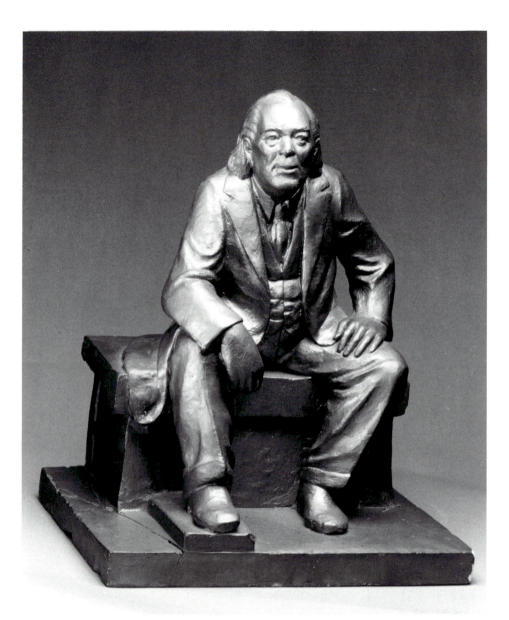

Meta Warrick Fuller. *Richard B. Harrison as "De Lawd."* 1937. Bronze.
H. 54 in. The Howard University Gallery of Art, Permanent Collection,
Washington, D.C.

*Facing page:* Meta Warrick Fuller. *The Awakening of Ethiopia.* 1914. Plaster,
full figure (bronze cast). 67″ × 16″ x 20″. Photo: Lee White. Schomburg
Center for Research in Black Culture, Art & Artifacts Division, The New
York Public Library, Astor Lenox and Tilden Foundations.

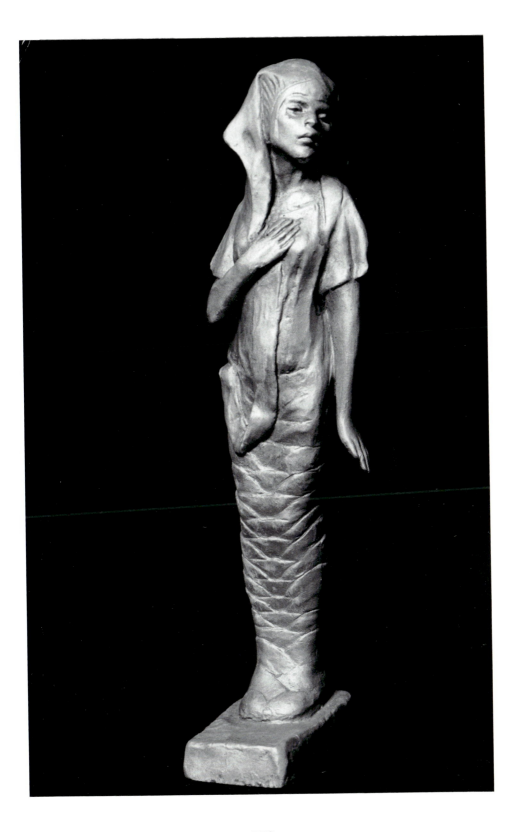

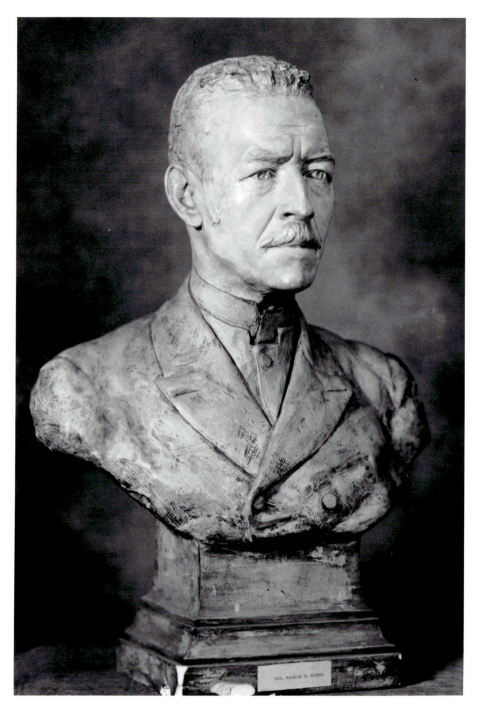

May Howard Jackson. *Francis J. Grimke*. 1920. Plaster.

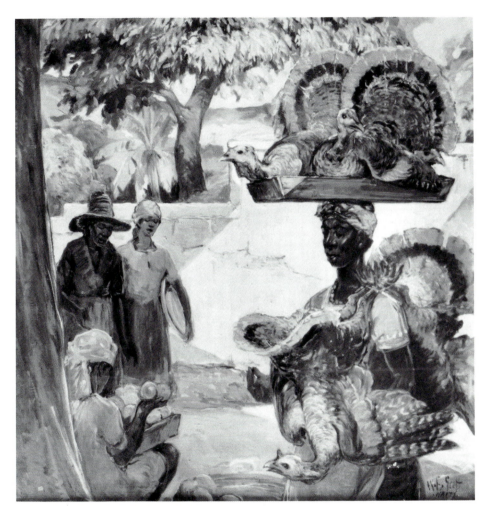

William Edouard Scott. *The Turkey Market*. 1932. Oil.

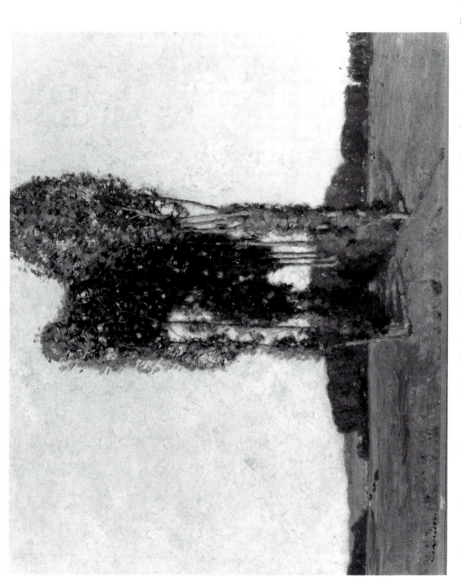

William A. Harper. *Afternoon at Montigny*. 1905. Oil. 23 x 28. The Howard University Gallery of Art, Permanent Collection, Washington, D.C.

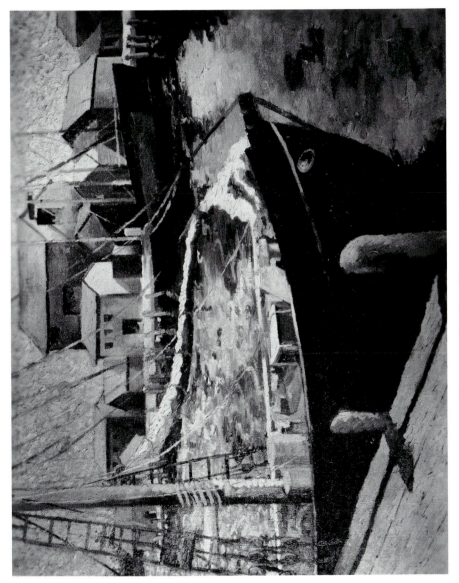

Allan R. Freelon. *Late Afternoon.* 1930. Oil.

227

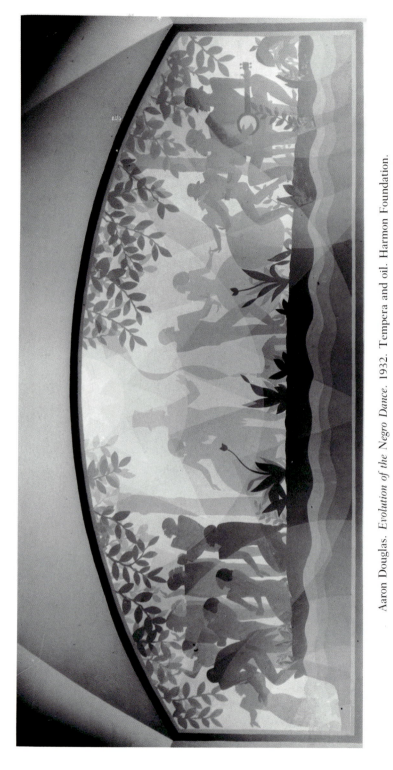

Aaron Douglas. *Evolution of the Negro Dance.* 1932. Tempera and oil. Harmon Foundation.

*Below:* Palmer Hayden. *Autumn, East River.* 1934. Oil. W.P.A. Federal Art Project.

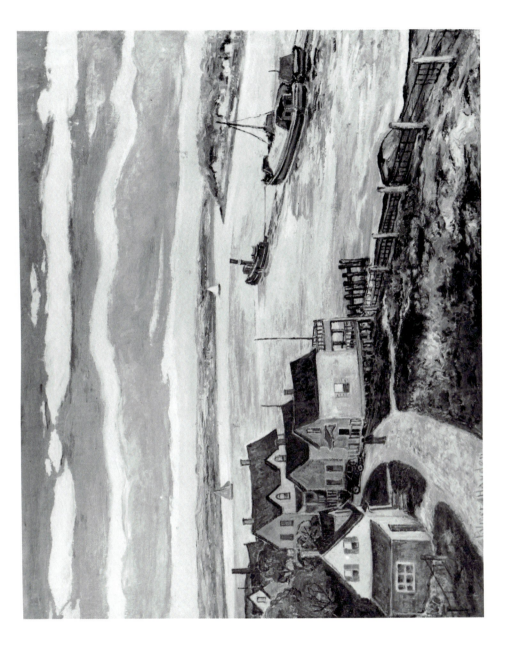

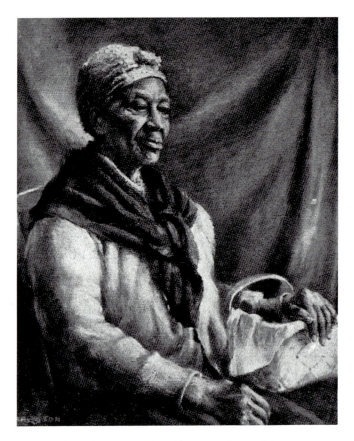

Edward A. Harleston. *The Old Servant.* 1928. Oil on canvas.
Harmon Foundation. Courtesy Mr. Donald Grant.

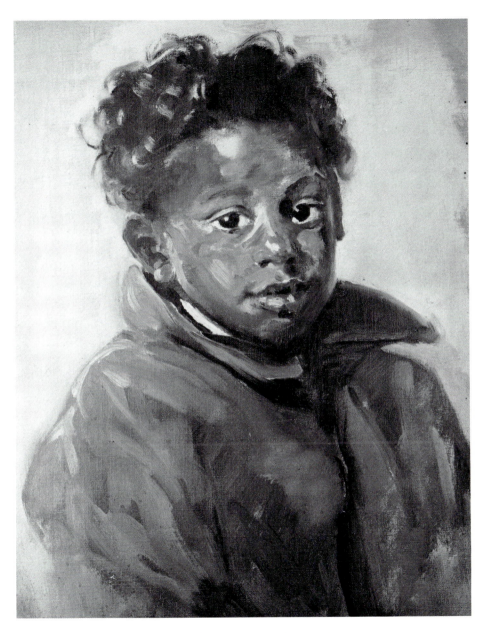

Laura Wheeler Waring. *Frankie*. 1937. Oil. 16 x 12.
Courtesy Mr. Robert McNeill.

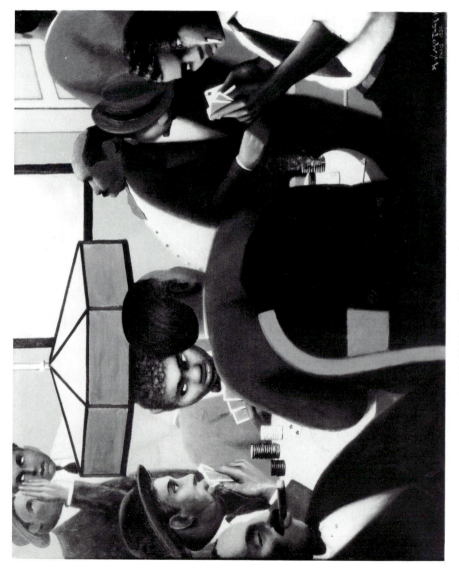

Archibald Motley. *Playing Poker.* 1933. Oil.

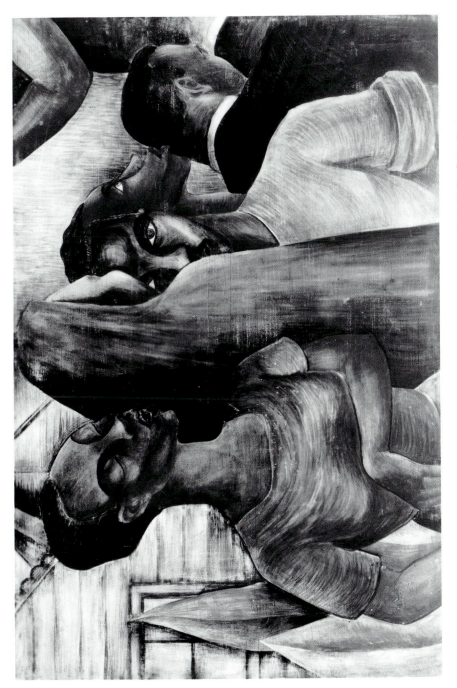

Charles Alston. *Magic and Medicine.* Detail. 1937. Oil. 23¼ x 33¼. W.P.A. Federal Art Project.

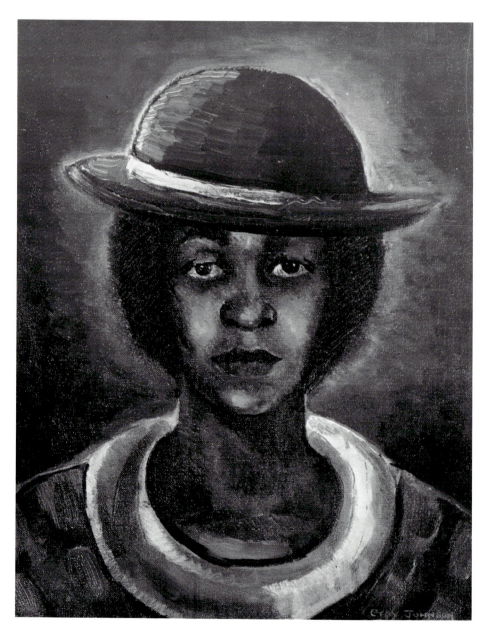

Malvin Gray Johnson. *Ruby*. 1933. Oil.

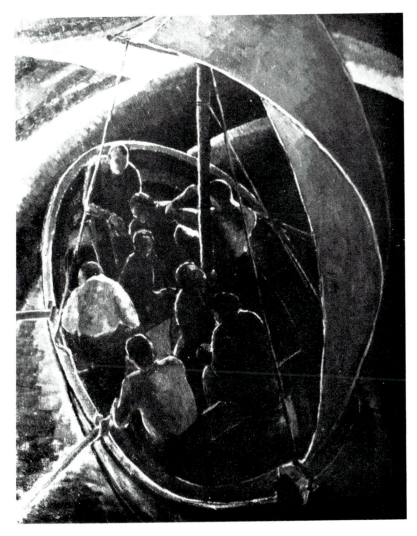

Malvin Gray Johnson. *Roll, Jordan, Roll.* 1933. Oil.

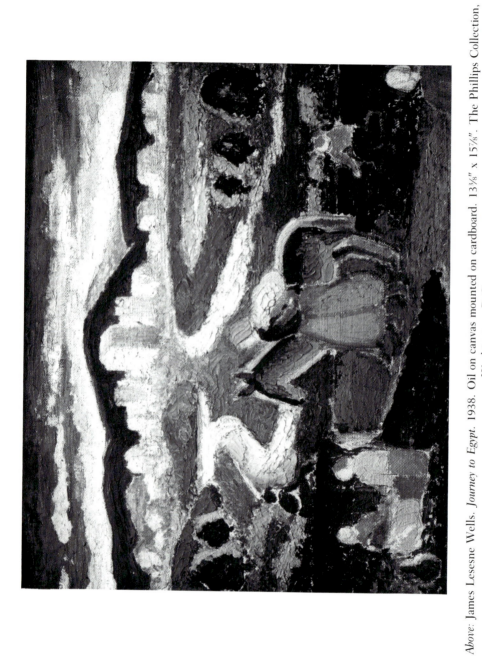

*Above*: James Lesesne Wells. *Journey to Egypt*. 1938. Oil on canvas mounted on cardboard. 13⅜″ x 15⅞″. The Phillips Collection, Washington, D.C.

*Below*: Edward L. Loper. *Across the Railroad Tracks*. 1939. Oil. The Howard University Gallery of Art, Permanent Collection, Washington, D.C.

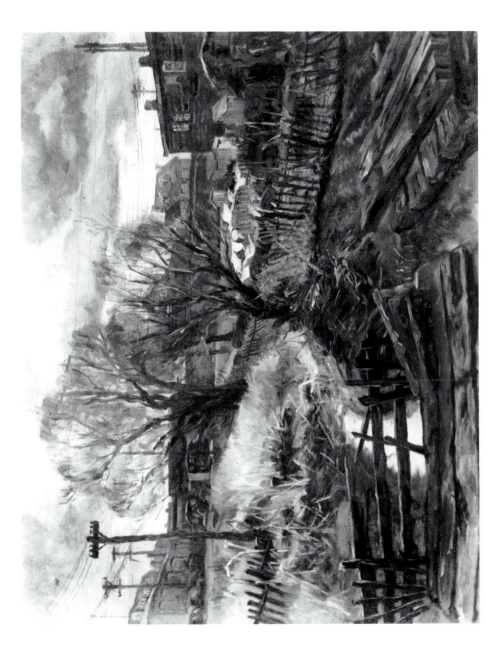

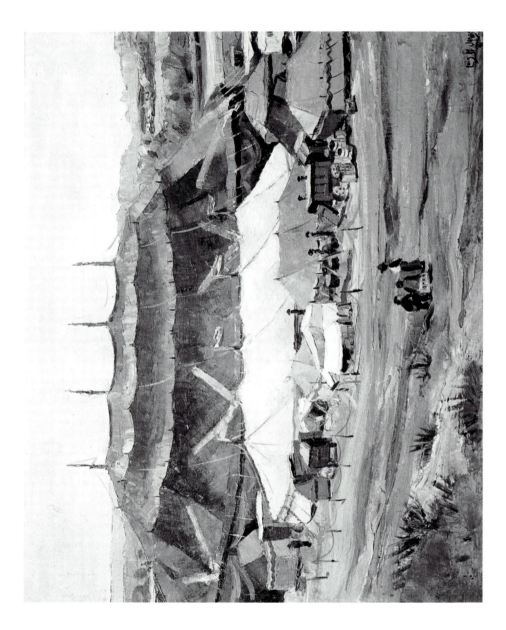

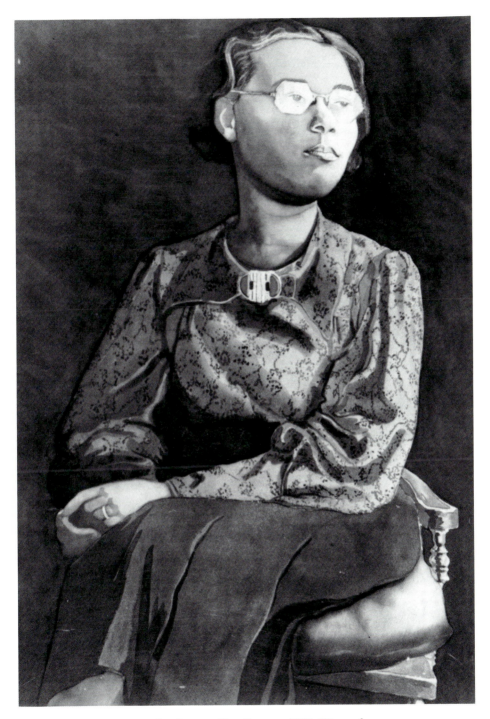

Samuel J. Brown. *Mrs. Simpson*. 1935. Watercolor.
W.P.A. Federal Art Project.

*Facing page:* Lois M. Jones. *Circus Tents*. 1941. Oil.
Courtesy Dr. Dorothy Porter.

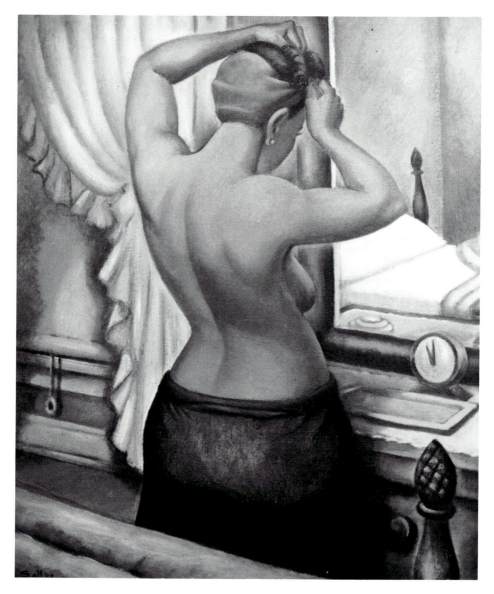

Charles Sallee. *Bed Time*. 1940. Oil.

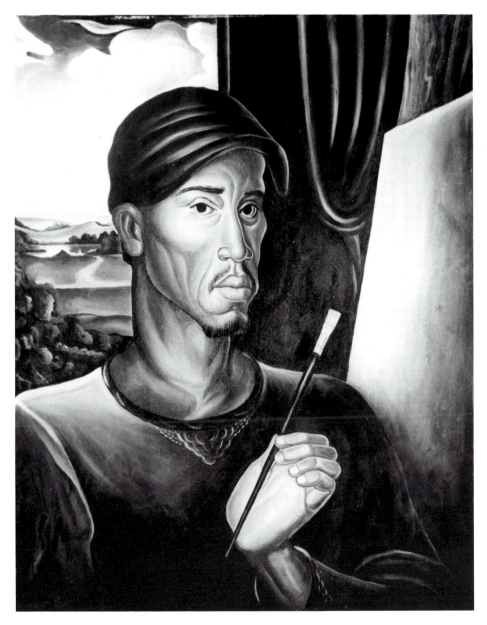

Frederick Flemister. *Self-Portrait*. 1940. Oil and tempera. 38¼ x 27½.
Alonzo J. Aden Collection.

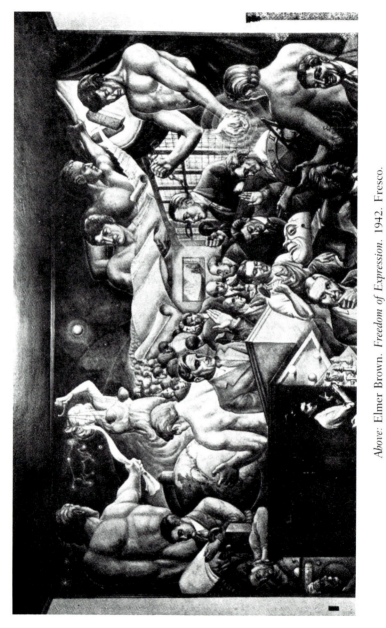

*Above:* Elmer Brown. *Freedom of Expression.* 1942. Fresco.

*Below:* Charles White. *Progress of the American Negro.* 5′ x 12′11″. 1941. Oil. The Howard University Gallery of Art, Permanent Collection, Washington, D.C.

243

Charles White. *Fatigue.* 1940. Oil. 71.1 x 81.3 cm. W.P.A. Federal Art Project. Heritage Gallery, Los Angeles.

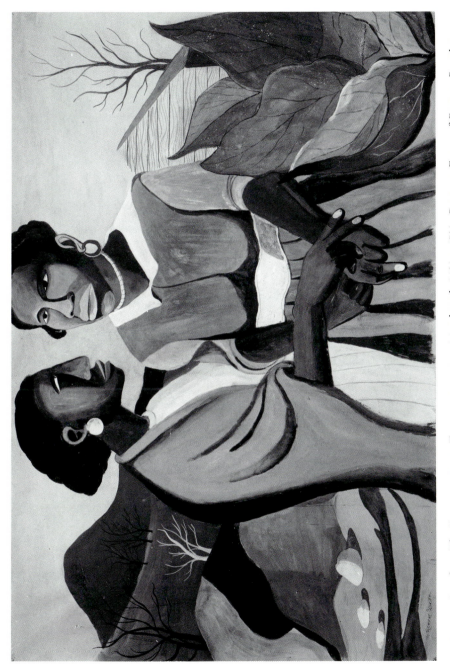

Romare Bearden. *The Visitation*. 1943. Tempera on composition board. 30¾ x 47⅞. Courtesy Estate of Romare Bearden.

William Carter. *Ballerina*. 1939. Oil. Courtesy Mr. William Carter

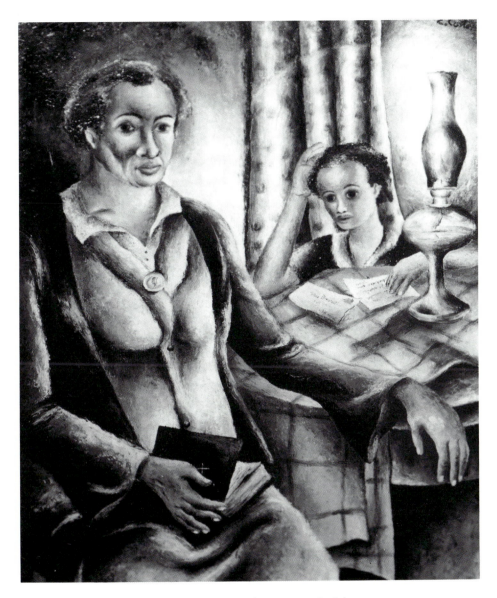

Eldzier Cortor. *Night Letter*. 1938. Oil.
W.P.A. Federal Art Project.

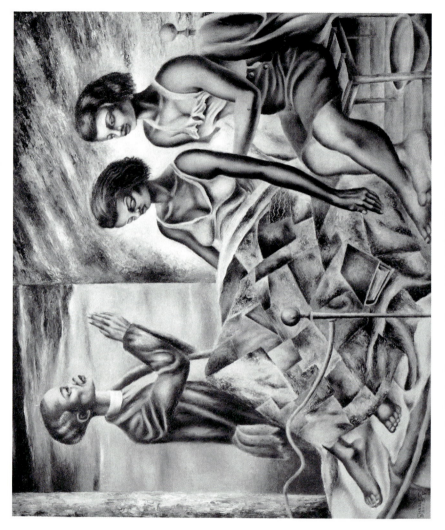

Charles Davis. *Victory at Dawn*. 1941. Oil. W.P.A. Federal Art Project.

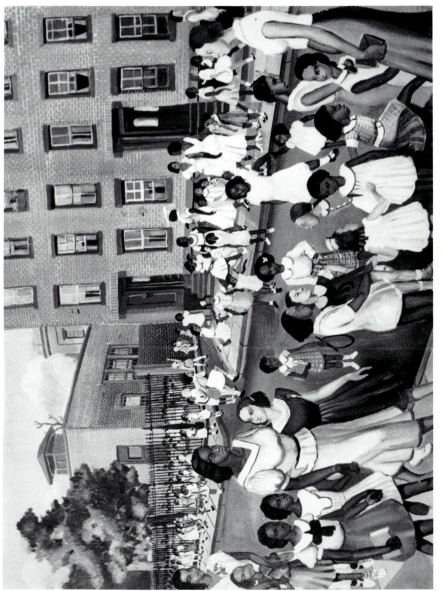

Allan Rohan Crite. *School's Out.* 1936. Oil on canvas. 30¼ x 36⅛. National Museum of American Art, Smithsonian Institution, transfer from the Museum of Modern Art.

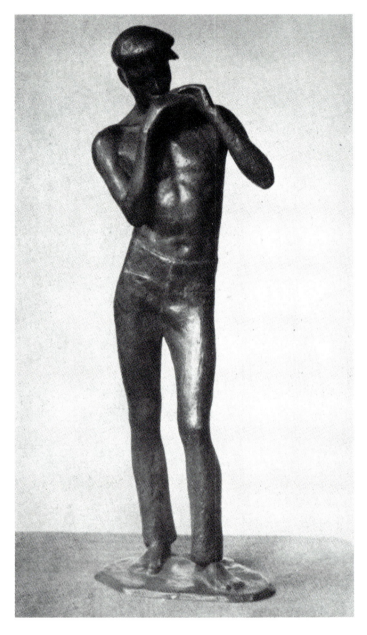

Richmond Barthé. *Harmonica Player*. 1934. Bronze.

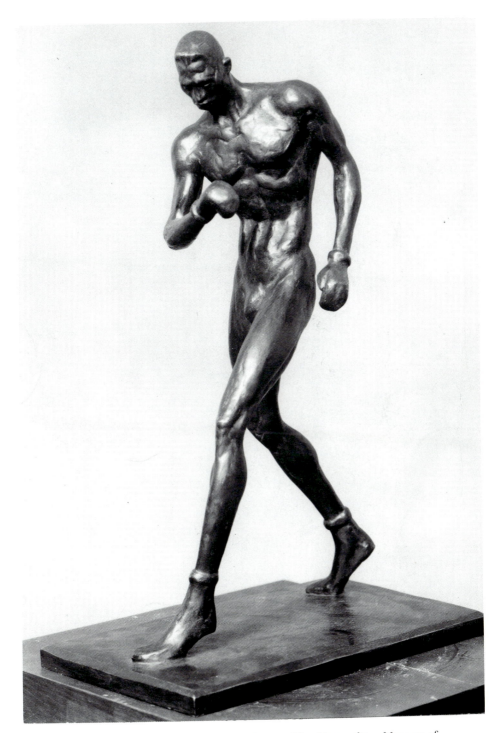

Richmond Barthé. *Boxer*. H. 16 in. Bronze. The Metropolitan Museum of Art, Rogers Fund, 1942. (42.180).

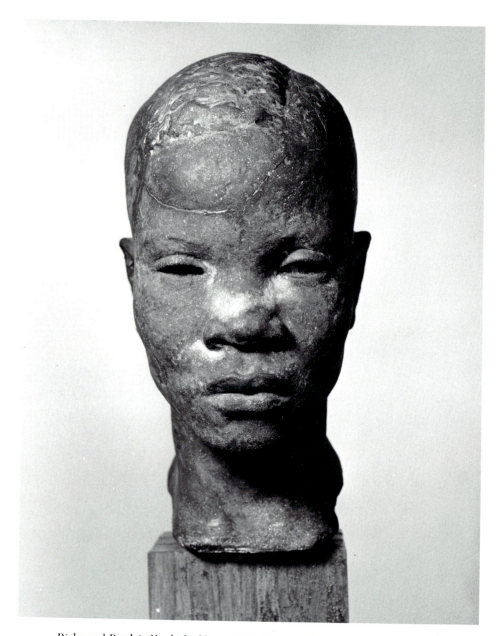

Richmond Barthé. *Head of a Negro*. 1938. Bronze. H. 7 in. Allen Memorial
Art Museum, Oberlin College; Gift of Mrs. Malcolm McBride, 1946.

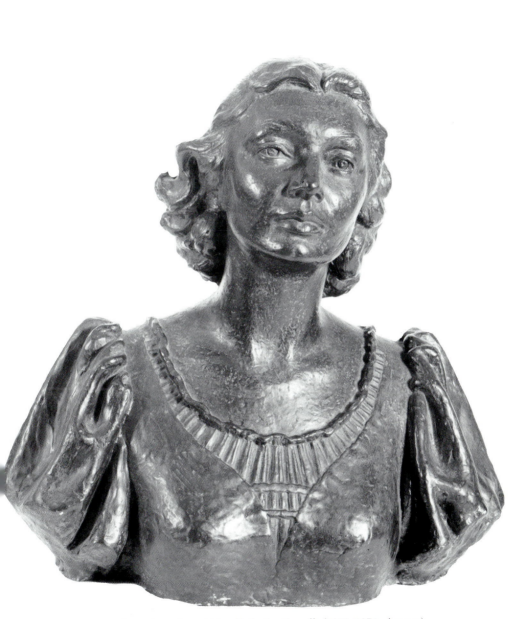

Richmond Barthé, 1901–. *Katherine Cornell.* (1893–1974, Actress)
Painted plaster, 52 cm. (20½ in.), c.1943. NPG.67.3.
National Portrait Gallery, Smithsonian Institution.
Gift of the artist through the Harmon Foundation.

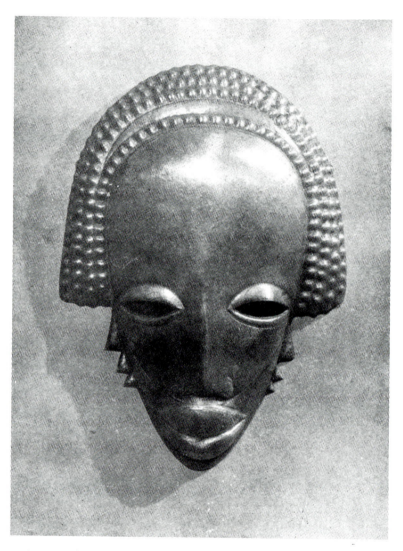

Sargent Johnson. *Mask.* 1933. Copper. 10⅞ x 7⅞ x 2⅜". San Francisco
Museum of Modern Art, Albert M. Bender Collection.
Gift of Albert M. Bender.

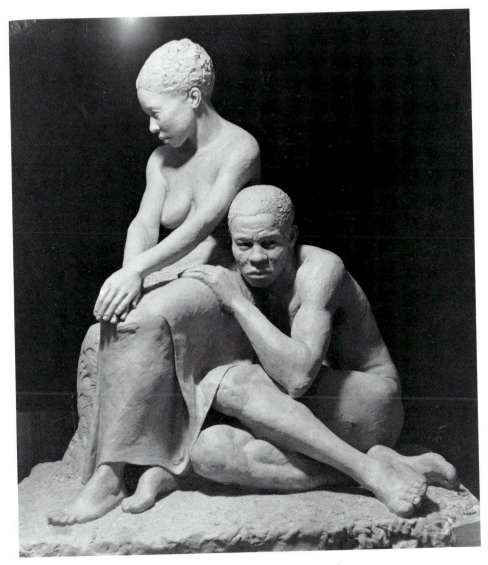

Augusta Savage. *Realization*. 1934. Clay.

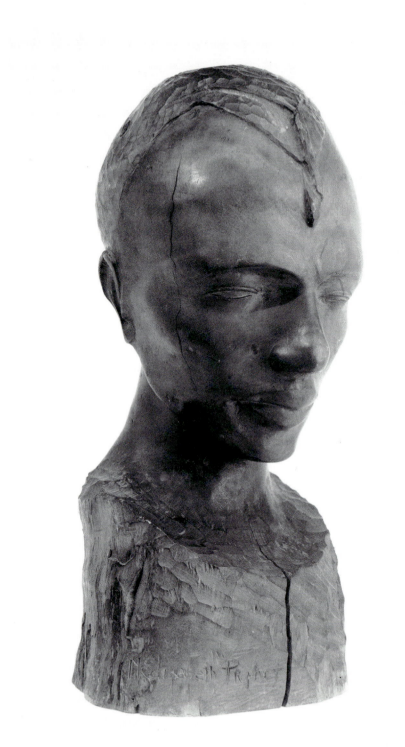

N. Elizabeth Prophet. *Congolais.* 1931. Wood.
16¾ inches (height). (42.5 cm).
Collection of Whitney Museum of American Art. Purchase 32.83.

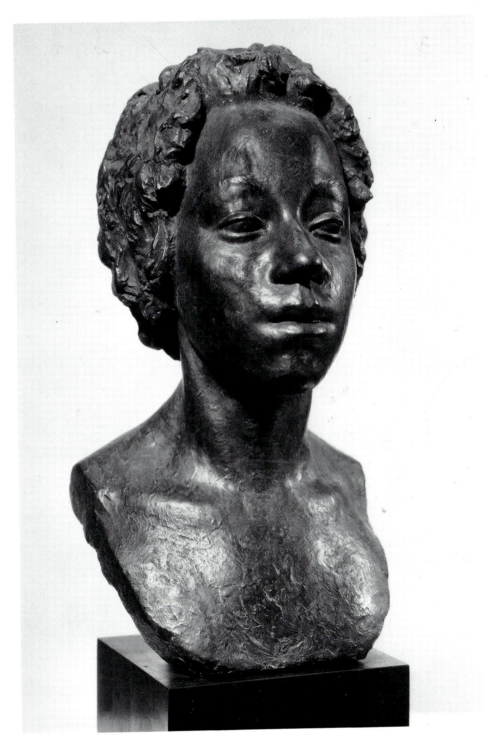

Clarence Lawson. *Head of a Negro Girl*. 1932. Bronze.

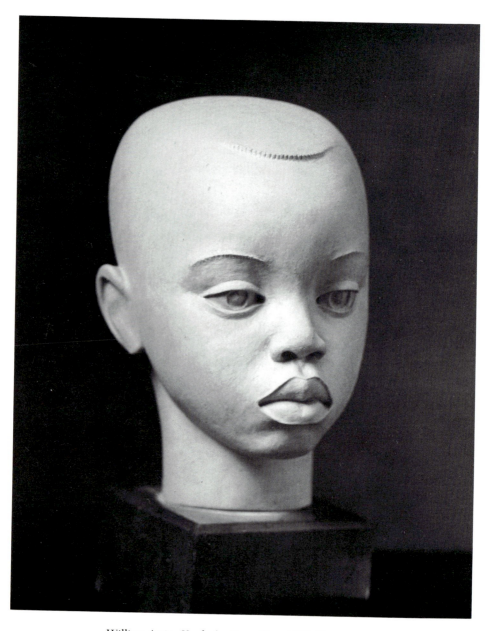

William Artis. *Head of a Negro Boy.* 1937. Terra cotta.
H. 10 in. Courtesy Dr. Dorothy Porter.

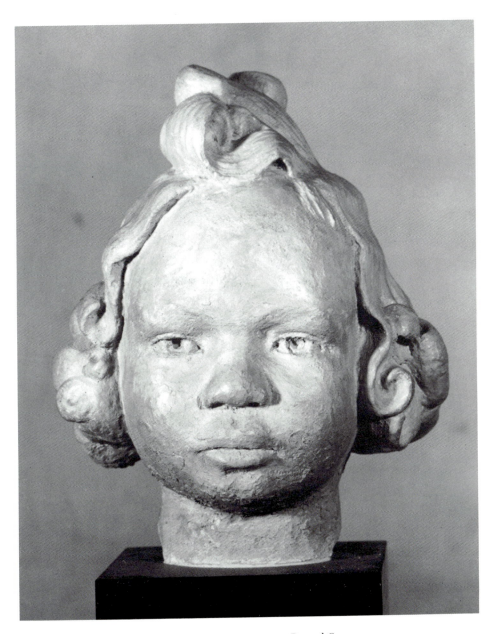

Joseph Kersey. *Anna*. 1939. Poured Stone.
Alonzo J. Aden Collection.

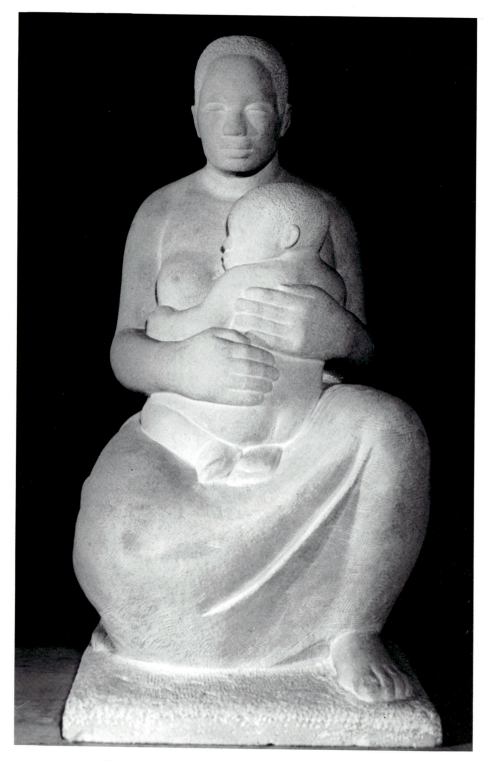

Elizabeth Catlett. *Negro Mother and Child.* 1940. Marble.

Selma Burke. *Lafayette*. 1938. Plaster.
W.P.A. Federal Art Project.

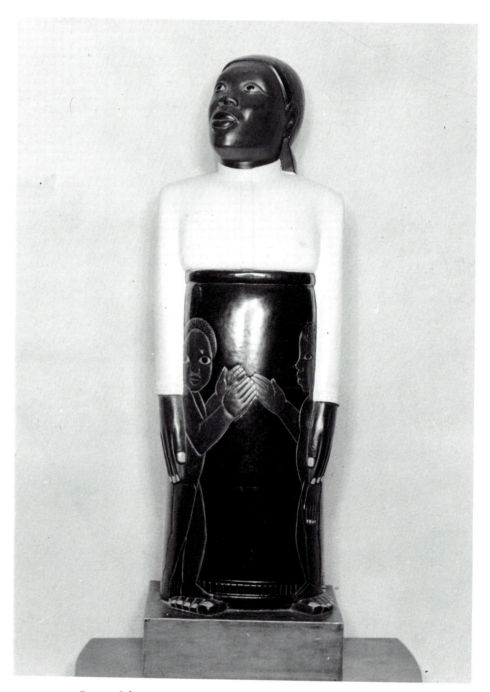

Sargent Johnson. *Forever Free*. 1933. Wood with lacquer on cloth.
36 x 11½ x 9½". San Francisco Museum of Modern Art.
Gift of Mrs. E. D. Lederman.

Horace Pippin. *Flower Study*. 1942. Oil.

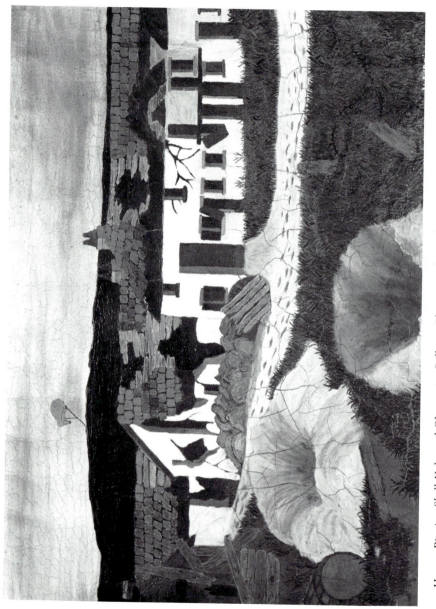

Horace Pippin. *Shell Holes and Observation Balloon, Champagne Sector* (ca. 1931). Oil on muslin. 57.2 x 81 cm. The Baltimore Museum of Art: Gift of Mrs. John Merryman, Jr. BMA 1967.48.

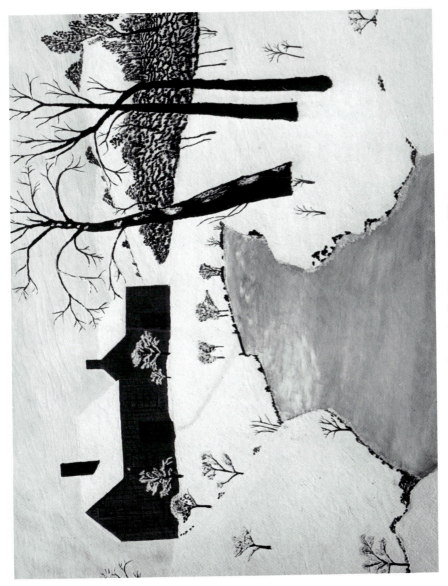

John Hailstalk. *Winter.* 1926. Oil.

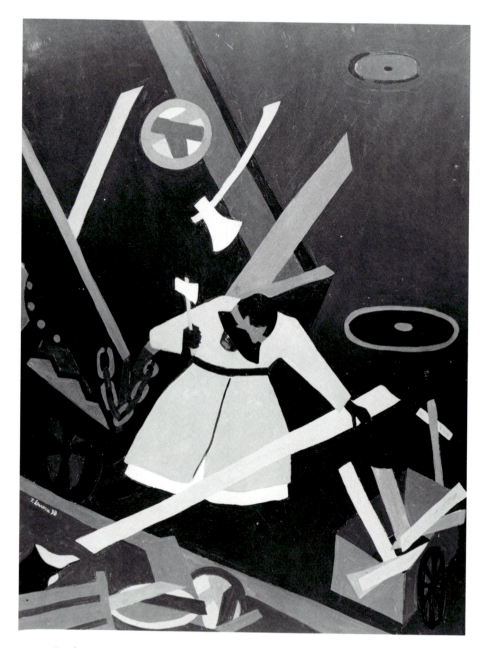

Jacob Lawrence. *Fire Wood*. 1938. Oil on wood. W.P.A. Federal Art Project.

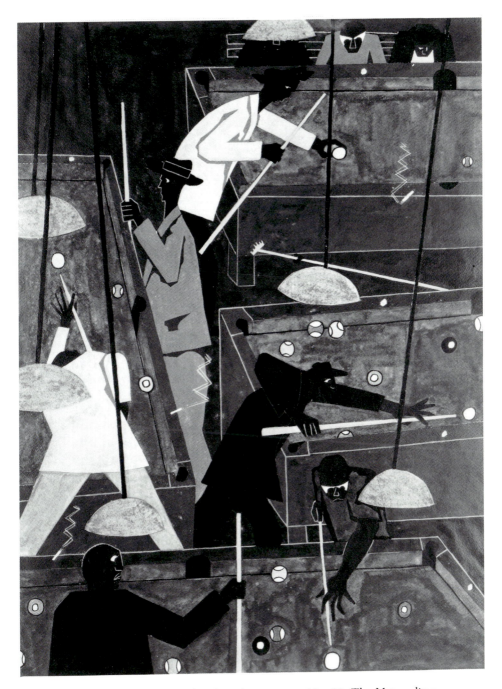

Jacob Lawrence. *Pool Parlor*. Gouache on paper. 30 x 32. The Metropolitan
Museum of Art, Arthur H. Hearn Fund, 1942. (42.167)

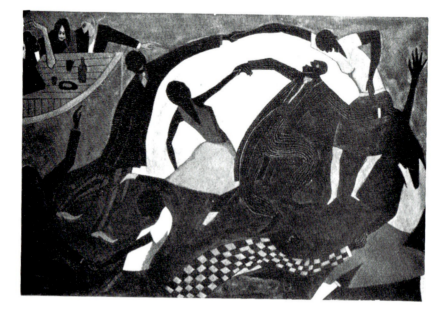

Jacob Lawrence. *Dancing at the Savoy* from the series *Harlem*. "Many whites come to Harlem to watch the Negroes dance." 1942. Gouache. 14 x 21.

*Facing page, top:* Jacob Lawrence. "One of the largest race riots occurred in East St. Louis" from the series *The Migration of the Negro*. (1940–41) Tempera on gesso on composition board. 12 x 18". Collection, The Museum of Modern Art, New York. Gift of Mrs. David M. Levy.

*Facing page, bottom:* Jacob Lawrence. "In the North, the Negro had better educational facilities" from the series *The Migration of the Negro*. (1940–41) Tempera on gesso on composition board, 12 x 18". Collection, The Museum of Modern Art, New York. Gift of Mrs. David M. Levy.

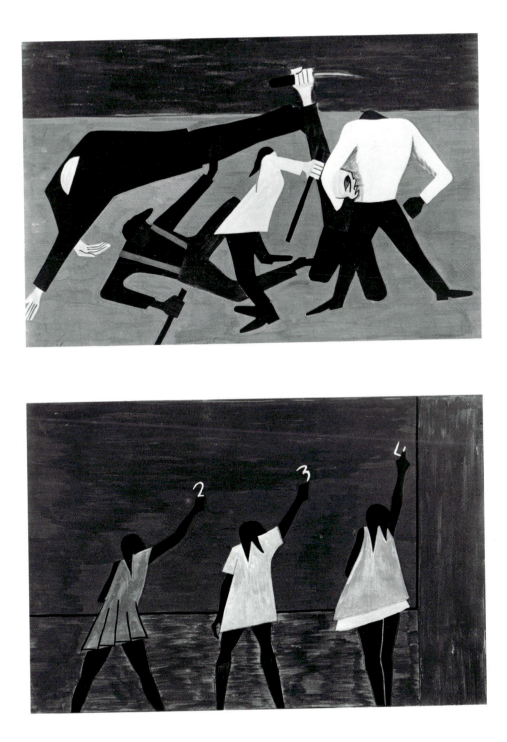

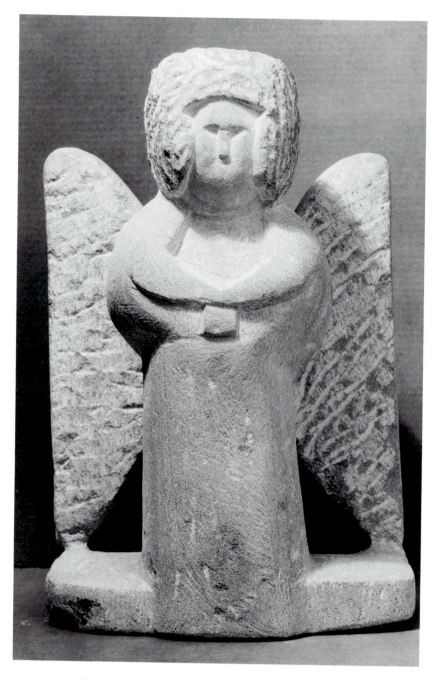

William Edmonson. *Small Angel.* 1937. Limestone. H. 17½ in.

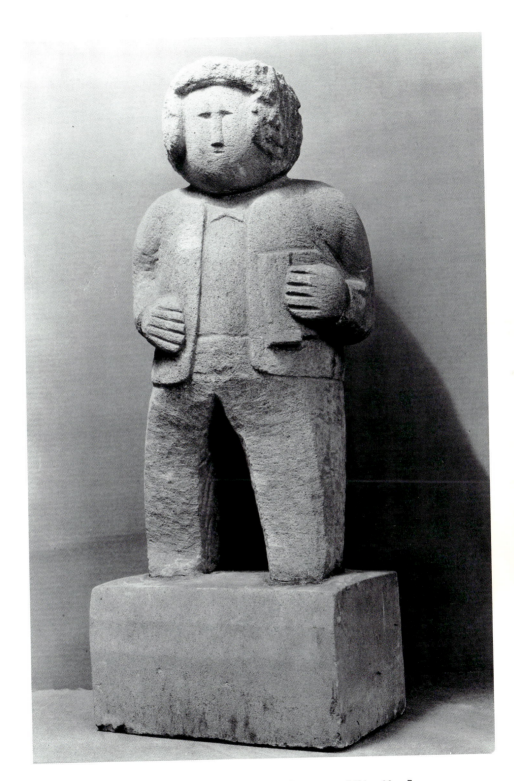

William Edmonson. *Lawyer*. 1938. Limestone. 26⅜ x 11 x 7.

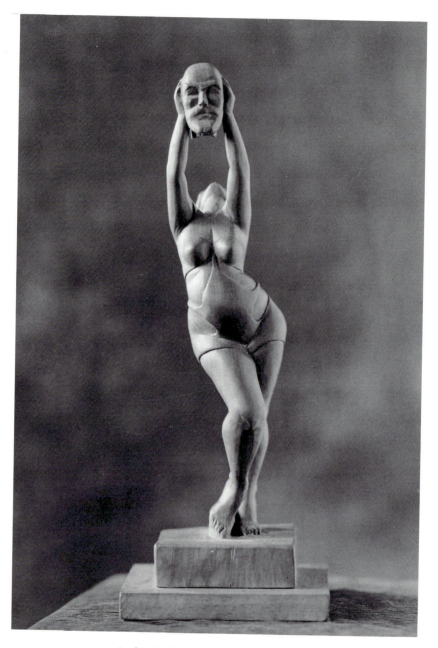

Leslie G. Bolling. *Salome*. 1934. Wood.

*Facing page:* Allan R. Freelon. *Unloading*. 1937. Aquatint.

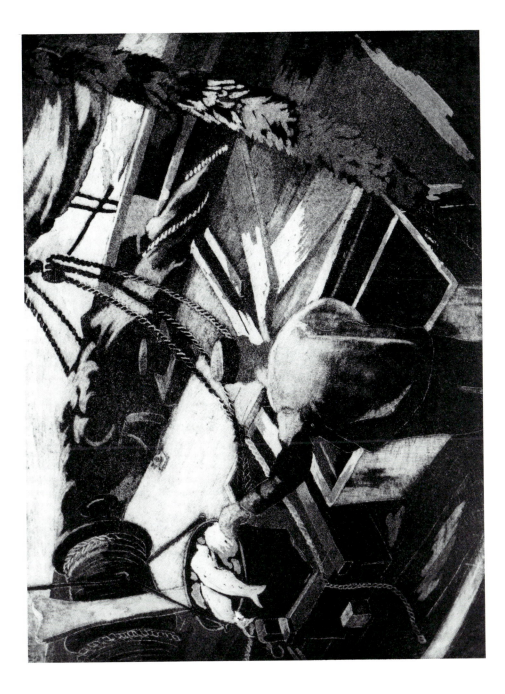

273

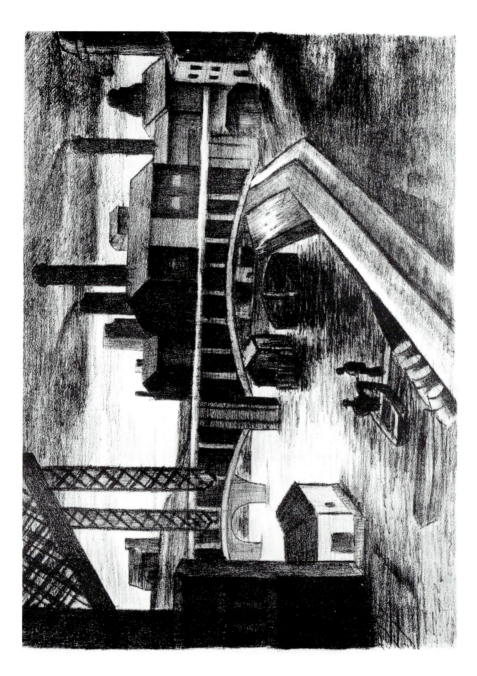

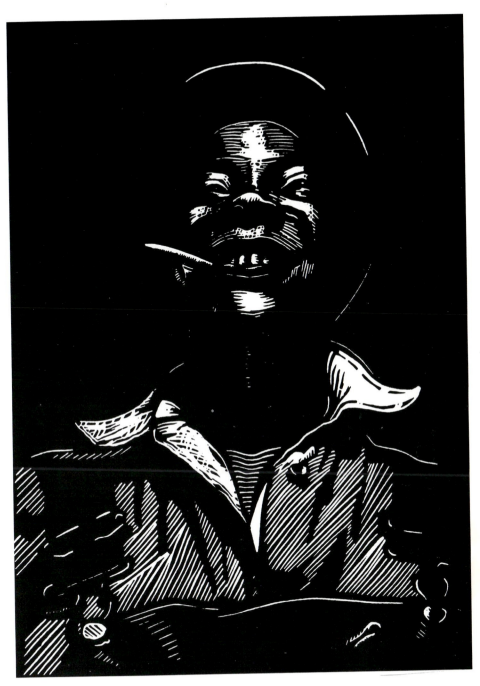

William Smith. *Pay Day*. 1941. Lino-print.
Courtesy Dr. Dorothy Porter.

*Facing page:* James Lesesne Wells. *East River, New York*. 1938. Lithograph.

Charles Sallee. *Boogie Woogie*. 1941. Etching. 7 x 4.
Courtesy Dr. Dorothy Porter.